John F. Moffitt
was Professor Emeritus of Art History
at New Mexico State University. Born in San Francisco
in 1940 and educated at California State University and at the
University of Madrid, he devoted many years to the study of
Spanish art and Hispanic culture. A frequent contributor to
scholarly journals, his many books included *Spanish Painting*
(1973), *Velázquez: Práctica e idea* (1991), *Art Forgery: The Case
of the Lady of Elche* (1995) and *The Islamic Design Module in
Latin America: Proportionality and the Techniques of
Neo-Mudéjar Architecture* (2004).

Thames & Hudson world of art

This famous series
provides the widest available
range of illustrated books on art in all its aspects.
If you would like to receive a complete list
of titles in print please write to:
THAMES & HUDSON
181A High Holborn, London WC1V 7QX
In the United States please write to:
THAMES & HUDSON INC.
500 Fifth Avenue, New York, New York 10110

Printed in Singapore

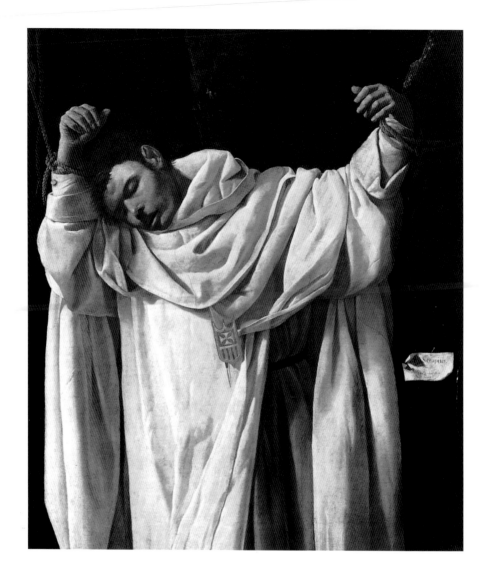

JOHN F. MOFFITT

The Arts in Spain

172 illustrations, 51 in colour

Thames & Hudson world of art

*por Gabriela, para que conozcas a fondo la cultura
que más admiro y que siempre me maravilla.
Immer Deiner, JFM*

Frontispiece: Francisco de Zurbarán, *St Serapion, c.* 1628

First published in the United Kingdom in 1999 by
Thames & Hudson Ltd, 181A High Holborn, London WC1V 7QX

Reprinted 2011

British Library Cataloguing-in-Publication Data
A catalogue record for this book is available from the British Library

ISBN 978-0-500-20315-6

Printed and bound in Singapore by C.S. Graphics

To find out about all our publications, please visit
www.thamesandhudson.com. There you can subscribe
to our e-newsletter, browse or download our current
catalogue, and buy any titles that are in print.

Contents

Map of Spain showing the principal artistic centres

Preface

A comprehensive history of Spanish art embraces some 30,000 years of continuously developing human creativity. Sprawling between the sunny Mediterranean and the chill fogs of the Atlantic, the Iberian peninsula was always a magnet attracting diverse peoples with alternating cultures, each characterized by a distinctive artistic language. This eclectic, sometimes conflicting, cultural situation is a constant trend throughout Spanish history. Spain is heterogenous, even today, including peoples as diverse as Basques (speaking a language unlike any other in Europe) and Andalusians (having their own Islamic influences), with Catalans and Valencians confronting Castilians and Galicians, and Balearic Islanders in the Mediterranean differing from Canary Islanders in the Atlantic.

In contrast to most other short histories of Spanish art, which tend to put greatest emphasis on relatively late periods from El Greco onwards, this book aims to redress the art-historical balance. Its guiding light throughout has been the recurrent native factor: the Iberian element underlying a Latin imposition; the singularity of medieval Spanish art compared to international Romanesque and Gothic modes; Hispanic responses to the Italian Renaissance; a self-dubbed 'National Style' responding to the European Baroque, and so forth. Even today, traits of the ongoing Hispanic tradition are still discernible within the international phenomenon of postmodern art. Some of what follows, particularly in the early phases, also applies to Portugal, a country which was later to tend, often deliberately, to follow a rather different course of self-expression than that pursued by its more powerful neighbour.

Spanish art has traditionally been divided into three genres: conventionalized religious subjects; austerely functional portraiture; and elementary still-life arrangements. Each is susceptible to either a moral or an analytical treatment, if not both at once. Although the situation obviously differed in sophisticated metropolitan circles, pre-modern Spanish art was rarely created to impress profane connoisseurs; its intention was to convey significant messages in easily read, visual media to simple people. The resultant images amply demonstrate that

anonymous Spanish vocational artisans working in provincial isolation were as able as their European counterparts to chronicle events visually, much as a newspaper photographer might today.

In his treatise *El arte de la pintura* (Seville, 1649), Francisco Pacheco, teacher and father-in-law of Velázquez, states: 'The aim of the painter, in his capacity as an artisan, will be by means of his art to earn a living…the end of painting in general will be, by means of imitation, to represent a given subject with all the power and propriety possible.' He is describing a rhetorical art: 'The goal of the Catholic painter is to endeavour, in the guise of a preacher, to persuade the people…Like the means of the orator, speaking appropriately and to the point, so too will his goal be to convince us…the principal goal of Christian images will always be to persuade men.'

Although today's goals are rarely those cited by Pacheco, even postmodern Spanish artists acknowledge their rhetorical role of 'preacher'. Nowadays their sermons are about Spain's need to be culturally progressive, in tune with the rest of the modern world. Evidence for the idea of art as an alternative moral-ethical system to religion is abundant in statements from most earlier vanguard European critics and artists, including in Spain Picasso, Gaudí and Dalí, among many others less famous.

Spain has unquestionably produced some of the most psychologically gripping visual imagery in the history of European art. I have tried as much as possible in this short space to discuss, besides painting, some representative examples of architecture and sculpture, particularly when they serve to illustrate significant cultural phenomena. The aim of this book is to present a representative anthology of individual works drawn from the Spanish artistic panorama, and then to situate them – selectively treated as model cultural illustrations – within their historical context.

Beginnings in Diversity

The first, surprisingly accomplished, manifestations of Hispanic art are to be found on natural rock walls within dark recesses of caves situated in the far northern peripheries of the Iberian peninsula. The earliest group belongs to the Aurignacian phase (30,000 BC) of the Paleolithic period, with its epoch of greatest artistic brilliance now being dated to between 15,000 and 8500 BC and assigned to that period known as Magdalenian (after the cave-site of La Madeleine in France). At that time, the last Ice Age was drawing to a close, and herds of reindeer and other large herbivores, especially bison, roamed Europe's plains and valleys. These were not only the principal source of nourishment for these precociously artistic people, but also the main subjects for their vivid pictorial cycles.

Perhaps the most impressive of these fleeting illusions of life and movement (reminiscent of the French Impressionists) are those of Altamira at Santillana del Mar (Cantabria), whose oddly 'modern' images remained wholly unknown to modern Europeans until 1879. Bored by her archaeologist-father's meticulous scrapings, Don Marcelino de Sautuola's little daughter María crept inside the rocky chamber of a cave near Altamira. A startled cry from within the cave immediately brought in her father who saw bison, horses, stags (one over seven feet long), ibex, boar, elk, and a wolf. Some 150 of these animals, mostly unknown or extinct in that region, had been rendered with the utmost liveliness and anatomical fidelity. Even at the very beginnings of art-making in Iberia there was a bias towards realism. A foreshortened, three-quarter viewpoint is commonly employed to enhance three-dimensionality. One figure, a boar, even shows a multiplication of feet, evidently a device to suggest movement which oddly foreshadows artifices employed by Futurist painters in the early twentieth century.

The artists who created these masterpieces were tall and long-boned Cro-Magnons. They had displaced the Neanderthal peoples, who never practised art, only rudimentary tool-making. The geographical range of Magdalenian cave paintings is restricted to territories embracing the Pyrenees, stretching from Catalonia into the

9

Bay of Biscay as far west as Asturias, and also north into the mountainous Dordogne region of south-western France, where Lascaux was discovered in 1940. These works are certainly not an example of 'art for art's sake', for current scholarship additionally concludes that they served a magical, totemic role. By ritualistically creating (and *ipso facto* 'capturing') the image, the artist-magus would have put individual beasts within the hunters' power. For the first time in history, we find compelling evidence for the division of labour. Abundance seems to have released some clan members from food-gathering activities, so creating a specialized, possibly even vocationally trained, artist class.

The painted ceiling of the cave at Altamira shows individual animals placed upon natural rock protuberances, which enhances the illusionistic effect of imposed painterly three-dimensionality. Depictions of humans – still only composition-less sequences of single figures with no narrative – are rare. These spirited drawings may have enjoyed a brief and functional psychic life; once their immediate ends were attained they were disregarded, hence the appearance of additions covering earlier works beneath. The creation of these often

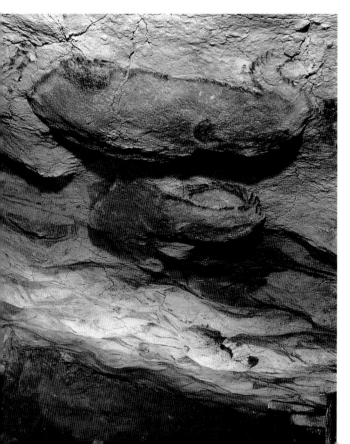

1 Painted rock protuberance in a cave at Altamira depicting a wounded bison, *c.* 8500 BC

superimposed images took place over many generations. Because they could only have been viewed by torchlight, and since there is little evidence of soot on the ceilings, they were clearly not put in their inaccessible locations in order to be contemplated for aesthetic pleasure. The depths of these rocky caves, well away from the brightly lit living areas at the cave mouths, must have been designated as sacred realms in a proto-architectural hierarchy of spaces. Oddly, although they are fairly common in other European Paleolithic sites, no examples of sculpture, especially the famous fertility-goddess types, have yet been found in the Iberian peninsula. The presence throughout the Paleolithic painting cycles of certain highly abstract signs, some appearing to represent human genitalia, might reinforce a fertility-ritual interpretation for these.

As H. W. Janson recognized some time ago, Altamira also reveals evidence of another supposedly wholly modern practice, the discovery of representational meanings in haphazardly shaped geological formations on cave walls. Iberian Stone Age artists were pursuing artistic imagery encountered by pure chance, millennia before the experiments of Dada artists in Zurich during the First World War.

Between 8500 and perhaps 2000 BC, during the post-glacial Mesolithic or Middle Stone Age, the rock-art tradition continued in the Spanish Levant, running from Lérida province in the north to Almería within the borders of Andalusia. This later, 'petroglyphic' style is smaller, and more cursive and sketchy, with simple silhouetted and monochrome figures – usually dark red or black in colour – drawn with undifferentiated backgrounds upon external vertical rock faces and not in caves. Despite their continuous exposure to the elements, these ancient pictures have been preserved by seepages of water with a high calcium content which functioned as an accidental glazing; there is also evidence of repainting in ancient times by subsequent generations of Mesolithic artist-conservators. Although they are far less illusionistic than those at Altamira, the use of narrative composition in these paintings is a revolutionary innovation. We repeatedly find anecdotal scenes of people either pursuing animals, some of which already appear to be domesticated, or battling with one another, probably because of territorial conflicts. Not only is there now a clear differentiation between the sexes, but there is also a corresponding job assignment: men are hunters and warriors; women are mothers, herders and food-gatherers.

'The Fate of a Bee-Robbing Honey-Gatherer' was depicted in 2 around 5000 BC on the irregular rock face of the Cueva de Araña, at

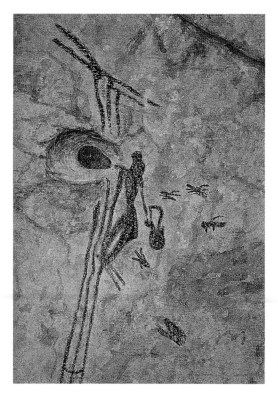

2 Wall painting in the Cueva de Araña, Bicorp, 'The Fate of a Bee-Robbing Honey-Gatherer', *c.* 5000 BC

Bicorp (Valencia). The silhouetted figure of a determined woman industriously climbs up a plaited rope of esparto grass to snatch honey from a real hole in a cliff face; the natural aperture in the rock must once have housed a colony of bees. The angered defenders buzz out to attack their audacious assailant. Doubtless this lively image commemorated an actual event: the woman is stung, yelps in pain and falls to the ground while her friends stand around laughing.

As elsewhere, the Mesolithic phase in Spain was gradually displaced by a fully Neolithic era, the beginnings of which date to perhaps as early as 5500 BC. This period saw the proliferation of agricultural settlements whose numerous technological innovations (including pottery-making and metalworking) were accompanied by the simultaneous proliferation of paintings, sculpture, and ever more ambitious architectural endeavours. The rise of bronze, mainly prized to make superior weaponry to fend off more primitive human beings armed only with obsolete stone, wooden or soft copper armaments, required both copper and tin. Spain herself was rich in copper, and

12

became a centre for the trans-shipment of tin to eager Mediterranean merchants from Galicia and more distant mines located far north in the Atlantic, principally Cornwall. Dominating the narrow and easily defended Straits of Hercules, prehistoric Hispanic entrepreneurs enjoyed a virtual monopoly of the metals market. Thereafter Spain was famed as a land of inexhaustible mineral wealth, a coveted El Dorado in the far west, or Hesperides in Greek.

Exploited as early as 3400 BC, copper mines were worked near Los Millares (Almería), a fortified town with towered walls and an aqueduct bringing water from a spring some three kilometres distant. Found in the local necropolis were thin 'idol plaques', which were evidently hung around the neck like crucifixes. In a later formal evolution, found in other burial sites in the Levant and Portugal, the flattened and finely polished stones of schist or slate are engraved with geometric designs and begin to acquire human shapes. These figures, often with staring eyes, are usually said to depict a mother goddess with a characteristic 'owl face'; alternatively, they may have represented the wearer, clad in a woollen poncho, for no gender is indicated. Since similar protective talismans or amulets have been found in Iberian coastal regions extending from the Mediterranean westwards towards the Atlantic, we have evidence for a widespread religious culture employing this shared iconography of all-seeing deities.

THE BEGINNINGS OF IBERIAN CULTURE

The first documented political-cultural entity in Spain – indeed the first advanced, independent civilization known to exist west of Italy – was described in ancient writings as a legendary kingdom, Tartessos, a seemingly inexhaustible source of gold, silver, lead and tin. The earliest textual reference (c. 620 BC) pointing to a specifically Spanish location for Tartessos was written by Stesichorus, who mentions 'the boundless silver-rooted springs of the Tartessus River'. Rather than to a city-state, the name Tartessos is now taken to refer broadly to the River Baetis (Guadalquivir). Various modern finds of golden treasure, at La Joya (Huelva), Villena (Alicante), Aliseda (Cáceres), El Carambolo and Setefilia (Seville) dating from between 750 and 550 BC, demonstrate that Tartessos had grown rich on its mines, its metalworking industries, and its monopolistic overseas trade. At an unknown date (a controversial Roman source, Velleius, suggests as early as 1100 BC, but the eighth century BC is more likely), Phoenicians from Tyre founded the rival

13

city of Gadir, meaning 'stronghold' in Punic and corresponding to modern Cádiz. Greeks trading with Tartessos and Gadir had no intention of colonizing Spain, nor even of exploring inland at any distance, but they did succeed in culturally colonizing the first native Spanish civilization for which we have abundant written and physical evidence: that of the Iberians.

Although the origins of Iberian culture remain rather mysterious, its peoples were probably indigenous to the peninsula; evidently Tartessos was their local point of departure. This post-Tartessian civilization produced the first native sculpture, and a distinctively expressive body of paintings. Its tentative beginnings were accompanied by waves of settlers arriving from the north; the first Indo-European penetrations, by Celtic peoples, began in perhaps the ninth century BC. In general, Celts occupied the wild north and centre of the peninsula, the Meseta, whereas the Iberians inhabited the fertile coastal littoral, stretching from the Rhône to Seville and Huelva. The northern half of coastal Iberia was the area most open to classical Greek influences. Further south, Iberian culture was decisively shaped by contact with Carthaginian settlements centred about Cádiz and Cartagena (Nova Cartago), thus injecting a pronounced 'oriental' factor into its subsequent artistic expression. Working as much from native traditions as from these foreign influences, the Iberians eventually developed a diverse, literate and complex society given to a luxury quite foreign to the pastoral and rudely agrarian lifestyle of the warlike and illiterate peoples of the interior.

The unifying element of Iberian civilization was a shared written language. The great ethnic and cultural variety otherwise manifested in Iberian cultural products is a result of geographical divisions: Catalonia, the Ebro valley, different sectors in the Levant, and further subdivisions within Andalusia itself. In these early epochs an eclectic fusion, constant in Spanish culture, of the diverse traditions of north African and trans-Pyreneean cultures is apparent, dominated by everstronger cultural influences coming westwards from the major Mediterranean civilizations.

The Iberians, unlike the Carthaginians and the Tartessians before them, left a significant art-historical legacy. The accepted range of its dating is roughly between 550 and 100 BC. After that time the Iberians effectively disappear as an autonomous cultural entity, most probably as casualties of the Punic Wars. Among others, we know that the important archaeological site of Illici at La Alcudia near Elche (Alicante) was razed to the ground by Hamilcar in 228 BC. The devastation

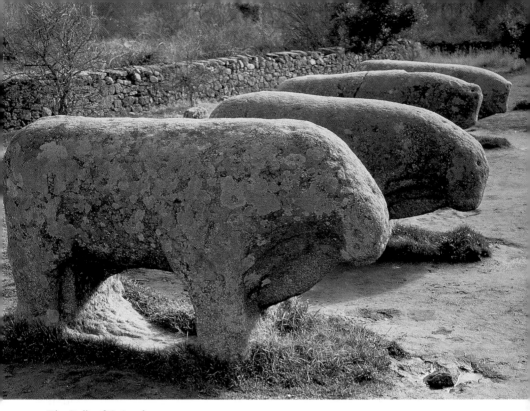

3 The Bulls of Guisando, *c.* 200 BC

wrought throughout Iberia at this time was profound; apart from a few subterranean tombs decorated with schematic paintings, we have no significant Iberian architectural remains, and no walls decorated with lively narrative scenes of the sort found on Iberian ceramic ware. Sculpture, generally executed in a pronounced archaic style and mostly surviving in a fragmentary state, represents by far the bulk of the tangible remnants of Iberian art. Particularly interesting are the large, roughly hewn stone Bulls of Guisando found near Ávila. These show the prestige of Iberian sculpture in Celtic territories and provide an early instance of the taurine iconography of Spanish art.

As distinguished by local schools or workshops, Iberian sculpture may be broadly grouped by subject matter into two categories: animal subjects (often including bulls), and human figures. Anthropomorphic figuration does not often appear north of Valencia, and its appearance

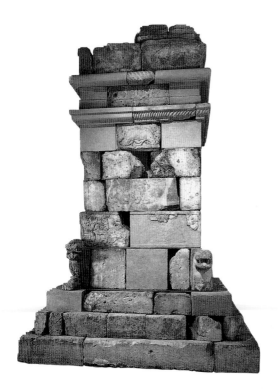

4 (*left*) Tomb at Pozo Moro, *c.* 500 BC, as reconstructed in the Museo Arqueológico Nacional, Madrid

5 (*below*) Sculptural relief from tomb at Pozo Moro depicting the 'Lords of the Dead', *c.* 500 BC

6 (*right*) Sculptural relief from the *Heroön* at Porcuna, *c.* 425 BC, showing an armoured warrior pulling the reins of his horse

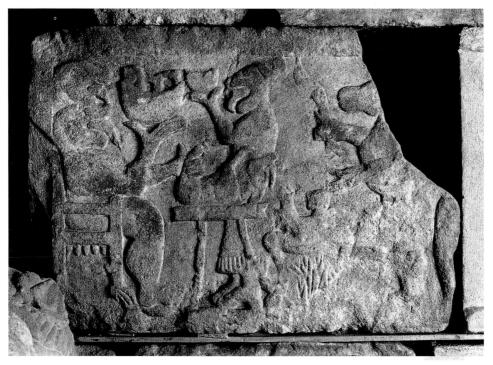

in southern Iberia is attributed to Punic and, particularly, Greek stimuli. Whereas the few surviving large Iberian sculptures are in stone, only very small figures remain in bronze. Relatively large numbers of the latter have survived; all of them evidently represent ex-votos for they were mostly found at known religious sanctuaries. At such places, seemingly bereft of temples, divine images or even altars, the devout bearers of offerings (perhaps the bronze figurines represent schematic portraits of donors?) could place themselves spiritually before their gods, without the mediation of priests, just as the Spanish mystics were to do in their meditational writings some two millennia later.

Some recent archaeological finds indicate the wide, even eccentric, range of Iberian sculpture. Scientific excavations conducted in 1982 at Pozo Moro (Albacete) recovered the tumbledown remains of a tower-shaped tomb. Probably erected around 500 BC, it stood some five metres high and was apparently covered with reliefs, with four guardian lions at its base. The iconography displayed in the surviving reliefs (all supposedly belonging to the tower) is bizarre, and their style rampantly exotic or 'oriental'. They mostly portray mysterious mythological scenes, with one apparently depicting a Punic version of Hell showing an enthroned, monstrous and two-headed god. This horrific creature with a protruding tongue holds up a bowl containing a tiny

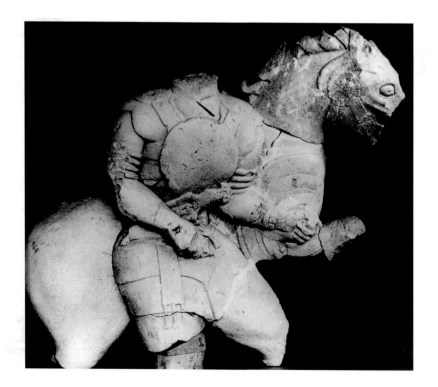

person; in his other hand he clutches a dead boar. Facing him is another fork-tongued monster, evidently female, behind whom is placed a horse-headed creature brandishing a curved dagger. This demonic ensemble is thought to represent the 'Lords of the Dead'. Another funereal complex, dated around 425 BC, was recently uncovered at Porcuna (Jaén), the ancient Obulco. Belonging to this ensemble are no less than forty half-life-size figures, portrayed in a variety of poses, standing or struggling with beasts. Because the style and iconography of this group are antithetical to the Pozo Moro reliefs, it has even been proposed – notwithstanding its many exotic details – as the work of an itinerant Greek craftsman; perhaps this odd arrangement of reality and mythology, with warriors, hunters, beasts and a goddess, originally comprised a *Heroön*, or Hellenic hero's sanctuary.

6

The other important category of surviving Iberian art is ceramics. To our still very imperfect knowledge of Iberian culture the painted subjects of these vessels make an invaluable iconographic and chronological contribution, particularly when they are found alongside datable imported Hellenic works. Iberian painting is known only from the miniscule ceramic remains which might, however, echo a native tradition of mural painting, perhaps of the sort practised by the Etruscans contemporaneously, and, much earlier, by the ancient Anatolians and Minoans. One Iberian figuration found on pots is abstract, usually a repeated 'tree of life' motif, with odd volute finials running around the vase. Unlike the elegantly proportioned silhouettes of Hellenic ceramics often found in Iberian sites, Spanish examples have a mundane cup-like shape that is both inert and inelegant, with simple vertical walls rising from a crudely rounded base. Likewise, the Iberian painter ignores the elegantly proportioned divisions of classical Attic vase painting, arranged in horizontal tiers of alternating narrative friezes and precisely drawn sequences of stylized floral motifs. Instead, he breaks his pictorial field into irregularly shaped and aligned vertical panels. The result is, however, a dynamic composition, for the front cannot be predicted from the back: the composition evolves as the pot is rotated. The variety of motifs can be startling: swastikas, stars, rosettes, meanders, cruciforms, floral spirals, leaves, wheels, spirals, concentric circles and zigzags. Iberian taste in décor was decidedly inventive and often fantastic: abstracted sun signs and floral devices might turn into animals and fish, or vice versa. Another type of Iberian ceramic painting is figurative and narrative, crammed with lively observed anecdote. At once complex and rustic,

these dynamic pictorial vignettes present a vivid cross-section of diverse social strata, offering invaluable insights into everyday Iberian life of two thousand years ago, about which we would otherwise know practically nothing. Illustrated here are bullfights, horse taming, hunts, magical practices, folk-dancing, musical processions, funeral rites, harvests and cavalry parades: life itself.

In whatever medium, the human figure in Iberian artwork is generally decorously clothed (although some nude figurines are to be found among the bronze ex-votos). In sculpture, the treatment of figures may be rendered either fully in the round or in bas-relief; if the latter, the relief is generally quite high, often almost rudely so. The trunk-like compositional patterns and carving techniques of some stone sculptures have suggested that there was also an important earlier group of figures carved from wood, but of course none of these have survived. Scores of unattached male heads found at the sanctuary of Cerro de los Santos (Albacete) and other sites suggest that their bodies (now missing) were carved in wood and polychromed. Whether executed in bronze or in stone, extant examples of zoomorphic figurations are more common than Iberian works of a strictly anthropomorphic character; most of the animals were probably associated with funerary monuments or sepulchres.

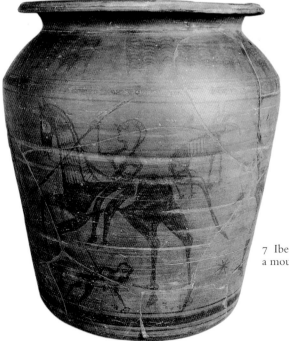

7 Iberian ceramic vessel showing a mounted warrior, 450–150 BC

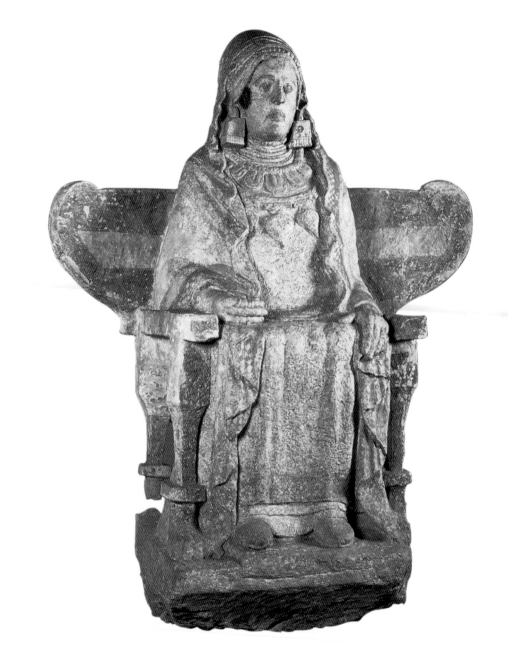

8 The *Lady of Baza*, 400–350 BC

Figures approaching life size are extremely rare in surviving Iberian sculpture, and non-existent in any other medium. Among works deemed absolutely authentic (having been scientifically recovered), there is only one exception: a masterwork exceptional among European art of this time (400–350 BC). Recovered from a warrior's tomb at Cerro del Santuario (Jaén) in 1971, the life-size, majestically enthroned *Lady of Baza* may represent an attempt at naturalistic portraiture. This impression is given by her dumpy figure and wholly unidealized, even melancholic face, which is painted to show touches of rouge and two spit-curls at her temples; other polychrome details reveal the colours and textures of her throne (dark brown wood), her clothing (of linen and wool), and details of her weighty jewelry.

Even admitting the possibility of itinerant craftsmen, there appear to have been several reasonably distinct centres of Iberian sculpture. One belongs to southern Iberia, and includes parts of the region now called Andalusia, commonly known in ancient times as Turdetania and corresponding to ancient Tartessos. Turdetania is the point of origin for nearly all of the small bronze ex-votos and the imposing *Lady of Baza*. A second area lies in the south-east of Spain, in the Levant,

9 Sculptural fragment from the temple precinct at Osuna depicting women in procession, *c.* 50 BC

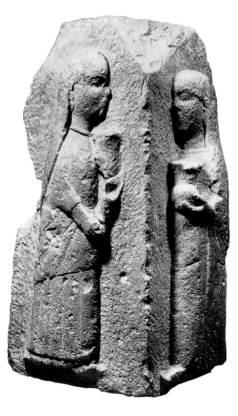

embracing the modern provinces of Murcia, Alicante and Valencia, areas collectively known in ancient times as Contestania, and includes Illici (Elche), the site which produced the most celebrated of all Iberian antiquities, the bust of the hauntingly beautiful *Lady of Elche*. (It has recently been argued, however, that she is a modern forgery concocted in the 1890s.) Another area is found in the north-eastern – now Catalan and Aragonese – part of Iberian Spain, centred around the fertile Ebro valley. Including Emporion and Tarraco (Tarragona), settlements initially colonized by Greek traders, this was the most highly Hellenicized region of Iberia. It was also the area most receptive to Celtic influences coming from the uncivilized interior.

From former Tartessian territories the most impressive, although rather late, sculptural remains have come from the town of Osuna, ancient Urso, lying some seventy kilometres east of Seville. First published as a comprehensive corpus in 1906, their formal effects were immediately received in modernist, proto-Cubist painting. The remains from Osuna constitute a coherent group of deeply carved stone reliefs in two or three series. These sculptural fragments – perhaps dating from as late as 50 BC, by which time Iberia would have become Roman Hispania – are believed to have formed part of a single building, most probably a temple or religious precinct. One series includes warriors; another (perhaps originally conceived in two parts) depicts civilians, who are mainly portrayed as worshippers. The stylistic character of these spirited representations of soldiers, dancers and musicians is summary in technique. The *taille directe* (or 'direct-carving') technique has left the neutral background behind the figures roughened in a way that suggests the impastoed surfaces of an early modernist oil painting. Picasso's *Portrait of Gertrude Stein* has a decidedly Iberian physiognomy; he finished the work in 1906 just after a visit to an exhibition of ancient Iberian sculpture, including the Osuna cycle, newly installed in the Louvre. The Osuna sculptures' effect on Picasso's epoch-making canvas of *Les Demoiselles d'Avignon* (1907–10) and other early Cubist paintings was considerable, as it was on the sculpture of Constantin Brancusi and other pioneers of the 'new plastic consciousness'. In these twentieth-century works, some very specific traits, most notably the rude direct-carving technique, are apparent.

The larger significance of these ancient Iberian works at that decisive moment may be quickly summed up. Well before 1906, there was already a 'primitivist' movement afoot in Europe. Since the Symbolist period, avant-garde artists had been searching for formal and spiritual

9

152

153

22

precedents in so-called primitive folk arts for their emerging anti-academic or modernist impulses. Among sources in public museums in Europe, Iberian works were considered to be among the most ancient. According to J. J. Sweeney, 'These sculptures gave the impression of a complete disregard for any refinements of manual dexterity, much less technical virtuosity.' In Picasso's case, there was also the emotionally provocative matter of racial pride. In any event, after 1906, his painterly style became for a while unquestionably primitivizing and rudely sculptural at the same time, hence 'neo-Iberian', just as he was to acknowledge later.

THE ENDURING ROMAN LEGACY

Of far more lasting significance than Carthaginian and Greek colonizations, and even the essentially ephemeral Iberian civilization, which were all mostly confined to limited coastal regions, was the artistic legacy of the Romans. Two hundred years of intermittent but savage warfare, culminating with the defeat of the Celto-Iberians at Numantia (Soria) in 133 BC and then four centuries more of the Pax Romana, imposed many Latin ideas upon ancient Iberia. The sobriety and stoic reticence so characteristic of classical Latin psychology proved to be especially congenial to the nascent Spanish character. The Latin colonizers provided the basis for the Castilian and Portuguese languages and the still-flourishing regional vernaculars: Catalan, Valencian and Galician, among other Romance languages. Besides instituting urbanization, enlightened Roman governors propagated the imperial concept of cultural unity achieved through political centralization and a universal system of law. The visual model of this policy, the urban forum, was described (c. 50 BC) by the Roman architect Vitruvius, and was scrupulously re-created sixteen centuries later by Spanish urban designers working in colonial Latin America.

These political developments were consolidated by Roman-built highways, bridges and aqueducts, some of which are still in use today. The arcaded aqueduct of Segovia, which once stretched much further than its present extent, and the soaring bridge at Alcántara (Cáceres), which is over 150 feet high, are particularly impressive. An imposing stage backdrop (*scenae frons*) is still highly visible at Mérida, the ancient provincial capital of Lusitania, once called Emerita Augusta. The stage was backed by two storeys of Corinthian columns lodging an impressive gallery of statues carved in marble, a Latin material new to Spain. Perhaps not coincidentally, this rather 'Baroque' example of boldly

10

shaped, scenographic architecture resembles many Christian struc-
tures erected in Spain much later during the Baroque period,
particularly Churrigueresque altarpieces.

Another factor which proved decisive for Spanish art was Roman
religion. Besides introducing the emotionalized idea of eternal life
through spiritual rebirth, the pious Latins also provided the Iberians
with a pantheon of new gods. Typically enshrined in a temple, these
commanding figures were consistently sculpted (or pictured) with
specifically human forms. In native Iberian religions, gods had never
been personalized and were rarely worshipped by way of images and
statues. Thus the Romans introduced mimetic portraiture into His-
pania, an art as suitable for the accurate depiction of mortals as for
immortals. Much sculpture and architecture survives from the Roman
provinces of Hispania. A good deal of the figurative work of higher
quality was imported from Italy (including a portrait-head of Augustus
found at Mérida). This Hellenistic sculpture, especially that destined

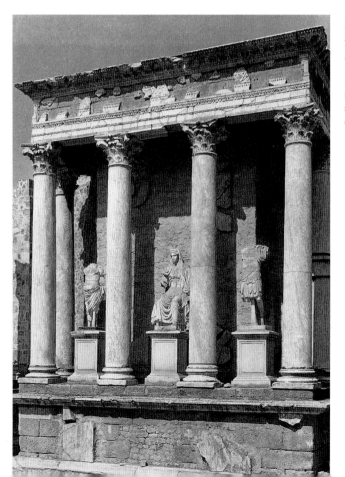

10 The *scenae frons* at the
Roman theatre, Mérida,
begun 18 BC and
completed *c.* AD 200

11 (*right*) Roman mosaic
from Bell-lloc del Pla
showing a circus scene,
c. AD 150

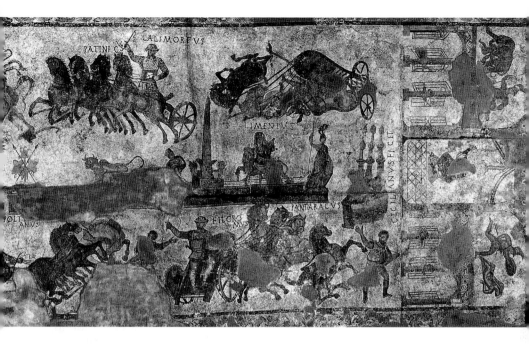

for public buildings, was thoroughly classical, and typically idealizing in content. Some provincial Roman art, however, accommodates rude native Spanish traditions; several Osuna pieces reflect this process. For the future course of the visual arts in Spain, the most significant contribution of Roman artists was their taste for verism. This trait was derived from ancient, pre-Hellenistic Italic portraiture, which aimed to document the sitter's actual appearance, rather than the sitter's ideal appearance without inevitable human imperfections.

In comparison with architectural and sculptural remains from this formative period of Roman occupation, very little painting survives. Whereas mosaics are fairly abundant, few mural paintings, evidently once as commonplace in Roman Spain as in Roman Italy, have survived. One representative work in mosaic, uncovered near Gerona (at Bell-lloc del Pla) in 1840 and no doubt wholly of native provenance, graphically depicts a circus scene; though crude ('provincial') in technique, it quivers with the excitement of the Roman games. Once realism was applied to the task of illusionistically recording real events, such as initially occurred during the period of Roman domination, the result was a vivid anecdotal reportage favoured by Spanish artists until relatively recently.

Another Roman floor mosaic, though different in style, can with hindsight be seen to point to the future of Spanish art. Now exhibited in the National Archaeological Museum in Madrid, it was executed around AD 150 in Cuevas de Soria and found in the ruins of one of the many sumptuous rural Roman villas uncovered by modern Spanish excavators. The image presented in the mosaic is abstract: geometric patterns of circles are neatly inscribed within tilted squares with angular and linear meander patterns at each end. Notwithstanding its modern appearance, the pattern is illusionistic, for it is a veristic simulation of a contemporary rug or woven carpet. Such patterning later became the ubiquitous but distinctive keynote of both Hispano-Islamic decoration and Christian *Mudéjar* architectural design; both were characterized by angular micro-motifs and prismatic silhouettes.

Because of the presence in Spanish territories of distinctive cultures unknown in similar proportions and proximities elsewhere in Europe, a unique repertoire of formal choices was readily available to native artists. In short, due to their singular historical situation, the Spaniards were able to acquire a distinctive visual tradition literally 'foreign' to that of their trans-Pyreneean professional peers. Rome, competing with Carthage for control over the Western Mediterranean, eventually absorbed the entire Iberian peninsula. A by-product of this military conquest, itself a symptom of the imminent collapse of the Pax Romana, was the advent of Christianity.

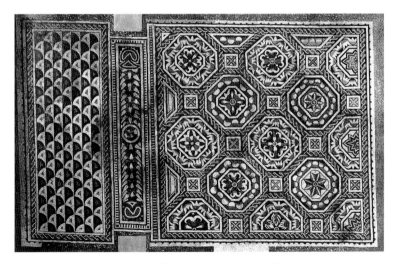

12 Roman floor mosaic from Cuevas de Soria with geometric carpet pattern, *c.* AD 150

Christianity and Islam in the Formation of Spanish Art

Initially a tilting-ground for struggles between evolving Christian dogmas, medieval Spain was to become the theatre of an immensely larger life-and-death struggle between paired, equally fanatical, opponents: the chivalric followers of Christ and the holy warriors of Allah. For centuries Occident and Orient were locked in internecine combat which would determine the historical course of both the Mediterranean and the Atlantic. The protracted peninsular confrontation also gave rise to a distinctive trait of subsequent Spanish history, a sense of mission, both territorial and ideological. As either a battleground for antagonistic sectarian beliefs and cultural ideals or as an arena of reconciliation (*convivencia*), Spain was to acquire those heterogenous ethnic elements, seemingly complementary consequences of geographical and historical necessity, which were to make its medieval arts unparalleled within the Christian era.

The declining fortunes of Roman Imperial rule in Hispania, which was officially terminated in AD 476, paralleled those of the metropolis on the Tiber. By the early third century the Church was already institutionalized in Spain, even though occasional later repressions gave rise to a pantheon of native martyrs. The official recognition eventually given to Christian religion in 313 by the Emperor Constantine in the Edict of Milan was due in large part to guidance from his spiritual advisor, Hosius, a Spaniard: an example of the dominant role henceforth exercised by Spaniards in shaping Catholic dogma. In 382, as a matter of state policy, the Iberian-born Emperor Theodosius began to settle wandering Germanic tribes upon beleaguered imperial frontiers. The most prominent of these nomadic warrior bands, the Goths, were Germanic peoples who had emigrated from Scandinavia south along the Black Sea and towards the Mediterranean. Once settled in their newly acquired lands, they founded a 'West-Goth', or Visigothic Kingdom in Spain; a complementary eastern, or Ostrogothic, branch moved into Italy, with its capital being established at Ravenna in 493.

The first wave of Gothic settlers entered the Spanish peninsula at Barcelona in 415 and soon afterwards Spain fell completely under

Visigothic dominion. A royal capital (*urbs regia*) was eventually established in 554 in the old Roman garrison town of Toletum (Toledo). The new Visigothic overlords probably never numbered more than half a million, and so could thus have represented only a tiny minority, perhaps an eighth, of the entire native population of Hispania. Moreover, since most of the Germanic invaders were Arians whose beliefs denied the divinity of Christ, there soon arose in Spain an antagonistic, native, 'Catholic' party, conforming to the implacable principles set down by Hosius long before. In 552, to further their religious convictions, not to mention their own dynastic ambitions, Catholic dissidents invited aid from the Emperor Justinian. The unwelcome result for both parties was the establishment of a Byzantine province; called Spania in Punic fashion, it stretched from Cartagena to Cádiz. Byzantines retained their hold over what is now called Andalusia until 621, when they were ejected by Swintila. Nonetheless, Byzantine ideas, particularly those pertaining to complicated court ceremony and its paraphernalia, remained to characterize an upstart, Visigoth monarchical culture based upon the 'royal city' of Toledo. Byzantine ritual suited the imperial, neo-Roman pretensions of Visigothic rulers, who were mostly largely illiterate war chieftains eager for prestige and ceremonial trappings. Romanization in dress and social custom and a thorough Latinization of language took place; the last evidence for a spoken Gothic tongue in Spain antedates the year 600. A ceremonial renunciation of Arianism was finally performed by Recared in 589 at the Third Council of Toledo, and an almost accidental Germanic colonial experiment finally became recognizably Catholic, Latin, regal, united and independent: a 'national Gothic people' (*patria vel gens Gothorum*), thus Spanish.

CONQUEST AND RECONQUEST

In AD 711, the most decisive single event in Spanish history occurred: an advance party of some 12,000 Muslims led by Tarik — mostly Berbers and Syrians, in fact, with the barest sprinkling of Arabs — landed at Gibraltar (Jebel-al-Tarik: Tarik's Mount). Christian resistance was ineffectual, largely due to internal discord among the reigning Visigoths. Little support could have been expected from the native-born and thoroughly Romanized Iberians for an ethnically diverse and heterodox Germanic ruling class. Their path cleared, the triumphant hordes of Mohammed quickly invaded the Iberian peninsula, a land they called al-Andalus ('Land of the Vandals', after another

Germanic warrior-tribe). Only a thin strip of steeply mountainous land in the far north, Asturias, backing onto the Bay of Biscay, remained under nominally Christian rule. The Asturians successfully resisted Islamic domination, just as they had earlier prevented Roman and Visigothic occupation of their inhospitable mountain territory. From this anarchic region resistant to and largely ignorant of Latin culture, the Reconquest of Islamic Spain was tentatively launched, beginning in 722 with a skirmish at Covadonga led by a guerrilla chief, Pelayo. A convenient myth makes Asturians the only Christians left in Spain. This was not the case: the majority of those left in Islamic Spain, al-Andalus, retained their Latin-Christian culture, especially their neo-Visigothic, or 'Mozarabic', liturgy and church architecture.

Some persistent, essentially legendary, after-images associated with the idea of Visigothic culture came to exert a discernible influence on later Spanish art and architecture, both Christian and Muslim. Visigothic high culture represents the exclusive preserve of a new professional class of bishops and monks, who were frequently more literate than their German political chieftains. An imposed post-Gothic union of art and propaganda is early revealed by an illuminated page from the *Codex Vigilano* executed in 976, barely one hundred and fifty years after the total destruction of the Visigothic kingdom. The neatly labelled illustration depicts an opportunistic political myth, stating that contemporary rulers of the then recently founded kingdoms of León and Asturias, shown in the middle register – Urraca, Sancho and Ramiro – were descended directly from the three Visigothic rulers shown above them: Chindawinthus, Reccevinthus and Egica. The bottom register contains portraits of the royal scribe Vigila and his two assistants; their precocious self-portraiture shows them as the foundations of a neo-Visigothic edifice supporting the regal pretensions of the tenth-century Asturian-Leonese confederation. Although we have practically no surviving examples of Visigothic painting (with the possible exception of a pen drawing depicting the *Compass-Rose of the Winds*, now kept in Verona Cathedral in Italy), the tenth-century *Codex Vigilano* not only seems to represent the ideal of a unitary and regal Visigothic culture, but also something of the style of a lost corpus of Visigothic painting, the first post-classical and purely Christian Spanish art.

Although no freestanding Visigothic sculpture has survived, several series of relief carvings are still extant. These appear to have replaced the abundant mosaics which decorated the buildings of Roman Hispania. The reliefs of the small hermitage church of Quintanilla de las

13

14

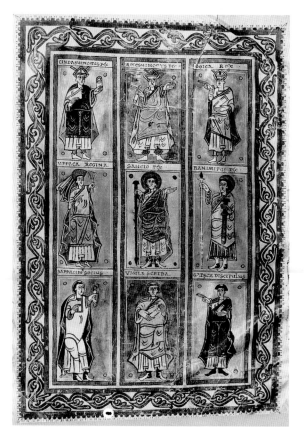

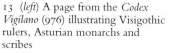

13 (*left*) A page from the *Codex Vigilano* (976) illustrating Visigothic rulers, Asturian monarchs and scribes

14 (*right, above*) Bas-relief sculpture from Santa María de Quintanilla de las Viñas showing Christ between two angels, *c.* 690

15 (*right, below*) Bas-relief sculpture from San Pedro de la Nave showing the Sacrifice of Isaac, *c.* 691

Viñas (Burgos) date from the late seventh century, and display the transitional character of Visigothic art as it spans Roman classicism and Christian transcendentalism. The style generally employed by relief-sculptors is a rude, linear and wholly planarized schematization. Such relief work was probably once polychromed, with paints laid upon a thin gesso ground applied to roughened stone. Especially when looking at this flat carving, we can easily imagine its primitive appearance: an overlaid scheme of flat, independently expressive and bright colours. The result is a forthright, decorative, abstract and anti-naturalistic format – precisely the style which generally characterizes later Spanish painting, at least until 1100.

This characteristic linearity and near-absolute symmetry is apparent in another extant Visigothic carving, the 'Sacrifice of Isaac', inserted into a capital in the church of San Pedro de la Nave (Zamora), which

was built *c.* 691 under the orders of King Egica. As is characteristic of Visigothic architectural decoration of this time, patterns of figurative sculpture are distributed over non-figurative architectonic fields, and so the abacus slab placed above the narrative scene displays series of floral motifs and stylized birds linked by circular enframements. The employment of running friezes of intertwined figural-architectonic sculptural embellishment did not become a commonplace elsewhere in Europe until the Romanesque period. Various figurative motifs found in these carvings reappear later in manuscript illuminations of the tenth century, further supporting the argument for the derivation of much Spanish medieval art and architecture from now-missing

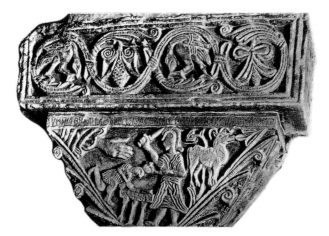

Visigothic models. The unique (Visigothic) characteristics of Spanish painting, sculpture and architecture were suppressed after 1100 when Hispanic art once again joined the international mainstream of European styles, first Romanesque, then Gothic. At the same time, the traditional Mozarabic rite was banned by papal edict in favour of a Roman liturgy, and the Lex Romana was officially adopted in Castile in 1081.

Unquestionably the most influential of neo-Visigothic paintings are the group of illustrations (*c.* 950) attached to the celebrated *Commentary on the Apocalypse* by Abbot Beatus de Liébana. The archetypal lost Beatus manuscript is known to have been embellished with some seventy illustrations, which were in turn copied from a *Commentary on the Apocalypse* composed by Tyconius, a fourth-century North African writer much admired by St Augustine. A new idea introduced by Beatus was his (unfounded) revelation that St James – Santiago – had evangelized Roman Spain. Copied frequently for centuries afterwards, and therefore of immeasurable significance for the development of European art, the Beatus represents an early expression of a uniquely Spanish visionary painting.

The style of the illustrations accompanying the lost Tyconius source-manuscript would have been moderately illusionistic, and typical of the few late Roman, fourth-century book illustrations known to us. The initial pictorial translations derived from the Tyconius illustrations by seventh-century Visigothic painters in Spain must have drastically altered the appearance of their late classical model, thus providing a wholly anti-classical, new stylistic model for innumerable subsequent illustrations of the Apocalypse cycle. One of the more celebrated derivations is the *Beato Morgan* (the *Morgan Beatus*), created in the Leonese monastery of Tábara and signed by the artist, Maius (or Magius), which is dated around 945. In this early and particularly striking example of Spanish visionary expressionism, a typical scene shows linearized angels presenting St John's gospel. The colours painted inside evenly spaced lines defining the figures are varied, and the hues are vivid and pure, with greens, reds, ochres, purples, yellows and blues predominating. Filled in with bright tints, these emphatically linear designs resemble contemporary Byzantine jewelers' *cloisonné* techniques. This expressive quality is apparent in any number of later Beatus illuminations; some twenty-six illustrated copies are now recognized, all made at different European scriptoria.

16 (*right*) Magius, *Angels Presenting the Gospel of St John*, from the *Commentary on the Apocalypse* (*c.* 950) by Beatus de Liébana, now in the Pierpont Morgan Library, New York

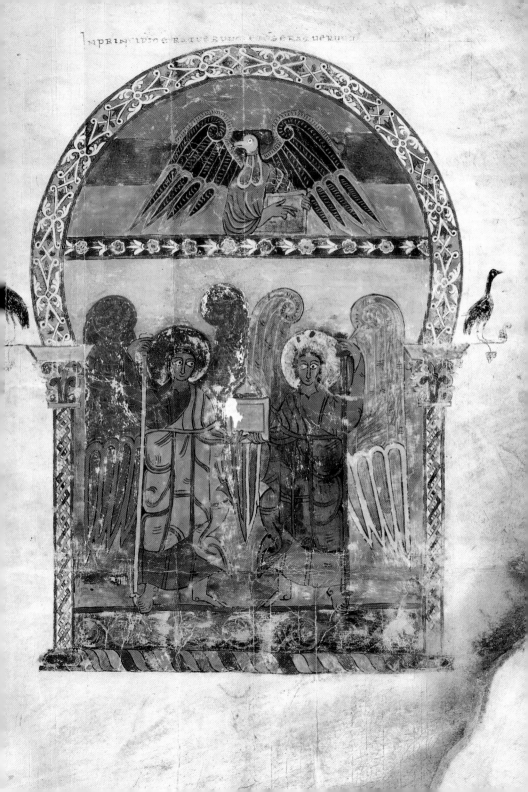

These vividly expressive paintings are at once iconographically conservative and stylistically progressive, and thus truly 'medieval'. Magius' pop-eyed heavenly messengers were ultimately derived from the tablet-bearing figures of Roman commemorative art. Above them is a most curious figure, for which there are no classical precedents: part man and part animal, it has the beaked head of an eagle, itself the widely accepted symbol of St John the Evangelist. The man-beast tetramorph symbol, very much evident in much later Romanesque painting and sculpture, most probably had Visigothic origins; one of the earliest known examples of this symbolic hybrid is a carving which was made around 700 at San Pedro de la Nave. Also noteworthy is the placement of Magius' fabulous figure within a specific architectural context; be it pediment or tympanum, the enframement itself is unmistakably a horseshoe arch, a structural innovation unique to Visigothic builders.

The distinctive shape of the horseshoe arch is seen in the church of Santa Comba de Bande (Orense, *c.* 670), where it was additionally employed to generate a masonry barrel vault of the sort only common later in Romanesque architecture. In fact, the horseshoe-arch device had previously appeared as an enframing decorative motif on numerous native Hispanic carved stone markers (*stelae*) from the second to the fifth centuries (there are some sixty extant). So, the *arco de herradura* is unquestionably a native Spanish, perhaps pre-Roman, device later used by both Christians and Mohammedans. But it is to the Visigoths, rather than the Muslims, that the original credit must be given for its use as a monumentally scaled, fully three-dimensional and structurally significant architectural element.

Medieval artists and designers throughout Europe, not to mention poets and rhetoricians, would customarily adhere to venerable prototypes, the *auctoritas*. Numerous domed, centrally planned churches erected throughout medieval Europe adhered to the *auctoritas* of the Holy Sepulchre in Jerusalem. Given this ubiquitous medieval habit, it seems logical that Visigothic art too, uniquely resulting from a curious cultural fusion of Latin and Germanic customs, provided a prestigious, but strictly regional, prototype. This visual authority inspired a considerable body of post-eighth-century Spanish art and architecture, even though later 'copies' often departed in minor details from the strict letter of the original pictorial *auctoritas*. That there was a considerable body of sophisticated Visigothic painting is unquestionable: St Isidore in *Versus in Biblioteca* (*c.* 630) describes his immense library, arranged by subject matter, with each topic placed beneath a painted portrait of its

17

34

most notable exponent. In Isidore's mind, the intimate association of image and word, paintings and books, was taken for granted. The continuous prestige of Visigothic painting is likewise easily documented: according to a chronicle of 883 we know that an Asturian king, Alfonso II (791–842), had decorated a palace erected in his new capital of Oviedo with long-destroyed paintings deliberately conceived 'in the [Visi]gothic manner (*more gothico*), such as was done in Toletum'.

From such scant but diverse evidence we know that manuscript illumination, easel or panel painting and even murals flourished in Visigothic culture. This painting of the sixth to eighth centuries, particularly if treated as provincial (or 'sub-antique') expression, probably represented the most radically anti-classical style practised at that time in Europe. As with the relief carvings described above, all illusion of plasticity was suppressed in favour of flat, symmetrically arranged planes, clearly established by means of emphatic but undifferentiated linear outlines. Again, the principal means of painterly expression would have been colour: bright, decorative and uninflected combinations of saturated hues. Moreover, other than in height and breadth, the figures depicted would have had in themselves no dimensional substance, and would have been represented in full frontality, casting no shadows upon an essentially spaceless pictorial plane. Also common would have been sharp-edged and prominent geometrically shaped frames (circular or rectangular for the most part) separating the brightly coloured illustrations from the pale ochre tonalities of the bare vellum page (or whitewashed wall) upon which they were placed.

In the case of architecture we do have some real evidence by which to assess both the originality of Visigothic buildings and their subsequent impact as architectural prototypes or *auctoritas*. On the basis of the few extant structural remains – less than twenty, with none surviving from urban contexts – and certain written commentaries, particularly Isidore's, the once splendid interior appearance of urban Visigothic churches can be imagined. If not actually vaulted with stone ceilings, the best churches of the time were roofed with elaborately crafted, open-beam, polychromed and gilded wooden ceilings (*artesonados*). There were also marble plaques on the walls, screened chancels, an iconostasis (a ceiling-height, multipartite altarpiece blocking off the apse), hosts of columns, paintings (perhaps figurative or merely decorative), and also hanging lamps, votive crowns and curtains. These sumptuous architectural complements and striking light effects would probably have drastically altered the viewer's perception of the spatial environment.

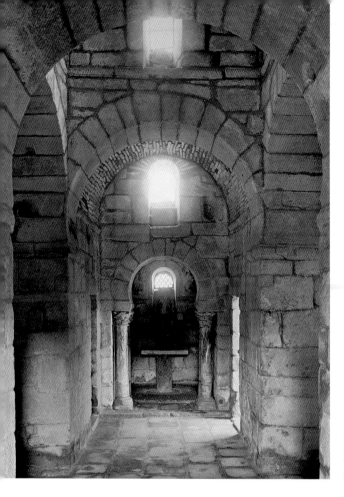

17 Santa Comba de Bande. Interior, showing the barrel vault apse with horseshoe arch motif, *c.* 670

In short, distinctively 'high medieval' traits of barrel vaulting, groining and ashlar construction are readily apparent in the few Visigothic buildings which have survived; these same structurally precocious or 'pre-Romanesque' traits and techniques must have been considerably more pronounced in the great urban centres of Toledo, Córdoba, Seville, Mérida and Tarragona, all since completely overbuilt. Nonetheless, the creators of the *more gothico* praised by Isidore were scarcely progressive in their ambitions. Instead, they were merely extending (as *auctoritas*) certain artistic techniques of the Late Imperial period with which the Visigoths were already intimately familiar in their native Hispania. As Isidore explained in his *De laude Hispaniae*, 'Even though

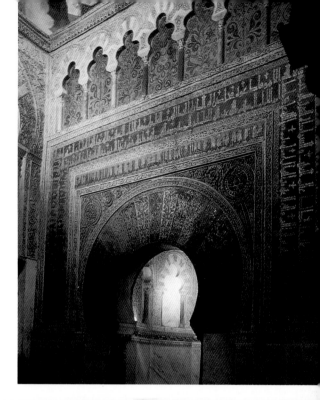

18, 19 Great Mosque, Córdoba.
Interior: (*right*) portal of the *mihrab*
with mosaic decoration, 965; (*below*)
nave with superimposed arcades, 987

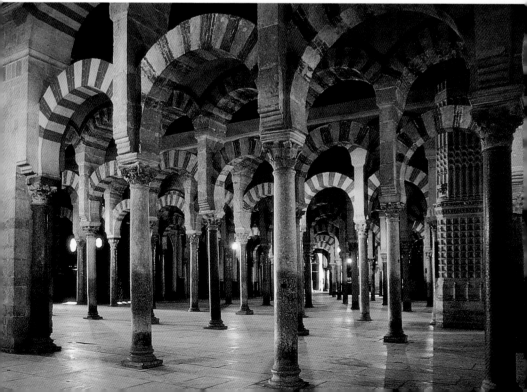

victorious Roman valour might have first taken you [Spain] as a bride, the driving Gothic race came later, carrying you off then to make love to you…That [Visigothic] race today delights in you, secure in the happiness of its [Hispanic] domain, with regal dignity and greatness of wealth.' In spite of his disturbing rape metaphor, Isidore makes it clear that the Visigoths saw themselves as the legitimate heirs to, and presently conservators of, the Roman Empire, of which Hispania was an integral part.

The techniques celebrated by Visigothic builders and artists were also to be adapted by the Muslim overlords of al-Andalus. However, in their visual arts certain strictures applied, mainly for religious reasons. For instance, within the complex ensemble of the Great Mosque of Córdoba one architectural sub-unit stands out particularly: the *mihrab* (or prayer-niche) erected in 965. Structurally and functionally corresponding to a Visigothic apse, this is a small, niche-like cavity dug out from the thick masonry of the exterior wall, with a horseshoe-arch portal, capped inside with a conch-shell ceiling motif. The richly coloured, and wholly planar, mosaic decoration played out around the upper parts of the *mihrab*'s portal reveals the complete, albeit drastically limited, allowable range of Islamic decorative and iconographical principles in a highly compressed format. These were comprised exclusively of three basic categories: 1) the epigraphic (highly stylized inscriptions in classical Arabic); 2) the geometric (in this case, bands of interwoven and highly stylized linear patterns); and 3) the arabesque or 'ataurique', from *al-turiq*, 'leafy design' (highly abstracted floral patterns placed upon the voussoirs of the arch above the entrance to the Córdoban prayer-niche). The same non-figurative vocabulary, and its distinctive compositional principle, is repeated throughout the mosque, also appearing to greet the worshipper at the decorative Gate of Hixim II (*c.* 975).

One enters the nave (*haram*) of the Great Mosque of Córdoba from the north after traversing the Patio de los Naranjos, a figurative 'Paradise Garden'. After the dazzling light of the outer courtyard, the darkness of the interior makes an extraordinary contrast. As the eye slowly adjusts to the dim illumination from hidden apertures in distant walls, a growing impression gradually takes shape, like a developing photographic print. The bedazzled viewer finds himself in a bizarre, petrified forest, surrounded by innumerable rows of columns separated into parallel ranks which appear to stretch away into infinity. There are now about 850 of these columns (once there were perhaps as many as a thousand); each is handsomely polished and topped with

its own highly stylized capital of the Corinthian order. The eye rises, and further series of superimposed arches are seen springing off the slim vertical elements, forming a different, superior screen-like maze pattern. Striped with alternating bands of red and yellow inlay work, the intersecting horseshoe arches reach outwards and upwards expanding in a crescendo of half-arches, growing in turn into further sequences of curved branchings and ramifications. In some places these are doubled; from one abstracted capital an arch will leap to the capital facing it; then, one metre above, yet another arch springs across the same gap. This stunning effect is further enhanced by a slight movement of the eye, for the merest lateral movement creates wholly new perspectives.

These wonderful effects betray an underlying 'anti-architectural' bias typical of much later Hispanic architecture. The denial of the principles of mass and weight, something like dematerialization, undermines the basic logic of classical architecture. Roman architects demanded that weight, mass and therefore visual emphasis gradually accumulate towards the ground. According to this reasoning, one must respect gravity; it is therefore the classical architect's task to illustrate visually the workings of the ubiquitous but invisible earth-binding linkages. Rejecting the classical principle, the immense weighty bulk of the mosque's exterior, 'in the world without', takes metaphorical wing within its mystically experienced interior whose spiritual focus is the *mihrab*.

The self-restricting, three-part (epigraphic, geometric, arabesque) formal vocabulary exhibited at Córdoba arises from Muslim beliefs, which proscribed the use of figurative representations in holy places. Figurative motifs were, however, allowed in the sumptuary arts and crafts, destined for strictly secular uses and aristocratic pleasures. Splendid examples of portable Hispano-Islamic luxury goods – principally ivories, silks and ceramics – survive in great quantity; many are still proudly displayed in Christian cathedrals, pious donations from the proud *conquistadors* of al-Andalus. Whatever its immediate historical sources, the canonic decorative scheme displayed in the great Islamic holy places is expressive of a mentality shaped by the common employment of the geometer's instruments, the compass, the carpenter's square and the straight-edge. Visual objects produced by artisans are decorated with set patterns, generated by initial geometric configurations of circles within squares, and squares within circles. As they multiply in ever-increasing complications, the basic forms evolve into the infinitely expanding and intricately geometricizing 'star patterns'

ubiquitous in Hispano-Islamic decor. An almost inevitable Christian appropriation of the same technical procedures in Spain was later to produce *Mudéjar* art and architecture.

Whereas Islam in al-Andalus could not sponsor representation and narrative painting, Christianity in Asturias, in the far north of Spain, certainly could. Asturian art belongs to the eighth to early tenth centuries, and was largely based upon its capital, Oviedo, a fictitiously reborn Toletum. Compared with the mercantilism, sensuality and liberalism which reigned in al-Andalus, life in the narrow and agrarian Christian enclave to the far north was harsh and straitened. This was an authoritarian and coercive culture, and its artistic manifestations, like the *more gothico*, were destined for the edification or enjoyment of an élitist minority. Asturian art is directly linked to a contrived idea of 'Catholic kingship'; its purpose was to lend prestige to a diminutive monarchy which brazenly proclaimed itself the one legitimate inheritor of a now-idealized Visigothic line. Another historically more immediate imperial model was the Frankish-German culture linked to the court of Charlemagne and based upon the Rhine. In both cases the common but blurred historical ideal was a *renovatio* ('renewal') of Imperial Roman authority and its prestigious classical culture. Most important for this renewal was the architectural enterprise of Asturias, motivated by memories of Isidore's proud boast that his sophisticated, seventh-century contemporaries had built with good quality hewn masonry, which the rude Franks ('barbarians', as he called them) were unable to do. Besides being more abundant, the majority of Asturian architecture is generally formally distinguishable from its acknowledged prototype, the earlier Visigothic style called the *more gothico*. That term precedes the invention around 1140 in the Île de France of the architectural mode we now call 'Gothic', then called either 'Frankish work' (*opus francigenum*) or 'the modern mode' (*opus modernum*). Usually roofed in wood, Asturian architecture was itself precociously cast in the *francigenum* mode, with oversized attached buttressing applied to disproportionately verticalized exteriors whose tiny windows pierced massive masonry walls.

The first important builder-king in Asturias was Alfonso II (*reg.* 791–842), who made Oviedo the neo-Visigothic emblem of his politically ambitious kingdom. His court architect, Tioda, was the designer (*c.* 830) of the palatine church of Santullano, or San Julián de los Prados, in the outskirts of Oviedo. In plan it represents the triple-aisled Latin-cross basilica with transept arms common to contemporary Carolingian architecture; to this standard format has been added a

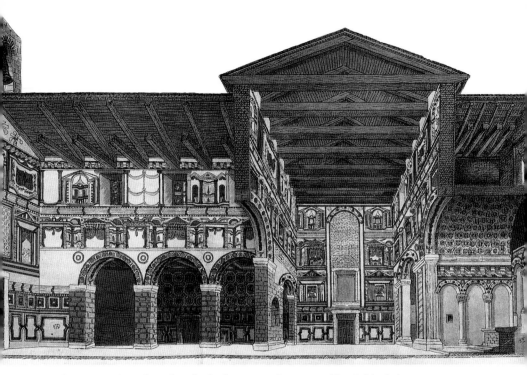

20 Reconstruction of mural-cycles in the nave and transept of San Julián de los Prados, Oviedo, *c.* 830

squared and vaulted, neo-Visigothic tripartite apse. This *more gothico* architectural layout additionally embodies a hieratic spatial composition. The holiest spot, the altar, is segregated from the congregation in the nave by a great arch (probably covered by a curtain); twin chambers flanking the apse, it is now believed, were reserved for the royal family. The overwhelming art-historical importance of Santullano resides however in its unique wall paintings. Seemingly at odds with their post-classical, Christian architectural setting, they represent the most surprising example of the survival of Hellenistic illusionism in early medieval Europe. In scale alone, they surpass anything comparable surviving from contemporary Carolingian culture. By employing painted architectural vistas such as those seen at Pompeii and Herculaneum these murals, expressive of Asturian imperial pretensions, revive specifically Roman illusionistic techniques once used in imperial palaces, the *scaenographia* and *picturis scaena* described by Vitruvius (*De architectura* 1, 6 and 7).

41

Nonetheless, the iconographic programme at Santullano is explicitly Christian; its focal point is a triumphal cross with *alpha* and *omega* emblems placed under an arch and flanked by paired micro-architectural structures. In this ecclesiastical setting these murals broadly illustrate the 'Heavenly Jerusalem', a visionary urban scheme reported in detail in both Old and New Testaments (Ezekiel 40 and Revelations 21). The solemn repetition of draped, classical portals, each apparently containing an ark with scriptures, additionally appears to allude to reunions of the thirty-eight national churches celebrated at the Ecclesiastical Councils formerly held in Visigothic Toledo, when all of Spain was politically united within one Catholic Church. A later Asturian chronicler states in 881 that Alfonso had deliberately erected 'houses of God', and 'as is done in royal palaces, he decorated them with diverse imagery'. These extensive murals, completely covering all the available wall-space, transfigure the interior of Santullano by providing illusionistic substance which articulates the strictly planar arcades springing from simple pillars without capitals. The lower zones were painted to resemble coloured marble panelling, while above in the transept there were up to four superimposed registers of elaborately painted simulations of classical architecture. The mastery of handling alone assures us that many other equally accomplished works have since been lost.

The next great builder in Asturias was Ramiro I (*reg.* 842–850). Being completely vaulted, the structures erected during his brief reign represent a break with Asturian tradition. Moreover, as they are supported by massive attached buttressing, their vaults rise to unprecedented heights, sometimes up to three times the width of the nave. One impressive example of such a precociously 'pre-Romanesque' building is San Miguel de Liño (or Lillo). This palatine church, now misnamed, erected upon the personal property of Ramiro, was originally dedicated in 848 to the Virgin Mary, just as Charlemagne's slightly earlier Palatine Chapel in Aachen (792–805) had been. Evidently, Ramiro fancied himself another King Solomon; according to an inscription placed upon an ark formerly kept in San Miguel (then Sancta Maria), his church was directly inspired by divine commandment. This narrow but tall edifice (of which only the Frankish-style, royal 'west-work' now remains), had several barrel vaults of different heights covering a triple-aisled nave (probably five bays long), a transept, and a tripartite, square-ended apse. Like Santullano, it was once completely covered by murals; today only a few fragments remain, enough to show a repetition of the illusionistic Santullano 'scenographic' scheme.

Although Santa María de Naranco, a few metres down the hill from San Miguel, once served as a church (from around 950 to 1930), it was originally the centrepiece of a palace-complex erected by Ramiro. Of rectangular ground-plan, it rises two storeys in height (the apparent third storey is fictitious), and has a sophisticated system of barrel vaulting displayed in both floors. The upper storey opens out on either side, with a handsome triple-arcade serving as a *belvedere*, or scenic lookout, thus indicating a precocious appreciation of the delights of natural landscape. Echoing Roman prototypes (some described by Pliny the Younger), this country villa-palace complex is a constant in regal Hispanic architecture; the idea reappears centuries later in different guises at Aranjuez, the Escorial and La Granja.

Within, there is a great hall, measuring some four by eleven metres, roofed with a barrel vault supported by boldly stated transverse ribbing demarcating seven bays. Plastically articulated lateral arcades provide a masterful visual transition from floor to ceiling. The interior ribbing-bay sequence is echoed outside by vertical bands of attached buttresses; these form a giant order of pilasters (without identifying capitals) which ties the different horizontal stages of the elevation together visually. On the north end, entrance to the *piano nobile* is gained by means of an attached double staircase, conducting the

21 Santa María de
Naranco, Oviedo,
c. 842–50. Exterior
showing ceremonial
staircase

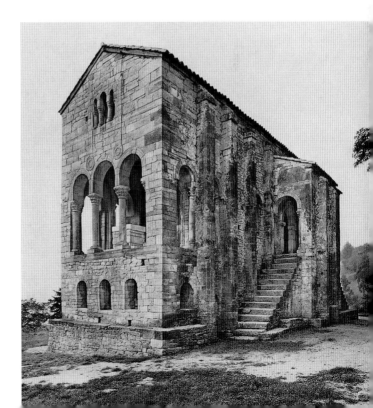

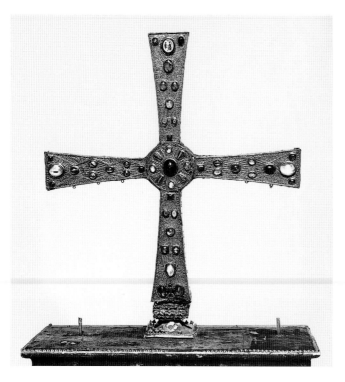

22 *Cross of the Angels*, 808

visitor to an elevated vestibule; this ensemble was repeated on the south elevation of the building. This magnificent ceremonial staircase particularly reveals the specialized function of Naranco as a royal ambassadorial reception hall, or *aula regia*. As such, Naranco is unique; there is nothing remotely comparable in the rest of contemporary Europe, even though very similar *aulae regiae* had been built by the Carolingians. Just as Charlemagne's *aula regia* at Aachen was directly connected by a covered walkway to his nearby Palatine Chapel, the latter still extant, so too was Ramiro's palatine chapel (Liño) exactly aligned upon his royal hall to the south. Diplomatic and cultural exchanges between Aachen and Oviedo must have been commonplace.

Asturian metalwork also deserves mention: the *Cross of the Angels*, donated in 808 by Alfonso II, may be taken as an emblem of the militant Christianity of the Reconquest. Using Maltese-cross emblems seen on Visigothic churches, this artefact was 'made by the angels' according to a devout Spanish chronicler; it clearly revives the

23 (*right*) Magius, *The Heavenly Jerusalem*, from the *Commentary on the Apocalypse* (*c.* 950) by Beatus de Liébana, now in the Pierpont Morgan Library, New York

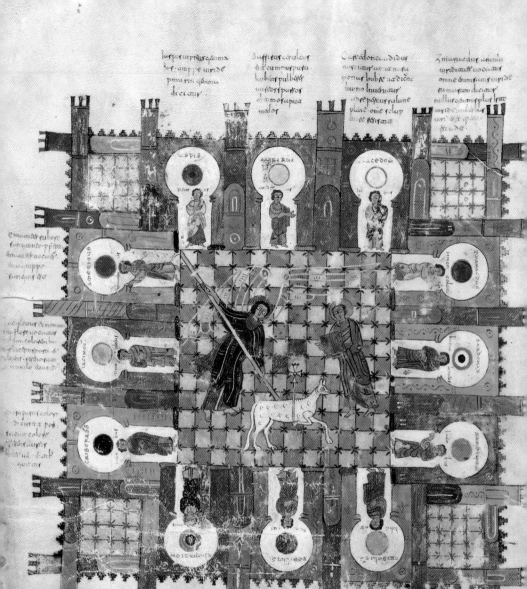

splendour of royal Visigothic jewelry uncovered in excavations around Toledo, including the spectacular Guarrazar Treasure. It is covered with forty-eight precious stones (four times twelve, probably a symbolic reference), including several antique cameos. Its talismanic inscription reads: *Hoc signo tuetur pius; hoc signo vincitur inimicus*, ('With this sign the pious are protected and the enemy is vanquished').

As successive waves of the Reconquest spread further south, becoming firmly established on the banks of the Duero by the year 900, former wastelands were made available for resettlement. León was founded and made the capital of a new Asturian-Leonese confederation by Ordoño II (*reg.* 914–924). Concurrently, a new ecclesiastical art appeared in Leonese territories which is often called Mozarabic, from *musta 'rib*, or 'arabized'. Whatever it may be labelled, this art was largely the result of successive waves of emigrating 'Arabized Christians' (*mozárabes*) coming from al-Andalus and moving north into the depopulated regions recently put under Asturian-Leonese dominion. Although Christianity was tolerated by the Muslim rulers of al-Andalus, they would not allow the construction of new churches upon Muslim territory, and so the expanding Christian population had to move away from Islamic territories and migrate north to establish its congregations and rites. These Christian emigrants were relatively sophisticated, often literate in Latin and sometimes able to read Arabic as well, and, for the most part, highly urbanized; they were, for instance, the majority of the population in Córdoba, Toledo and Seville. The Mozarabs were the proud possessors of a still-living Visigothic cultural tradition, as is clearly revealed by their art and architecture. San Miguel de Escalada (León) is a fine example of Mozarabic architecture: a monastery-scriptorium, it was consecrated in 913 with three horseshoe-shaped apses, and was embellished with a horseshoe arcade on its southern flank in *c.* 940.

We have already met Magius, the monk-painter once associated with the prolific *scriptorium* attached to the Leonese monastery of 23 Tábara. Another of his illustrations in the *Beato Morgan* demonstrates that the Great Mosque of Córdoba had itself become a venerated scriptural model or *auctoritas*. The overall layout and the decorative details of the mosque are painted in bright hues and seen in a diagrammatic bird's-eye view, with the twelve horseshoe-shaped doors it boasted in the tenth century. What Magius literally meant to represent in the larger sense by his mosque image is nothing other than the ancient scriptural image of Heaven on Earth as expounded in Revelations 21. That the Great Mosque of Córdoba was commonly perceived

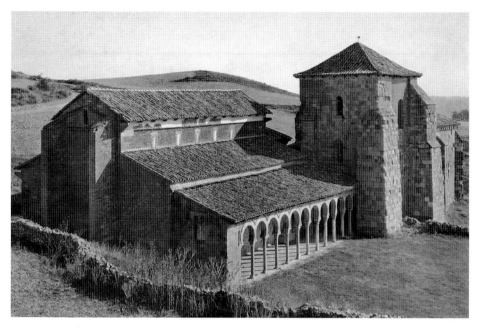

24 San Miguel de Escalada, 913

as a fitting representation simultaneously of Paradise and a Holy City is a point confirmed by contemporary Islamic chroniclers in al-Andalus.

Given the peculiar details of Magius' architectural re-creation of the Heavenly City of Jerusalem we need not be surprised to discover that this talented Mozarabic artist was himself a native of Córdoba. In 926, he came as a youth to work at San Miguel de Escalada, later moving to Tábara. It was there, twenty-five years later, that he produced in his maturity the splendid *Beato Morgan*. On one of its pages he explained in a note that he had just 'painted a series of pictures [of the Apocalypse] based on the wonderful words of its stories that the wise may fear the coming of the future judgment at the end of the world', a dreaded event expected to transpire shortly, at the turn of the first Christian millennium in the year 1000. Magius, rightly called by his admiring contemporaries an *archipictor*, died in 968. Following directly in his stylistic footsteps, a slightly later version (*c.* 975) of the ever-popular *Beato* (preserved in Gerona Cathedral) is signed by the first woman artist known in the history of Spanish art, the nun Ende. The text of the *Beato de Gerona* was written at Tábara by the scribe-priest

47

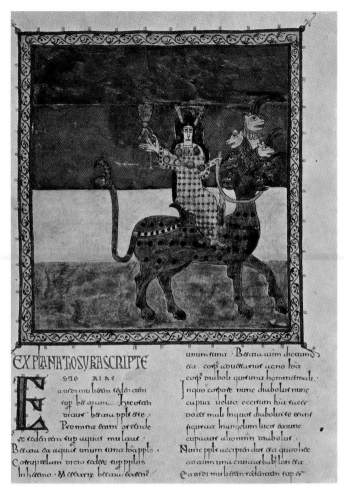

25 Ende, *The Woman on the Seven-Headed Beast*, from the *Commentary on the Apocalypse* (*c.* 975) by Beatus de Liébana in Gerona Cathedral

Senior in an archaic, but still highly venerated Visigothic script. Likewise, Ende's forcefully stated and brightly coloured representation of *The Woman on the Seven-Headed Beast* again points to a pre-Magius prototype executed in *more gothico*. However legendary, even deliberately fictional, it may have been, the Visigothic contribution to the future course of Spanish arts was unquestionably decisive.

48

The Europeanization of Spanish Art

After the portentous turn of the Christian millennium in 1000, the Spaniards began to participate fully in mainstream European art. A provocative and rare example of the Mozarabic painterly style translated into a monumental, Romanesque idiom is to be seen in the remains of a mural cycle, dating from the mid-twelfth century, taken from the Hermitage of San Baudelio, Casillas de Berlanga (Soria). Constructed at the beginning of the eleventh century upon the uneasy frontier between Islamic and Christian territories, the already unique architectural interior of the Berlanga hermitage, Mozarabic in style and oddly palm-vaulted, was dramatically transformed a century and a half later by the addition of two unparalleled cycles of wall paintings. Although the murals were removed from the chapel in 1926 and sent to various collections in the United States, we know that the upper walls of the building were decorated with an elaborate Christological cycle in the twelfth-century European style, including a properly solemn representation of the *Last Supper*. A lower register oddly included some simply painted hunting scenes and seemingly unrelated individual panels, depicting animals and illusionistic simulations of tapestries. In fact, all of these equally 'profane' and 'exotic' subjects can be found on Islamic luxury goods (ivories, silks and ceramics) destined for aristocratic consumers. The style which characterizes the secular scenes is much less linear than the religious subjects placed in the superior register, and creates its forceful impression through a use of firm outline and brilliant colours employed in series of superimposed, flattened and regularly spaced, heraldic images.

26

27

Struggles between Christian and Muslim territories were widespread at this time. The Christians finally formed a military alliance capable of overturning the Caliphate (1032), and those southern areas remaining under Islamic sway broke up into the *taifas* (warring kingdoms), while León joined with Asturias in 1034 to create the ephemeral 'Christian Empire' of Sancho the Great of Navarre. Further east, in the Marca Hispanica established by the Carolingians, a distinctive Catalan culture emerged based on a great port, Barcelona. In 1071, Ramón Berenguer I, Count of Barcelona, expanded north into

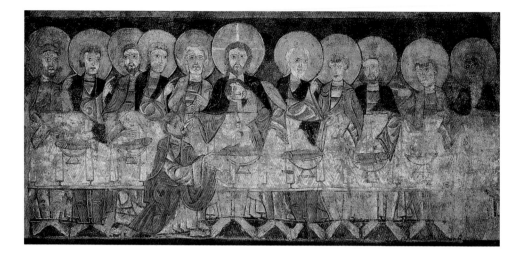

Provence, purchasing Carcassonne and Rasès. The Union of Catalonia and Aragón was cemented by marriage in 1137, and the Treaty of Cazorla (1179) ambitiously divided the rest of Islamic Spain, as yet unrecovered, between them and León-Castile.

By the mid-eleventh century, therefore, a seemingly united Christian Spain was finally able to initiate full diplomatic and ecclesiastical relations with Europe. As a result, ever-increasing streams of European pilgrims eagerly thronged along roads leading across the Pyrenees and headed west towards Santiago de Compostela, the supposed site of the tomb of the martyred Apostle James (beheaded AD 44), which was first made into a political emblem by ambitious Asturian monarchs and later celebrated by Habsburg imperial patronage. Thereafter, various Italian and French religious orders were to establish reforming centres south of the Pyrenees; these evangelical groups brought in their wake a taste for monumental art and architecture, in short, the material splendours of European Romanesque culture.

The shrine at Santiago de Compostela stood at the end of the medieval world, at the very *finis terrae*; a pilgrimage there required an exhausting two- to three-month journey on foot. Begun in 1070, the great cathedral was not completed until 1211. Its monumental Romanesque austerity has been largely covered since by Renaissance and Baroque embellishments, but the massive 22-metre-high nave

retains its original solemn grandeur, typical of the other great pilgrimage churches stretching north and east along the Jacobean route. Fortunately, many of its original sculptural programmes remain. These iconographic cycles in bas-relief, rendered in a sinuous linear style probably originating at Toulouse, coincidentally revived the Visigothic manner of lapidary architectonic figuration. The narrative reliefs now seen upon the southern Puerta de las Platerías (*c.* 1100), with two tympana portraying episodes from the life of Christ and a magnificent rendering of Abraham rising from his tomb in the centre, were originally installed in the northern transept portal, the Puerta de Azabachería. The title of the ensemble refers to the style of a silversmith (*platero*), echoed later in the Renaissance architectural style known as Plateresque. The direct evolution of Spanish architectural sculpture into the international Gothic mode can be appreciated at the western entry to the cathedral, the so-called Pórtico de la Gloria. Dated between 1168 and 1188, this was the work of Master Mateo. Here the figures, nearly-three-dimensional column statues (originally polychromed) of Prophets and Evangelists, become increasingly detached from the wall, acquire realistic and individualized faces and seem to look about at one another. An interesting and largely unprecedented detail lies directly behind the portal: a self-portrait by Master Mateo, kneeling with his eyes towards the distant altar, the first in a

28

29

26 (*left*) *Last Supper*, mural from the Hermitage of San Baudelio, Casillas de Berlanga, *c.* 1125

27 (*right*) *Elephant*, mural from the Hermitage of San Baudelio, Casillas de Berlanga, *c.* 1125

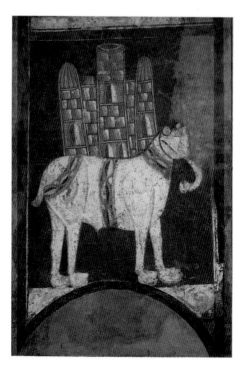

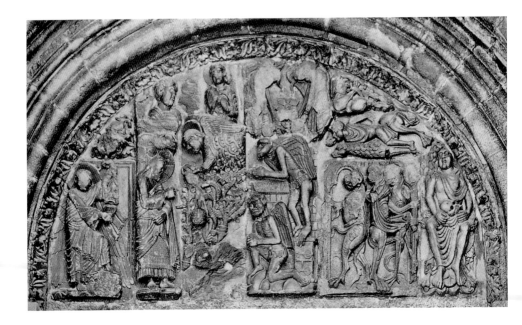

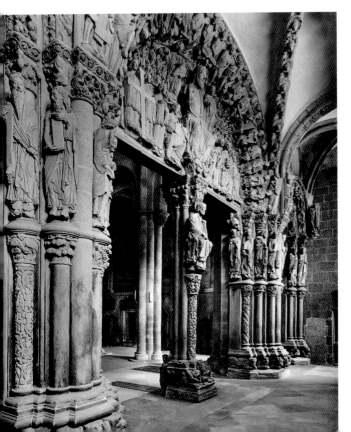

28 (*above*) One of the tympana from the Puerta de las Platerías, Cathedral of Santiago de Compostela, showing scenes from the life of Christ, *c.* 1100

29 (*left*) Master Mateo, Pórtico de la Gloria, Cathedral of Santiago de Compostela, 1168–88

30 (*right*) The façade of Santa María de Ripoll, *c.* 1160

long Spanish tradition of devout figures looking towards the celebration of the Eucharist.

Something similar – the narrative, even rhetorical, relief-cycle frozen in stone – can be seen further east, in Catalonia, at the Benedictine monastery of Ripoll (Gerona). The alabaster façade of Santa María de Ripoll is arguably the greatest single work of Romanesque sculpture in Spain. Executed around 1160, and arranged in superimposed horizontal friezes flanking a figurative arch of triumph, there are more than a hundred separate scenes to contemplate. Set within a great rectangular field, the story of Moses and his people in the Exodus flanks the entrance arch, then comes the translation of the Ark of the Covenant and the founding of Jerusalem and Daniel's vision of the Children of God set free by the Messiah. Since depictions of King David and other Old Testament monarchs are accompanied by portraits of the contemporary Counts of Barcelona, we recognize that these scenes really expound metaphors of the foundation of Catalunya itself, of the subsequent retreat of Christians from the Moors and of their return after the expulsion of the infidels (Lérida and Tortosa were in fact reconquered in 1148). Other scenes display the Seasons and

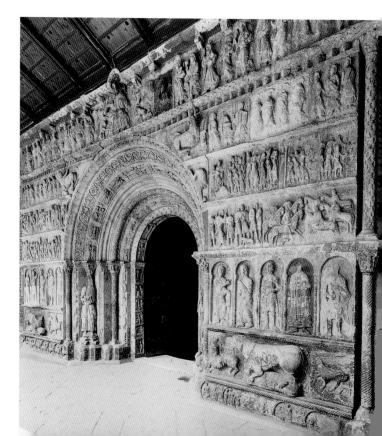

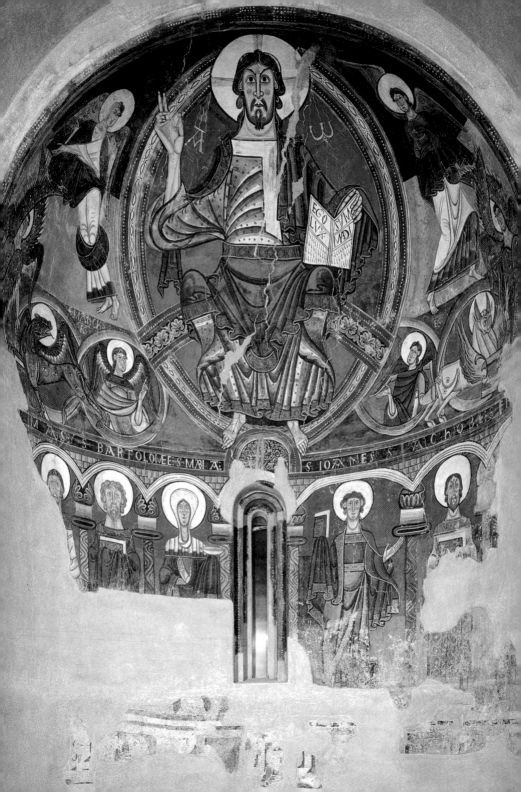

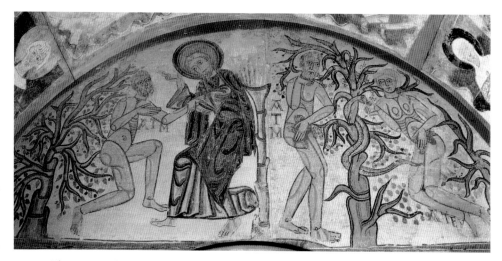

32 *The Creation of Adam, and the Original Sin.* Apse mural from the chapel of the Hermitage of the Holy Cross, Maderuelo, *c.* 1125

Labours, and Catalans industriously working in their bountiful 'promised land'.

The full brilliance of Spanish Romanesque painting, unique in Europe for its quantity and preservation, can still be seen in the surviving wall-painting cycles. Some of the finest of these are now preserved in the National Museum of Art of Catalonia in Barcelona. Even though their iconography and typology were obviously conceived for an unlettered laity and thus typically limited to a Christ in Majesty or an Enthroned Virgin in the apse, the Catalan murals' formal achievement is astonishing. The brilliance of their colours is due to the fact that the painters rarely employed true fresco, but instead painted over a light coat of whitewash which does not absorb and mute colours as does wet lime. Their original location in humble parish churches situated in the daunting heights of the Pyrenees protected them from both the misfortunes of war and the vicissitudes of artistic fashion. One of these rustic structures was San Clemente de Tahull (Lérida). The effect of its apse mural, executed in 1123 and now in Barcelona, is stunning. With almost primitive vigour, this large, brightly hued painting reflects with stringent provincial economy a by-then thoroughly internationalized Byzantine manner, that mainly transmitted by the Cluniac Order. Close-knit compositional unity and clear and ponderous rhythms enhance a brightly coloured but austere expressionism

31 *(left) Christ in Majesty with the Symbols of the Four Evangelists, Angels and Saints.* Apse mural from the Church of San Clemente de Tahull, 1123

which shapes the central image of the Cosmic Pantokrator. The overall effect is one of boldness and majesty.

Outside Catalonia, other developments in Romanesque mural painting can be seen in a section of the wall paintings (*c.* 1125) from the main chapel of the Hermitage of the Holy Cross, Maderuelo (Segovia), where an extremely schematic and linear treatment of the nude figures predominates. First discovered in 1907, these Castilian works, supposedly executed by a colleague of the Tahull Master, demonstrate the effects of a possible Mozarabic contribution in the diffusion of the forceful Byzantine-Romanesque Hispanic style. Like the Pyreneean wall-painting cycles, the Maderuelo murals were removed from their original location, transferred to a canvas backing, and are now (in this case) handsomely preserved in the Prado. Treatments of the nude are infrequent at this period (and in Spanish art in general): according to Gregory the Great, the body is the abominable belly for the soul and nudity is a symbol of sin (*nuditas criminalis*). One image points to the disastrous Fall of Mankind. The emphatic tracery delineating the figures of Adam and Eve reveals the unempirical and inorganic, abstract and design-oriented modes beloved of the medieval craftsman-artisan. It also reveals a subordination of anatomy and plasticity to overriding principles of compositional vitality and rhythmic integration, principles later present in, for instance, the work of Picasso, a great admirer of native medieval painterly expressionism.

One important mural cycle which remains intact in its original site is found in the Pantheon of the Kings, beneath the Palatine Church of San Isidoro in León. This ensemble is unique for being directly

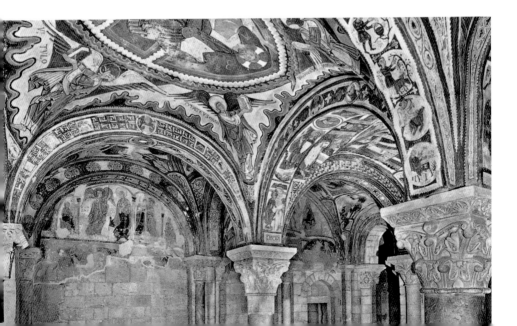

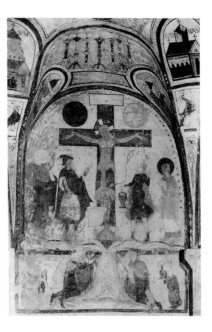

33 *(left)* Ceiling paintings from the Pantheon of the Kings, beneath the Palatine Church of San Isidoro, León, *c.* 1105

34 *(right) Crucifixion with Fernando I and Queen Sancha.* Ceiling painting from the Palatine Church of San Isidoro, León, *c.* 1105

associated with royal patronage which depended upon either Ottonian or Holy Roman Empire artistic models in order to appropriate imperial associations. Even though the royal church was consecrated in 1063, and then dedicated to exhibiting relics belonging to the cult of the venerated Visigothic scholar-saint Isidore, its mural cycle (painted in tempera rather than true fresco) was probably not installed until around 1105, by which time a shift to Romanesque-European styles represented official policy. As befits a structure destined to function as a royal pantheon for the Leonese line, the historiated sequences are genealogical and dynastic. Christ in Majesty and his ancestors are equated to ambitious sibling ruler-patrons, King Alfonso VI *(reg.* 1065–1109) and Queen Urraca *(reg.* 1109–1126), and others in their family, beginning with their parents, Fernando I and his consort Sancha, who are imperiously depicted standing at the foot of a Crucifixion scene. Other images are more transcendental. When the viewer looks up directly into an oversize, red and blue, mandorla-framed *Maiestas Domini,* floating on a white ground just a few metres above his head, the effect is that of an immediate and intimate blessing descending directly from the Lord of the Heavens. Such a blessing had earlier fallen upon Alfonso VI, before whom Toledo providentially fell in May 1085.

35 A page from the *Cantigas de Santa María de Alfonso X, el Sabio* (*c.* 1280) showing (bottom right) a Moor converted by an icon of the Holy Virgin

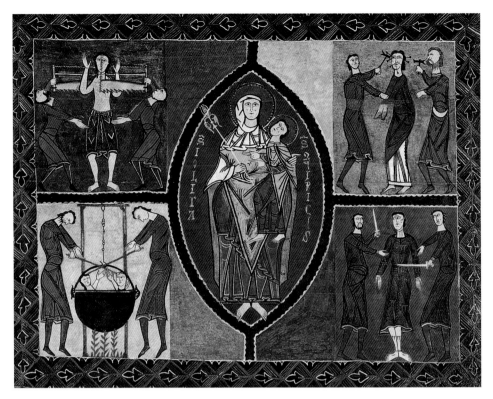

36, 37 (above) *The Life and Martyrdom of St Julita and her son St Quiricus*, a painted wooden *antependium* from the hermitage church of Santa Julita de Durro, *c.* 1170; (below) *Funeral Procession*, a painted wooden panel from the sepulchre of Don Sancho Sáinz Carillo, *c.* 1330

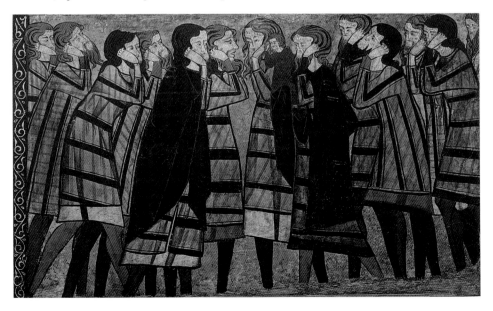

Another important regal Castilian commission produced the
35 *Cantigas de Santa María de Alfonso X, el Sabio*, in which a new taste for
vivid genre scenery, characterized by an eye for sharply observed anec-
dotal detail, makes itself manifest; it remains a constant factor in
Hispanic pictorial expression. The patron of these spritely illustrations,
which belong to a collection of over 400 poems praising the Virgin
written in the Galician dialect of Santiago de Compostela, was Alfonso
X the Learned (*reg.* 1252–1284), king of Castile and León. His reign
fostered a rebirth of learning, a precocious 'renaissance' consciously
shaped by Alfonso to mould a specifically Spanish culture out of its
diverse Greco-Roman, Islamic and Hebraic roots.

The severity of form and purposiveness of content that developed
during the Romanesque period proved crucial to subsequent artistic
expressions of Iberian ethical purposes. Another instance of the Span-
ish taste for expressionistic realism, based upon cold-blooded
observation and coupled to an almost clinical dissection of form and
36 content, is to be seen in a painted altar frontal (*c.* 1170) or *antependium*,
which depicts the martyrdom of St Julita and her son St Quiricus. The
tortures so graphically portrayed here – sawing, nailing, stabbing, boil-
ing – are illustrations of textual passages drawn from the apocryphal
Acts of Quiricus and Julita; the style of such an inexpensive wooden
panel, typically destined for a humble parish church, resorts to folk-art
directness. Another example of medieval expressionism, dating from
the beginnings of the fourteenth century, is to be seen in a painted
37 panel from the tomb of Don Sancho Sáinz Carillo, from Mahamud
(Burgos). It is almost possible to hear the wails of anguished mourners,
and the jagged linear distortions and patterned formal liberties seem
to foreshadow the expressionistic traits of Picasso's *Guernica*. This is no
coincidence; like so many other striking medieval masterworks, these
two *antependia* were on public display in Barcelona, and Picasso proba-
bly saw them before he executed his modernist masterpiece in 1937.

A similar artistic expressionism appears in provincial Hispanic
wooden sculpture. The late twelfth-century *Deposition* from Erill la Vall
(Lérida), with its seven highly individualized, life-size figures, is the
most complete to survive from Romanesque Europe. It appears that
such complex ensembles, originally brightly polychromed, were
intended to be viewed from both sides, almost making the onlooker an
active participant. In this example, radically simplified drapery patterns
and emphatic curved volumes contrast with eloquently stated, grand
gestures of pathos. The slumped figure of the dead Christ is especially
poignant, particularly when contrasted with the energetically sup-

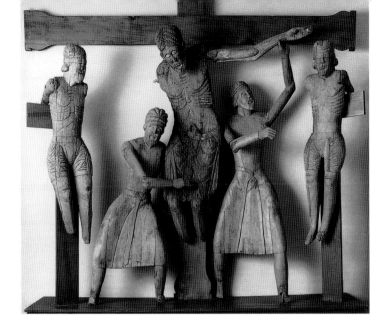

portive efforts of Nicodemus and Joseph of Arimathea. With stylistic adjustments coming from later European art-historical sequences, this is a basic, multipartite and polychrome format that will endure; it reappears five hundred years later in the meticulously realistic (even somewhat surrealist) sculptural ensembles by, among others, Francisco Salzillo (1707–1781). Salzillo's detailed *Agony in the Garden* (1754), which even includes a leafy tree, represents a final outburst of this grandly affective tradition. This is a truly mobile sculpture, a *paso procesional*, meant to be carried into city streets by devout bearers during feast days through milling crowds of the faithful.

38 (*above*) *Deposition* from Erill la Vall, *c.* 1180

39 (*left*) Francisco Salzillo, *Agony in the Garden*, 1754 (detail)

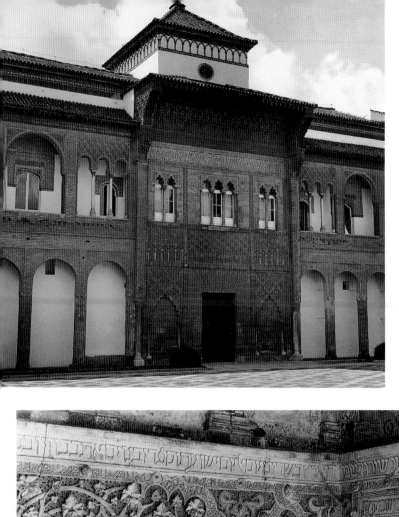

40 (*left, above*) Façade
of the Alcázar, Seville,
1364–6

41 (*left, below*) Interior
of Samuel Halevi's
Synagogue (del Tránsito),
Toledo, 1354–7

42 (*right*) Torre de San
Martín, Teruel, *c.* 1315

By the mid-eleventh century, in nearly all significant respects, mili-
tarily, politically and economically, Islamic al-Andalus was in decline.
Nonetheless, long after its final temporal demise in 1492, it was still to
exercise a lasting influence within Spanish and Latin-American art
and architecture. This Moorish residue, in part, explains the persistent
anti-classicism of Hispanic visual expression. Even though
Mohammedans were later obliged by law (from 1502) either to emi-
grate from territories reconquered by Christians or to become

Catholic converts, their design traditions lived on in Christian Spanish art. Those uniquely skilled Muslim artisans remaining in Christian territories were known as *mudéjares*, from the Arabic *mudayan*, 'one permitted to remain'. Elements of their neo-Moorish style were also assimilated by Christian artists, so giving rise to *Mudéjar* art, which appears most typically in architectural decorations with geometrically derived, brick and/or stucco-based designs usually further embellished with ornamental tiles.

Mudéjar form was opportunely used to express Christian, particularly imperial, ideas. The Alcázar in Seville, originally an Islamic structure dating from 1171, was carefully restored by order of Pedro I of Castile ('el Cruel', *reg.* 1350–1369). The façade of Pedro's palace shows the characteristic design patterns diagonally generated by *Mudéjar* tiles, brick- and stucco-work; its interior is decorated with polychromed and gilded wood. Pedro's court style is an upstart Christian ruler's emulation of an Islamic monarch's palace. King Pedro's

40

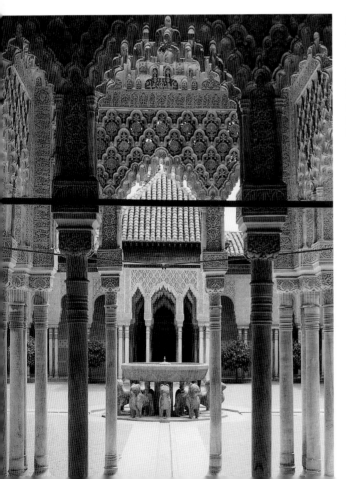

43 (*left*) Court of Lions, Alhambra Palace, Granada, *c.* 1360

44 (*right*) Ceiling painting in the Hall of Justice, Alhambra Palace, Granada, showing a chivalric scene with Christian and Muslim knights, maidens, and a wild man, *c.* 1375

well-regarded treasurer was a Jew, Samuel Halevi. In 1357, he grate-
fully dedicated to his Christian monarch a lavishly appointed private
synagogue in Toledo (later called del Tránsito) whose polychromed 41
plaster walls are embellished with delicately tooled arabesques and
scriptural inscriptions in classical Hebrew in the typically rug-like,
geometricized patterns of the *Mudéjar* mentality. One Aragonese
town, Teruel (in Christian territory since 1171), is a veritable museum
of Christian *Mudéjar* attitudes. Among its many massive, tile- and
brick-decorated bell towers is the striking Torre de San Martín 42
(*c.* 1315) which seems more like an *alminar* (minaret) from al-Andalus,
such as the famous Giralda Tower in Seville (1198), than a contempo-
rary Italian *campanile*.

One of the oddest examples of *Mudéjar* art is a brilliantly conceived
series of stage sets for regal reveries displayed today in the Alhambra
Palace in Granada in one of the four arcaded halls opening onto the
spectacular Court of Lions. This court has at its centre a magnificent
fountain supported by bronze lions; it makes a pointed reference (doc-
umented by contemporary courtier poets) to both an archetypal
Paradise Garden and more particularly to the Temple of Solomon and
its brazen font, thereby alluding to the proverbial wisdom of the
monarch currently inhabiting the Alhambra Palace. Placed upon the

ceiling of the Hall of Justice are three distinctive, oval-shaped paintings which in no way conform to our idea of Islamic art. In style as well as in content, these images appear to be wholly European. Nonetheless, all the available evidence (including a coat of arms) identifies these paintings as a commission of a Nasrid king of Granada, Muhammad V; a date in the 1370s seems most appropriate.

Perhaps most striking is the complex, specifically chivalric, scene in the southern vault, which shows elegant maidens with long blonde hair standing in Gothic-style towers and admiring manly deeds performed by mounted knights. The warrior to the left, obviously a European, is shown dispatching a staple of European folklore, a hairy 'Wild Man', who has seized an elegant demoiselle. On the right, a turbaned Muslim warrior spears a Christian knight while the tallest blonde applauds his prowess. Although there are no known Arabic precedents for such narrative dramatizations, either textual or iconographic, such motifs are known to have been commonly employed on, for instance, fourteenth-century French ivory caskets, highly prized artefacts that were probably imported into al-Andalus. It appears that the paintings were executed by *Mudéjar* painters lent to Muhammad V by Don Pedro, the Christian ruler of Toledo. The paintings' purpose was twofold: to show that the Nasrid ruler was *au courant* with fashionable European innovations, and to exhibit an enviable chivalric prowess to spur on Muslim knights. This singular pictorial cycle reveals the cultural reciprocity, unique to Spain, between Christian and Muslim and vice versa.

OUTPOST OF GOTHIC EUROPE

As a constructive counterbalance to indigenous *Mudéjarismos*, progressive European currents also imposed themselves in Spain, particularly the 'modern' Gothic mode. The closest equivalent to coeval French architecture, and the best of a tiny number of examples in this mode, is the grandly conceived Cathedral of León. Begun in 1225, and largely finished by 1302, its apparent contemporary model, particularly for the sanctuary, was the Cathedral of Reims, the coronation church of the French monarchy. Léon Cathedral also has the finest stained-glass cycle in Spain, which transforms its interior into a refulgent, transcendent vision of the Heavenly Jerusalem. A more original approach to Gothic design is found in Catalonia a century later. The common type of Catalan church in the fourteenth century has no side aisles or transepts, but instead a single, wide, hall-like nave, usually with a

polygonal rather than a hemispherical apse. In Barcelona there is the striking example of Santa María del Mar (1329–67), which was rebuilt with four ribbed bays on the supposed site of the original episcopal seat in the age of Constantine. According to the city chronicles, most of the able-bodied population of Barcelona worked on the new church, thus ensuring its reputation as a truly popular building, of and for the common people. Although it eschews the spires, filigree work and pointed ogives of contemporary French fashion, its stark interior is a marvel, with a narrow lateral ambulatory which curves to form a hemispherical apse at about the same height as the soaring central nave. The ceiling is supported by huge, bare, polygonal pillars; half way up, they blossom into ribbing. There are four in the nave while eight more define the ring of the presbytery. The inter-columnation of this lapidary grove is the widest of any Gothic church in Europe, measuring about forty-three feet from centre to centre. 46

By 1238, Muslim Spain had been reduced to the region around Granada; by now Allah posed little threat to Christianity. That other, larger part of the Iberian peninsula, politically subject either to the

45 León Cathedral,
1225–1302

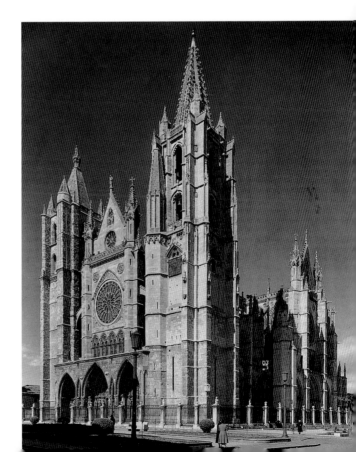

kingdoms of León-Castile or Catalonia-Aragón, now became thoroughly Europeanized, as did its art. With the military threat of Islam so diminished, Spain emerged from the Middle Ages, and looked towards the Renaissance art emerging in Italy. In the expanding Kingdom of Aragón, particularly in Barcelona and Valencia which face Italy and were always receptive to her innovations, there appeared in the second quarter of the fourteenth century an eclectic style known as 'Italo-Gothic', which more or less faithfully echoed the dominant artistic modes of Trecento art. Painters' names began to be routinely

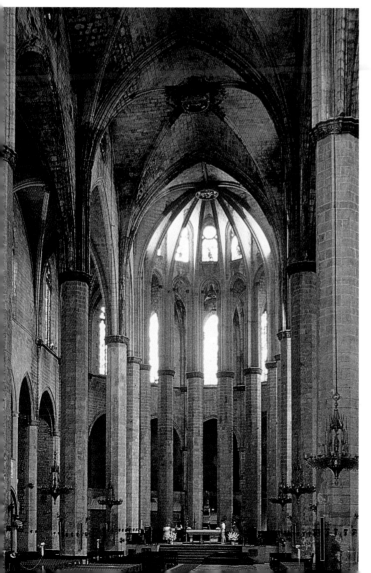

46 Interior of
Santa María del Mar,
Barcelona, 1329–67

47 Ferrer Bassa, *The Adoration*, a mural from the Chapel of San Miguel in the cloister of the Monastery of Pedralbes, 1346

recorded. A major marker of the new manner is a striking mural cycle by Ferrer Bassa (*c.* 1290–*c.* 1348), commissioned in 1346 for the Monastery of Pedralbes (Barcelona). Although executed in the non-Italian oil technique, Bassa's murals closely approach the style of Giotto and, in format and technique, recall the Arena Chapel in Padua. Even more apparent are certain Sienese spatial innovations belonging

to the same moment, from Duccio through to the Lorenzetti, particularly early naïve 'doll's-house' perspectival constructions. Bassa's murals introduced a sense of sculptural bulk, amplified space and psychological gravity into Spanish painting. Another distinctive trait of the Spanish Italo-Gothic style in Bassa's composition, for instance, are the sinuous linear outlines placed around the figure of the Virgin. Since such stylistic features were as common in French Gothic art as in Sienese art, Bassa's style can be seen to be literally 'international'.

Nonetheless, these innovative Aragonese painters lacked the Italian sense of the ideal and also ignored Italian classicist pursuits of perfection in form and finish. The monumental painting style early pioneered in Rome by Pietro Cavallini and Giotto, and thereafter adopted by Bassa's contemporaries in Aragón, was soon to be supplanted by the pan-European, late Gothic 'International Style' which emerged at the end of the fourteenth century and is characterized by anecdotal charm, compositional superfluity and mannered elegance. This femininely sinuous and minutely rhythmic style, with its heightened interest in genre detail, is neatly exemplified by the *Altarpiece of the Holy Spirit* (1394) in the church of Santa María, Manresa, a work in an already archaic Italian manner by the Catalan painter Pedro Serra (who died after 1405). Serra's style was the point of departure for many painters working in Valencia and in the Balearics, but it was soon supplanted by a wholly different approach, a harsh naturalism derived from northern European art which was to produce a lasting effect in Spain.

Universally cited as the first evidence for a Hispano-Flemish style is a work by Luis Dalmau, *The Madonna of Councillors*, commissioned in 1443 for Barcelona Town Hall, where it was installed in 1445. As it is known that Dalmau (*c.* 1405–1460) was acting in 1428 as court painter to Alfonso V of Aragón in Valencia, and that he had been sent on missions to Bruges beginning in 1431, this work must be modelled upon two masterpieces Dalmau would have seen there: Jan van Eyck's *Ghent Altarpiece* and his *Madonna of Cardinal van der Paele*. Dalmau flattens the flowing plasticity of his Flemish models, rejecting volume in favour of stiffly linear designs, and turns their rich chromatic coloration into a dusty and earthy palette. The Spaniard is also less subtle in his presentation of iconographic details. Thereafter an absence in Spanish art of disguised symbolism, a marked trait of Flemish sophistication, becomes significant and that lacuna betrays native preferences in the fifteenth century for a more immediate and direct narrative statement. As we will see, however, the use of pictorial metaphors would become a commonplace in seventeenth-century Spanish painting.

49

48 Luis Dalmau, *The Madonna of Councillors*, 1443–5

Since an Aragonese painter like Dalmau was familiar with the Flemish vocabulary of disguised symbolism, and the purposes it fulfilled, its rejection then must have been due to a native cultural bias. It seems that, at this time, both Spanish artists and their patrons preferred direct representations, emphatic narratives and immediate sensory renderings of religious experiences. These tastes are well documented in later mystical writings by, among others, St Teresa of Ávila. There are other revealing divergences from the Flemish norm: the brilliance of northern European coloration is consistently replaced by muted tonalities, and Flemish spatial illusionism is generally renounced in favour of two-dimensionality and crowded, patterned surfaces. The precision of the Flemish miniaturist's technique is exchanged for a

71

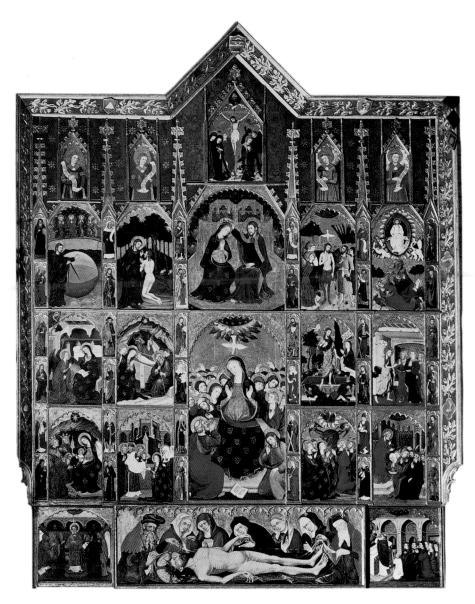

49 Pedro Serra, *Altarpiece of the Holy Spirit*, 1394

50 (*right*) Fernando Gallego, *Pietà*, c. 1465

cruder, broader and more spontaneous brushwork; likewise, the Flemings' balance of gesture and often wooden poses are increasingly replaced with emphatic movements and facial expressiveness, a simultaneous development in Rhenish art.

In the work of the Salamanca-born Fernando Gallego (c. 1440–1507), the first influential master of the Castilian School, landscape is finally accepted as an integral part of pictorial composition. Gallego's work also reveals an often overwrought emotional expressiveness, the specific trait of northern naturalism most prized by Spanish painters. In his highly dramatized *Pietà*, painted c. 1465, Gallego was strongly influenced by the drama of contemporary Flemish religious art, including its sculpture, and also German naturalism,

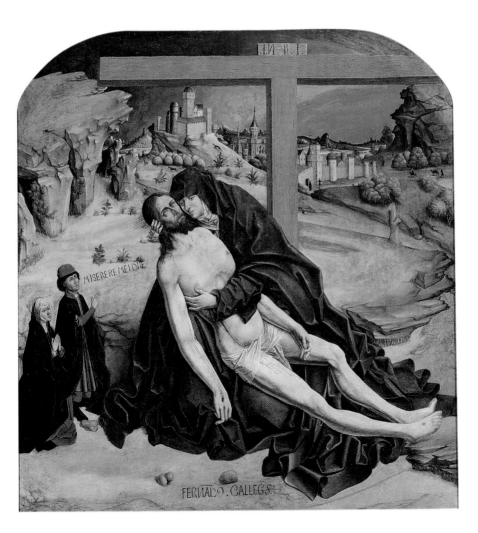

particularly as exemplified in the widely circulated graphic work of Martin Schongauer. This does not, however, imply that Gallego ever left Spain or even, for that matter, Castile. At annual trade fairs, where Castilian wool was exchanged for northern artefacts, representative examples of northern European art would have been easily available to native artists like Gallego, especially in the form of published engravings. For Gallego, however, foreign influences only provided a point of stylistic departure in the formation of his own, native brand of heightened, almost primitive, realism, which manifested itself melodramatically in twisted and contorted poses, extreme facial expressiveness and an overall, most uncomfortable, angularity. Gallego's highly personal style was innovative and widely disseminated, even as far west and south as Extremadura. His love of expressionistic devices and simplified surfaces with repeated textures, which tie the whole surface of a painted panel together by means of wiry, sinuous rhythms, indicates a resurgence of the persistent Spanish search for eloquent forms which transcend their superficial decorative significance.

Two hieratic portraits of saints from the second half of the fifteenth century by Bartolomé Bermejo (c. 1440–1495) and Jaume Huguet (c. 1415–c. 1492) are representative of a period (c. 1470–90) when Spanish painting had fallen nearly completely under the sway of the expressive precision of Flemish naturalism. Nonetheless, some distinctive native anachronisms persisted. Unlike their Flemish counterparts, both examples contain a fundamental conceptual dichotomy between realistically rendered faces and the gilded, patterned and symmetrically arranged surroundings from which they emerge. A notable indigenous peculiarity here, perhaps provoked by the geometry of contemporary *Mudéjar* decoration, is a certain compositional rigidity and axialarity, which breaks up the pictorial compositions into paired, almost symmetrical patterns. The painter's attention is concentrated upon the face at the expense of the rest of the ensemble, so creating an iconic central focus and an almost hypnotic effect of rigid frontality. Here, another perennial Hispanic trait, enhanced by contemporary Flemish naturalism, is revealed: an objective or veristic analysis of individual character based on a minute frontal portrayal of facial features. The Spaniard, unlike the contemporary Italian, delighted in idiosyncrasy.

The two painted saints by Bermejo and Huguet would once have been attached to quasi-architectural settings (*retablos*) – monumental altarpieces, sometimes called 'retables' or 'reredos' – which were common in both the Middle Ages and the Renaissance. The *retablos*, providing dramatic backdrops to celebrations of the Mass, were to

74

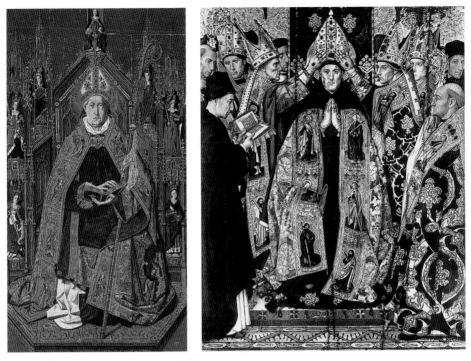

51 Bartolomé Bermejo, *St Domingo de Silos*, 1474

52 Jaume Huguet, *The Episcopal Coronation of St Augustine*, the central panel of the *retablo* of the Barcelona Tanners' Guild, *c.* 1480

remain for a long time the main theatre for collective Spanish artistic endeavour. The name is derived from the Latin, *retro tabulus*, 'behind the altar table'. Typically rising from the floor of the church, encased in heavy frames and stretching up into towering vaults, these are literally 'multimedia' artworks: tremendous agglomerations of polychrome panel paintings or bas-reliefs, with gilt and stucco ornamental carvings framing ranks of wooden sculptures. Although the genre is found all over Europe, Spanish retables were by far the largest and most elaborate. They evolved from grandiose apse murals or humble altar-frontals and other small-scale panel paintings which had been rendered obsolete by liturgical changes. Altars were moved to the back wall and a need was created to elevate altarpieces above an officiating priest who would otherwise have blocked the congregation's view of the sanctifying images.

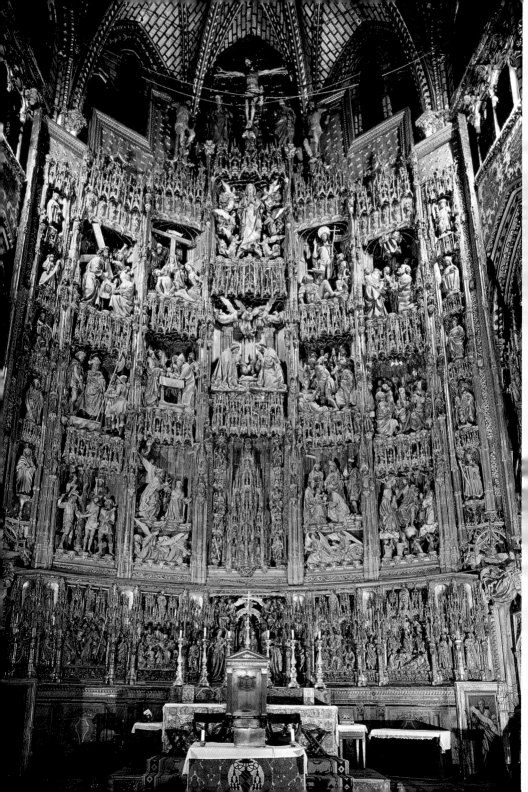

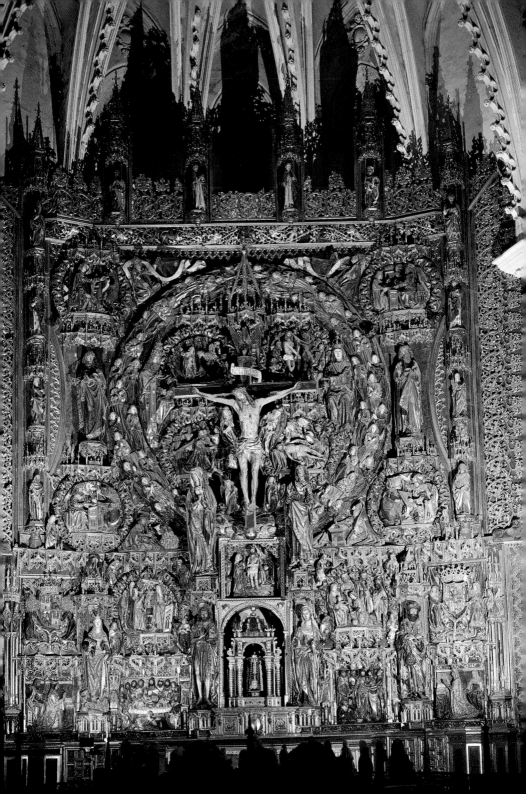

By 1360, the new layout had become established: the central body (*cuerpo*), a base with narrative scenes (*banco*, corresponding to the Italian *predella*), and a pseudo-architectural enframement (*guardapolvos*, or 'dust-guard'). Within the central axis of the retable, situated above the priest's head, was commonly placed the Custodia, a micro-architectural tabernacle for the Host, or simulacrum of the Corpus Christi. After 1400, the Custodia was conventionally located in the heart of the *retablo* to provide a spiritual vanishing point for the gaze of all communicants. Accordingly, the *retablo* itself, just like the Host at its centre, becomes a Eucharistic representation: the retable image has itself collectively become the literal incarnation of the Mass, culminating in the Elevation of the Host, a favourite subject of Spanish artists. Moreover, according to extant contracts which stipulate that 'left' and 'right' refer to points of view incorporated within the *retablo* itself, such images were collectively understood to be viewed by an all-seeing God rather than by earthbound spectators. The fact that Heaven itself, the site of God's omnivoyant gaze, is inherently spaceless and timeless might explain the Spaniards' rejection of Italian perspective systems, which are essentially temporal and earthbound.

Subsequent innovations were mostly increases in scale: some *retablos mayores* were to occupy the entire apses of churches, rising from floor to ceiling. The massive high altar in Toledo Cathedral (begun in 1498) may be taken as representative of all such quasi-architectural structures, which can comprise as many as sixty narrative panels. They can strike the non-Spaniard as being overly ornamented, while also presenting a curiously flat appearance. They lack the illusion of space found in their contemporary Italian equivalents. Illuminated mainly by the feeble glimmer of flickering candles beneath, the *retablos* sparkle almost mystically with pure hues and light glinting from broken surfaces covered with gold and silver leaf. Their brightly coloured painted images cling to a stylized vision of a world where saintly beings are set against patterned and textured gilded backgrounds, a world where landscape, if it is shown, has no atmospheric substance and where the sky becomes a mysteriously radiant gold-leaf ground. In short, the humble Spanish artisan had evolved the perfect visual equivalent for the inner mystical experience recorded so vividly in words by his literate contemporaries, the mystic writers.

53

53 (*p. 76*) The high altar of Toledo Cathedral, begun 1498

54 (*p. 77*) Gil de Siloé and Diego de la Cruz, High altar of the Carthusian Monastery of Miraflores, Burgos, *c.* 1496–9

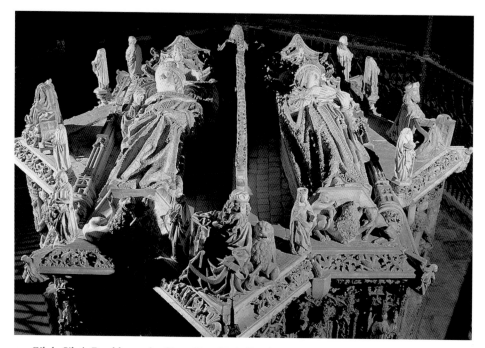

55 Gil de Siloé, Double-tomb of Juan II and Isabella of Portugal, 1486–99

The formal arrangement of these *retablos mayores* recalls the traditional Hispanic, especially *Mudéjar*, affection for a carpet-like effect and a characteristic *horror vacui*. Emphatically framed and tied together by wiry geometric arabesques with angular borders which reflect the reticence and conservatism of Spanish ritual, they develop within their framings a cellular repetition of broader themes and micro-motifs, so creating patterns of unremitting movement. Another representative *retablo* is the magnificent example in the Carthusian Monastery of Miraflores in Burgos (*c.* 1496–9). This impressive altarpiece by the Castilian master Gil de Siloé and his follower Diego de la Cruz displays at its centre the inspiring emblem of the Crucifixion – the Tree of the Cross, signifying Christ Himself – set against a geometric, or *Mudéjar*, carpet-like pattern of circles and rectangles.

54

Also at Miraflores is another stunning work by Siloé, the alabaster double-tomb of Juan II and Isabella of Portugal commissioned by their daughter, Isabella the Catholic, which was erected in 1486–99

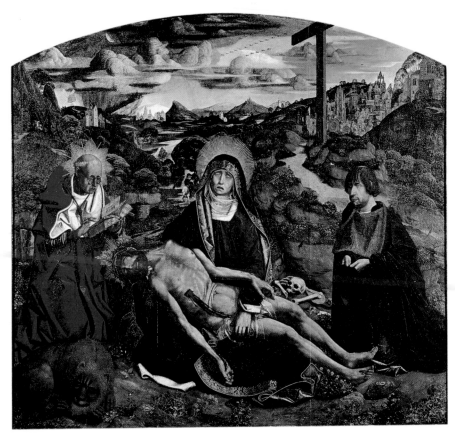

56 Bartolomé Bermejo, *Pietà*, 1490

beneath the eventual location of the slightly later *retablo mayor*. A truly
virtuoso piece, this work incorporates (besides the two intricately
carved royal effigies) Biblical scenes, Evangelists, Virtues and sixteen
lions guarding the royal arms. Since the full compositional grandeur of
Siloé's tomb complex can only be appreciated when viewed from
above, like the great *retablos* just discussed, this sepulchral arrangement
also metaphorically presupposes a viewpoint from on high, that of
God himself. Seen from this superior perspective point, the figures
axially aligned by Siloé to the altar are arranged exactly like standing
saints on cathedral façades, and, the compositional framework is a

boldly proclaimed eight-pointed star. This is probably because Hugh of St Victor (among others) mentions an 'eighth day', which surpasses the earthly week, as signifying eternity. The tomb is thus conceptually linked to the altarpiece serving as its figurative counterpart, and the two-part ensemble is reminiscent of both Master Mateo's self-portrait at Santiago de Compostela, his eyes fixed on a distant altar exhibiting the Host, and the Escorial, where two imperial families rivet their spiritual vision for eternity upon a similar altar-Host ensemble.

The style of Siloé's work belongs chronologically to the so-called Plateresque (silversmith) conventions which initially determined architectural design in Renaissance Spain. As exemplified by the façade of the Convent of San Esteban in Salamanca (designed *c.* 1524 by Juan de Alava), the traditional retable format could become fully architectural, and, as a *fachada-retablo* ('altarpiece-façade'), could serve as an ecclesiastical frontispiece. Such altarpiece-façades were constructed upon the same compositional principles as the towering

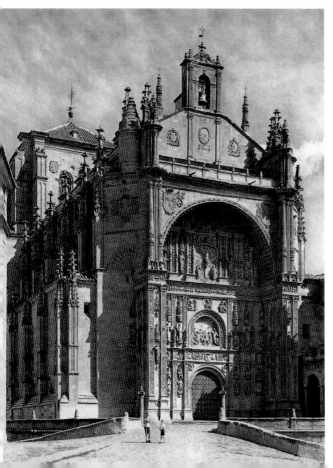

57 Façade of the Convent of San Esteban, Salamanca, *c.* 1524; shown as completed in 1610, by Juan Antonio Ceroni

retablo mayor inside the church and thus an emphatic stylistic homogeneity and spiritual bonds between exterior and interior, and between architectural form and liturgical content are apparent. This distinctive format endures in traditional Latin-American architecture.

An anachronistic use of gold-leaf backgrounds and geometric fragmentation were not the only significant characteristics which distinguished fifteenth-century Spanish painting; ever stronger influences from other parts of Europe were felt too. Naturalistic traits, with significant emotive innovations, are seen in one of the unacknowledged masterpieces of European art, Bartolomé Bermejo's *Pietà*, signed 'Opus Bartolomeus Vermejo Cordubensis' and dated 1490. Bermejo was the first Spanish painter to employ comfortably the Flemish technique of translucent oil glazes. The striking *Pietà*, a decade and a half later than his similarly impressive *St Domingo de Silos*, demonstrates further adaptations of an expressionistic sensibility, and spatial articulations associated with the later Flemish masters, who followed the path set by the Van Eycks, Rogier van der Weyden and Dieric Bouts. While Bermejo's figure types are generically Netherlandish, the sombre, brownish coloration and emphasized silhouetting of the dark forms in the foreground seem to provide an emphatically Spanish response. Bermejo's *Pietà* – a centred, two-part lamentation scene with flanking actors – additionally recalls the Catalonian tradition of polychrome wooden sculptural groups with moveable, individual figures.

Bermejo shows his swarthy-faced, stubble-bearded donor, Canon Lluís Desplá, kneeling on the right and portrays him with veristic harshness and psychological acumen. At the Virgin's right hand St Jerome searches through his Vulgate translation of the Bible for consolation and inspiration. Compositionally, Desplá and Jerome serve as anguished brackets to a grief-torn Mary with the rigid, gruesomely bloodied body of her martyred son. Here, perhaps for the first time in Spanish painting, the donor's facial expression and attitude indicate his full participation in the Christian drama; even the stubble on his chin may be an indication of the time he has spent mourning the death of Christ. The vertical patterns of dried blood clots tell us how long his Saviour must have hung upon the cross, shown looming in the background, before his stiffened body was taken down. This large panel (measuring 1.75 × 1.89 m) was intended to hang independently in the donor's private oratory. Every time Desplá regarded the tragic scene on Golgotha, he viewed himself as a participant in the ultimate Christian drama.

But the principal dramatic element in Bermejo's *Pietà* is a troubled sky with the sun rising in the east over the earthly Jerusalem and directly above a grieving but spiritually enlightened Desplá. This new dawn dispels the stormy darkness hovering to the left above the head of the dead Saviour. In contrast to this, the foreground of Bermejo's landscape teems with life: small animals, birds and insects. Each of these may be read symbolically: lizards were salvation-seeking creatures; the 'ladybird' (*mariquita*) represents the Virgin; butterflies were ubiquitous symbols of the Resurrection; and even snails provided once widely understood references to the Entombment and Resurrection of Christ. Bermejo's *Pietà* foreshadows sixteenth-century artistic concerns; this exceptionally dramatic, truly unique, meteorological *mise-en-scène* prefigures a mood of emotional turmoil and unease which was to afflict European art some decades later. Art historians usually cite Giorgione's famous *Tempest* (c. 1505), the early works of Altdorfer, such as his *Satyr Family* (c. 1507) or his *St George in a Wood* (c. 1510), or even Patinir's *Charon Crossing the Styx* (c. 1520–5), as the earliest examples of a conscious preference for landscape over figures as the major vehicle for expression in painting. But the Bermejo *Pietà* clearly antedates these, with its distinctive wind-torn clouds, flickering lights, fretful dawn and flocks of startled birds fleeing the storm-clouds.

Dramatic works such as these provide an insight into the Hispano-Flemish style. Its wholesale acceptance in Spain, especially Castile, after 1470 is due in large part to external events. Throughout the fourteenth century, Aragonese rulers had been successful in extending their sphere of influence into southern Italy; their art was initially Italianate. This situation was modified by two shifts in political gravity: the first, towards the centre of Spain, when the Houses of Aragón and Castile were joined in marriage in 1469; and the second, towards the north of Europe, in 1496, when Ferdinand and Isabella joined their tragic daughter Joanna the Mad in marriage to Philip the Fair, heir to the northern Habsburg dominions. The realism of the Flemish style appealed to the engrained Spanish taste for the particular and the concrete far more than the mannered elegance of the competing Italo-Gothic mode.

The Martyrdom of St Cucufat was painted in 1502–6 by a follower of 58
Bermejo, Ayne Bru (Henrick Brun?), a Brabant-born artist working in Catalonia. It displays the celebrated Hispanic delight in the gruesome. Like Bermejo, Bru was interested in an expressive, local landscape setting; here he accurately depicted the abbey-church of

Sant Cugat del Vallés (Barcelona) which originally housed the painting. Bermejo's other contribution to Bru's vision is to be seen in the contrasting characterizations of an executioner on the left and some impassive spectators, including a sleeping dog, on the right. The executioner is grimly efficient in his professional labours, biting his lower lip as he earnestly dispatches a slumped martyr with upturned, now sightless eyes. The callous indifference of the three witnesses contrasts starkly with the physical torments inflicted upon the martyr, whose self-control and religious dedication provide a moral example to the onlooker. A similar duality – defenceless victims confronted by implacable executioners – would later inform Goya's *The Third of May, 1808 (Executions)*. St Cucufat's blood spurts vigorously into the foreground, directly into our space. A moral ending is provided however in the distant picture of a beatific Cucufat (Cugat) borne aloft by hovering angels into the heavens upon his winding sheets.

Blood itself is a notoriously persistent motif in Spanish painting and polychromed sculpture. Certainly there is much more blood in Spanish portraits of martyred saints than in Italian painted and sculpted examples. The reason for this is strictly local: *limpieza de sangre*. That term, current in Spain as nowhere else in Christian Europe, literally means 'cleanliness of blood', but more specifically refers to blood-lines. 'Purity of blood' was a Jewish concept long before it was opportunely appropriated to become a Christian-Spanish obsession. Blood represented genealogical pedigree, serological proof in Spain of a specifically Christian ancestry, which would preferably be traced to Visigothic sources, thus making the bearer both 'pure and authentic' (*castizo*) and an 'old Christian' (*cristiano viejo*) with a family tree antedating all subsequent (post-711) Islamic and Jewish incursions. Once realism had become widespread in Spanish art (something which coincided neatly with the founding of the Inquisition in 1478), pictorial bloodbaths became ubiquitous. As in so much Spanish art, behind the superficial carnage and revulsion is revealed the true purpose: an essentially stoic, morally rigorous and impassive narration elevates the subject beyond mere melodrama. Generally intended for public display, such blood-soaked imagery is often appalling, but, to Spaniards, it is also truly edifying, conferring spiritual health upon all onlookers.

136

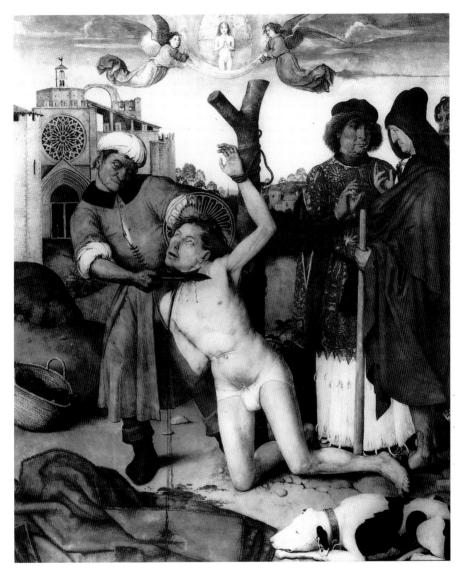

58 Ayne Bru, *The Martyrdom of St Cucufat*.
Central panel of the *retablo major* of Sant Cugat del Vallés, 1502–6

Renaissance Adaptations in Sixteenth-Century Spanish Art

The nation we call Spain has only been in existence since the very end of the fifteenth century. With the marriage in 1469 of the Catholic Monarchs, Ferdinand of Aragón and Isabella of Castile, political unification of the Iberian peninsula was finally achieved. In 1478 the Inquisition was renewed in Spain; it was not to be officially abolished until 1820. With the fall of Granada and al-Andalus in January 1492, the Reconquest was complete. Shortly afterwards, Columbus was opportunely sent to discover a new world, which itself was to require a lengthy, neo-chivalric conquest. In that decisive year appeared the first vernacular grammar, Antonio de Nebrija's *Gramática de la lengua castellana*, designed to impose political unity by instructing 'our language to Basques and Navarrese', among other diverse Iberian and, later, New World peoples. The year 1492 symbolized, at least for Spaniards, the triumph of Catholic civilization over Islam, and they immediately imposed their victorious creed and idiom upon the as yet unenlightened native Americans on the far side of the Atlantic. The gold of the Indies paid for a transatlantic eruption of ecclesiastical monuments and transfiguring artworks to fill the Spaniards' New World.

In 1519, three years after his arrival in Spain, a Flemish prince was elected Emperor of the Holy Roman Empire and given a new name, Charles V. The later Habsburg rulers of Imperial Spain, from Philip II (*reg.* 1556–1598) onwards into the next century, continued to extend their power and prestige throughout Europe, Africa and the Americas. Political ambitions unleashed a series of misadventures, territorial clashes, dynastic entanglements and intense religious evangelization, all of which significantly dissipated Spanish wealth, manpower and morale. The impressive artistic achievements of the Spanish Golden Age take place against this unlikely background of territorial conflict and appropriation, and ideological affirmation and confrontation.

The pattern was set by Charles V, who ruled until 1555. Regarding himself as the personal champion of a Universal Christendom, Charles V was to become the most determined sponsor in Spain of an antiquarian classical style. During stays in Italy for various state visits and

triumphal entries, the young Emperor's admiration for contemporary Italian classicism grew; he saw it as a re-creation of the content of ancient Imperial Roman art, the concrete expression of absolute temporal power. Pure classicism, at odds with the medieval expressionism still attached to religious commissions, was to become the preferred iconographic language of the Imperial Court; it was best expressed in architecture, long since an ideological vehicle of Spanish rulers.

Surely the most severely classical European structure erected at this time was the Palace of Charles V in Granada. Initially conceived some time after 1526, when the Emperor visited Granada and decided to transform the acropolis of the Alhambra into a tangible symbol of triumphant Universal Christendom, the ground plan of the palace is a purely geometrical abstraction, a circle inscribed within a square, long before cited by Vitruvius and famously illustrated in Leonardo's 'Vitruvian Man'.

The Palace of Charles V was designed by Pedro Machuca (c. 1495–1550), who trained as a painter in Italy; begun in 1533, the project remained unfinished at Machuca's death. Its location is exceptional: it forms an organic, if stylistically incongruous, part of the fabulous Nasrid palace, the Alhambra, whose neo-Solomonic Paradise Garden Charles took great pains to preserve. In the imagination of its recent conquerors, Granada represented a facsimile of Jerusalem, with its conventional Solomonic and Christological associations now restored after Islamic profanation. In 1523, Charles V permitted to be

59 Pedro Machuca, Palace of Charles V, Alhambra, Granada, begun 1533

erected within the Great Mosque of Córdoba, which he otherwise left undamaged, a great metropolitan cathedral completely executed in the new architectural style of Universal Christendom. The façade of the Palace of Charles V employs the severe Tuscan order and a primitive rustication, two features conventionally suggestive of primordial strength and martial virtue. A complicated iconographic programme, including allegorical scenes, the Labours of Hercules, the Order of the Golden Fleece and the *Plus Ultra* device (paired columns signifying the Strait of Gibraltar, now 'further extended' to America), alludes to the Emperor's recent military successes. This emblematic façade extends the indigenous architectural tradition of sermons in stone into the new classical idiom.

In Rome, albeit on a much smaller scale, this symbolic circle-within-a-square arrangement had earlier been used by Bramante in the so-called Tempietto erected inside the Monastery of San Pietro in Montorio; originally centred within a square cloister-garden built upon the supposed site of St Peter's crucifixion, its format is that of the circular-peristyle martyrium. Bramante's perfectly centred 'little temple' (only 15 feet in diameter) was commissioned in 1502 by the Catholic Monarchs. Similarly shaped structures, circular, domed and colonnaded, appear in contemporary prints and medallions, and are labelled Templum Domini, thus placing the architectural prototype in Jerusalem, the Anastasis or Temple-Tomb of Christ; one of the Catholic Monarchs' titles was 'King and Queen of Jerusalem', the earthly regents of the Holy Sepulchre. Eighty years later, a descendant of Bramante's archetypal Tempietto-Anastasis reappears in the centre of a square cloister-garden, the Patio of the Evangelists, at the Escorial. The programme explicitly assigned to the setting by the royal chronicler Friar José de Sigüenza (in his 'Fundacion del Monasterio de El Escorial', 1605) makes it an imperial Garden of Eden, with four rivers and four Evangelists spiritually watering Europe, Asia, Africa and America. The austere, domed Tempietto was again replicated in miniature inside the basilica at the Escorial as the Custodia (Sacrament vessel) holding the Corpus Christi on the high altar.

The imperial exemplars notwithstanding, there are abundant reasons for questioning whether a fully 'classical' art, which rigorously focused upon a new union of theory and 'science' expressed by proportion, symmetry and perspective, ever occurred in Spain to parallel the Italian Renaissance. That, for the most part, such a rebirth of classical principles did not happen in Spain may be explained by the strong gravitational pull of native tradition, in this case artisan customs rooted

in the Middle Ages, and a mind-set shaped by the centuries-long Reconquest and its inflexible ideological positions. Besides, marriages pursued by the Catholic Monarchs directed Spanish interests towards the Low Countries, not Italy.

The return to specifically 'antique' classicism was paramount in fifteenth-century Italian architecture. At odds with then-current Italian parlance, Spanish sixteenth-century treatises on architecture continued to refer to what is now known as the Gothic style as 'modern', and long after the term *architettura moderna* had been used in Italy to describe the fully classical style of High Renaissance architecture. The architectural style deemed most fitting for domestic purposes in Spain was instead Plateresque (a term current only centuries later) which was called in its time 'Romanizing', *a lo romano*. The resultant post-Gothic operation involves some Italianate classical motifs (often grotesques derived from those painted in Nero's Golden House in Rome), but they are mostly used as a veneer to embellish a façade, being derived from contemporary prints and then superimposed upon medieval compositional schemes. These *grutesco* motifs were

60 Diego de Sagredo, Grotesque motif from *Medidas del Romano*, 1526

illustrated by Diego de Sagredo in his *Medidas del Romano* (1526) as examples of the 'monstrous order'. Representative examples include San Juan de los Reyes in Toledo, an Isabelline commission, and the intricate façade of San Gregorio in Valladolid, with its exotic 'wild man' theme. Only in the 1520s were the clustered colonnettes and flattened, multiform ogive arches characteristic of Isabelline design gradually supplanted by a truly classical architectural framework, with a weighty entablature supported by freestanding colonnades or arcades equipped with canonic capitals and bases.

Almost as numerically abundant as their Italian counterparts, Spanish sixteenth-century art treatises respect the ancient genealogy of the specifically Spanish art-historical legacy. This national self-consciousness is stated initially in Felipe de Guevara's *Comentarios de la pintura* (*c.* 1560) and reiterated in later treatises. Common however to theoretical works produced elsewhere in the Renaissance is the demand for 'liberal artists', as differentiated from mere 'artisans', who pursue 'vile and mechanical trades'. But official acceptance in Spain for the *artes liberales* was to be long delayed, coming a century or so later than in Italy. In Italian terms (Giorgio Vasari's), Spanish artists typically lacked *gentilezza, dottrina, mesura* and *vera proportione*. The average Spanish painter, an artisan typically preoccupied with tradition-bound religious commissions, showed little interest in theoretical arguments; an interest in theory would have been the preserve of a 'liberal artist'. But in reality, until 1783, Spanish painters legally remained manual labourers, for they had to pay an onerous ten-percent retail tax, the *alcabala*, on their handiwork. The sole exceptions were paintings which depicted religious subjects. Mythological subjects (*poesías*), profane narratives (*historias*), and still-life compositions (*bodegones*) were taxed unless they could be shown to convey religious content by means of veiled subject matter. Searching nonetheless like all contemporary Europeans for an adequate expression for an obviously 'new' age, the Spanish artists who attempted Italianate exercises were many; by temperament and tradition, however, they remained faithful to their cultural heritage.

OLD SPAIN, NEW ITALY

For about a century, Spanish culture had much difficulty in creating a viable synthesis between old and new. Artistic endeavour in Spain lacked the patronage of courts and city-states which had proved advantageous in Italy and was therefore extremely scattered. Certainly Spain embraced wholeheartedly the principles and techniques of Italian humanism, but typically the greatest monument of the new erudition was strictly religious: the *Polyglot Bible* (1514–21), which was sponsored by Cardinal Cisneros, himself the patron of a polyglot architecture. Moreover, the aesthetic direction of Italian art, propelled by secular patronage sponsoring the 'modern' emphasis on idealism, theory and antiquarianism, tended to ignore the simple directions favoured by Spanish narrative immediacy, which best expressed itself in conventional religious themes.

Although during the first quarter of the sixteenth century Spain

welcomed the Italian Renaissance and particularly its learned humanism with a fervour perhaps unmatched elsewhere, the stylistic expression of much Spanish painting persisted in *Mudéjar* and gothicizing anachronisms. Even though the Italian, especially Roman, High Renaissance style found scarce response in Spain, native artists yielded enthusiastically to a more emotional style later created by Italian artists: Mannerism. Its earlier phase, which might be said to represent a 'Counter-Renaissance' movement (in effect, a gothicizing reversion), is commonly observed in Italian art from 1515 to around 1545. The formal medievalisms and emotionalism of the new Italian style proved to be much more congenial to Spanish artistic taste than did the calm perfection, balanced harmonies and, above all, Olympian distance of Italian High Renaissance classicism, best exemplified by Raphael's Vatican Stanze.

Native naturalistic tendencies, sometimes almost journalistic in their end results, can be seen in a provocatively objective rendering of an *Auto de fe* by Pedro Berruguete (*c.* 1450–1503), a major figure in the 61 Castilian School. Now installed in the Prado, its original destination was the Sacristy of the Dominican Monastery of Santo Tomás in Ávila. Religious non-conformists are shown being led impassively to the stake with a fatalistic acceptance of their bureaucratically determined fate. Portrayals of such stoic resignation in the face of death were to reappear again centuries later in Spanish academic painting, where the dangerous virtue of political rather than religious non-conformity is featured. Although all the details of the mass execution, a public spectacle, are meticulously rendered by Berruguete, nobody seems to care: one inquisitor is even shown snoozing throughout the entire grim business. Berruguete was chronologically the first of the new 'Italianizing' painters. But, after Bermejo, Berruguete was also the supreme Spanish practitioner of the Flemish technique of oil glazing. A dynastic portrait he executed (*c.* 1480) at the humanist court of Federico da Montefeltro, Duke of Urbino, reveals his thorough comprehension of 62 an Italian Renaissance integration of plastic figures in ample spaces defined by classical architectural settings. Nonetheless, after his return to Spain (*c.* 1483), he reverted to traditional pictorial conventions; native traits inform his elegantly precise and icon-like portrait of *King* 63 *Solomon*, with its anachronistic, tooled gold ground.

Another prominent Castilian master is Juan de Borgoña (*c.* 1470–1536) who was probably of Burgundian origins. It is generally accepted that he was trained in Florence in the workshop of Domenico Ghirlandaio, who was also the master of the young

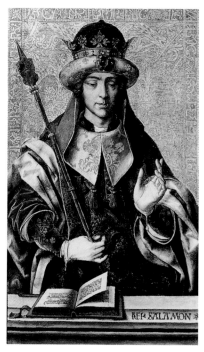

61 (*above*) Pedro Berruguete, *Auto de fe*, c. 1498

62 (*above right*) Pedro Berruguete, *Federico da Montefeltro, Duke of Urbino, and his son Guidobaldo*, c. 1480

63 (*right*) Pedro Berruguete, *King Solomon*, c. 1485

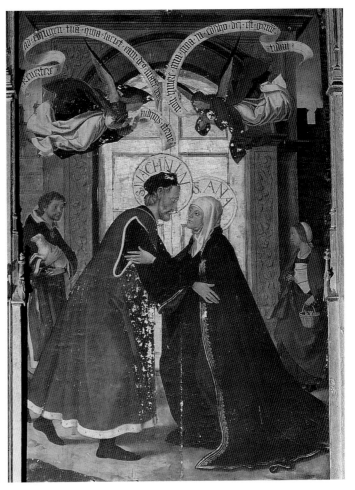

64 Juan de Borgoña,
*Embrace Before the
Golden Gate, c.* 1509–11

Michelangelo. In Toledo, Borgoña worked for Cardinal Cisneros, and
ambitiously attempted to assimilate solidly modelled figures into clas-
sical architectural settings in a way comparable to the advanced
painterly effects being produced in Italy. Nonetheless, in his rendering
of a solemnly choreographed *Embrace Before the Golden Gate*, the
proportional relationships between figures and their stage-like archi-
tectural enframements are disconcerting, while the central personages,
Joachim and Anne in this case, assume rigid, ritualistic poses. Even
more distinctive is the specifically Hispanic setting of these paintings
all'antica, in the *Mudéjar* Sala Capitular of Toledo Cathedral.

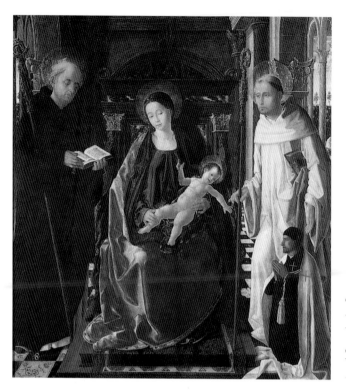

65 Paolo da San Leocadio,
*Madonna of the Knight of
Montesa, c.* 1485

66 (*right*) Fernando
Yáñez de la Almedina,
St Catherine, c. 1515

Valencia was early to receive Italian influences, often from the court of King Alfonso of Aragón in Naples. The unsigned canvas depicting the *Madonna of the Knight of Montesa*, formerly attributed to Rodrigo de Osona (*fl.* 1476–1484), is now considered to be the work of Paolo da San Leocadio (1447–*c.* 1520), an Emilian artist brought to Valencia in 1472. It recalls late Quattrocento art in its compositional balance and elaborately 'classical' architectural setting but closer inspection of the miniaturized donor figure, the uniformly wooden gestures, stiff draperies, startling colour, patterned background, and studied facial types nonetheless show the Italian's adoption of Spanish painting styles. In the work of Fernando Yáñez de la Almedina (*fl.* 1505–1536), also active in Valencia, influences from Raphael (his tapestry cartoons), and even from Leonardo can be felt; Yáñez was probably the 'Ferrando Spagnuolo' mentioned by Vasari as a collaborator on Leonardo's *Battle of Anghiari*. However, there is a peculiar spatial sense in Yáñez's work, which is often flattened like a painted stage set, and a nervous self-consciousness and psychological intensity quite

94

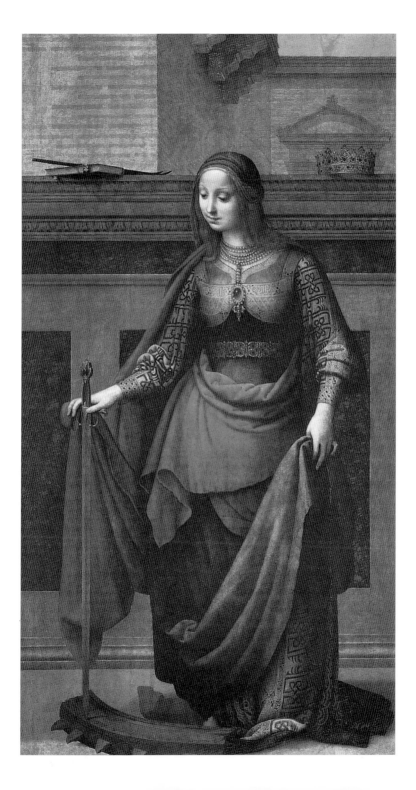

unknown in the works of his putative Italian models. The range of Yáñez's artistic ambitions appears in his famous *St Catherine* in the Prado. As before, the handling of the architecture resembles a stage set, in odd contrast to the curvilinear arabesques of the drapery designs. An anomalous *Mudéjar* detail is the inscription – in Arabic – carefully painted on Catherine's tunic.

Similar conflicts between deformative native religious expressionism and Italian idealism are seen in works by contemporary Spanish sculptors. Whereas their frequent (but inconsistent) use of monochrome marble as an artistic medium reveals their commitment to Roman precedent, the agonized postures and acute attention paid to the realistic definition of the wounds of martyred flesh point to native Spanish traditions. This conflict can be seen in the work of Diego de Siloé (*c.* 1495–1563) and Juan de Juni (*c.* 1507–1577). The anguished figure of *St Andrew* (*c.* 1519) by Bartolomé Ordóñez (d. 1520) is a Michelangelesque exercise in expressive *contrapposto*. Such anatomical deformation would later be taken to unparalleled extremes in the wooden sculpture of Alonso Berruguete.

67 Bartolomé Ordóñez, *St Andrew*, detail from the Tomb of Philip the Fair and Joanna the Mad, Capilla Real, Granada, *c.* 1519

In the second third of the sixteenth century, the beginnings of Mannerism in the Italian sense of the word *maniera*, the deliberate adoption of another's style, became apparent throughout Europe. By *c.* 1525 it was to become an international style, with local adaptations. International Mannerism is essentially post-artisanal and thus post-medieval; the emphasis is upon *idea*, art as an intellectual or theoretical activity. According to Francisco de Holanda (*Tractado de pintura antigua*, 1548), the art of painting now represented 'a declaration of thought in visible and contemplative creation'. Again, Valencian masters took the lead in Spain in appropriating a prestigious foreign manner. In the *Martyrdom of St Agnes* (*c.* 1535) by Vicente Masip (*c.* 1475–1550), an 68 artistic rhetoric derived from the later school of Raphael becomes apparent, with figure-crowding, spatial compression, deliberately confusing composition, unclear space and contorted postures; an attempt to stylize style itself is apparent here. In the work of Masip's son, Juan de Juanes (*c.* 1512–1579), a much calmer use of Italian models is evident, particularly in his monumental rendition of *The Last Supper* 69 (*c.* 1570) commissioned for the high altar of San Esteban in Valencia. At first sight, this might appear to resemble Marcantonio Raimondi's widely circulated print of Leonardo's famous mural of the *Last Supper* in Milan, but closer inspection suggests that the compositional pattern was instead borrowed by Juanes from Titian's *Last Supper*, earlier sent to Philip II and installed in the Escorial by 1564.

Nonetheless, a spatial sense typical of Italian masters such as Leonardo or Titian has been altered by an outsized vessel and basin prominently displayed in the foreground of Juanes's painting. These quasi-liturgical accessories detract from the essential narrative taking place in the middle plane and serve further to ornamentalize the pictorial ensemble. Juanes also departs from his Italian models' example by rejecting their theatrical treatment of the drama of Christ's denunciation. He chooses instead to concentrate upon a mystic revelation conveyed in the gesture of the Saviour's symbolic presentation of his flesh in the Eucharist. By focusing upon a disputed contemporary ritual issue, the elevation of the Host disparaged by Protestants, Juanes reveals himself to be a conscientious illustrator of contemporary Counter-Reformation polemics. Perhaps more successfully than most of his Spanish contemporaries, Juanes was able to adopt and intensify the external features of Italian classicism, and, in particular, its larger compositional formats. Nevertheless, in his greater religious – as opposed to strictly aesthetic and formalistic – liturgical concerns, he departed characteristically from his foreign stylistic sources.

68 Vicente Masip, *Martyrdom of St Agnes*, c. 1535

69 Juan de Juanes, *The Last Supper*, c. 1570

70 Pedro Machuca,
Deposition, before 1520

According to Roberto Longhi and other scholars, two Spaniards were instrumental in the creation of Mannerism within the High Renaissance style in Italy itself; in fact, they are cited as being the first non-Italians to employ that anti-classical style consistently. One of these we have already encountered as an imperial architect. In his panel of the *Deposition*, which perhaps dates from his Italian apprenticeship before 1520, Pedro Machuca employs complications of composition and gesture and a heightened use of chiaroscuro. His virtuoso displays of complicated figure groupings echo the extravagant taste of Florentine Mannerism at this time. While Machuca's sense of dramatic lighting appears precociously to announce the pronounced tenebrism (shadow-painting) of Caravaggio (which began around 1590), these effects, which do not conform to any logical or single light-source, are also found in the work of Italian Mannerists such as Rosso Fiorentino.

71 Alonso Berruguete, *Salome*, c. 1515

72 Alonso Berruguete, *Sacrifice of Isaac*, 1527

The other non-Italian initially to employ Mannerist techniques was Alonso Berruguete (1488–1561) who, primarily in his capacity as a sculptor, should be recognized as the greatest artist – other than El Greco – professionally active in sixteenth-century Spain. Berruguete might indeed be described as a Spanish Michelangelo, had the great Italian ever reverted to polychromed wood. Berruguete was in Italy from around 1504 to 1518, and was well known to Michelangelo, being mentioned on occasion in his correspondence; he is also cited five times by Vasari (as 'Alonso Spagnuolo'). A painting from his Italian period, the Uffizi *Salome* (c. 1515), reveals a religious, almost neurotic intensity unmatched by his Tuscan contemporaries and an innovative system of anatomical deformation. Whereas the Italian Mannerists calculated formal distortions of visual appearances precisely, Berruguete's

73 Luis de Morales, *Pietà*, *c.* 1570–80

convulsive internal rhythms pull the figures away from all references to the classical norm. It is possible to identify a more or less consistently logical use of Mannerist devices in Italy; Berruguete (possibly paralleled by the Italian Pontormo) manifests their consistently illogical, essentially emotionalized adaptation. He was to bring this expressionist innovation – actually a medieval reversion – back home with him to Spain.

Berruguete had in fact returned to Gothic canons of verticalism, elongated proportions, smoothly pneumatic surfaces, malleable anatomical distortions, spatial renunciations, intentionally otherworldly colour systems, and contorted spiritual expressionism. Although today he is primarily remembered for his unquestionably original wooden sculpture, it is as a painter that he was consistently noted in contemporary documents. As exemplified by his dramatic rendition of the *Sacrifice of Isaac*, part of the San Benito altarpiece, his approach to sculpture is indeed painterly. Expressive wooden figures with bright polychrome stucco veneers twist with flame-like movements, as though endeavouring to transcend the earthbound

limitations of form. In the writings of a contemporary mystic, St Teresa of Ávila, such flames illustrate her 'ardent' desire for spiritual union with God.

The emotionally distorted compositions of Berruguete were not unique in that time and place. In the work of Luis de Morales (*c.* 1510–1586), a mostly undocumented painter of provincial origins from Extremadura on the Portuguese border, an 'unaesthetic' type of ingenuous religious emotionalism is to be found. His fragile and melancholic *Pietà*, displayed against an inky, nearly airless background, is typical of his production, which is well represented in art collections outside Spain. In his own day, the expressive but sometimes saccharine work of Morales was very popular, as is proven by the many copies which survive of his imagery. Nonetheless, his ignorance of fresco technique did not endear him to Philip II who dismissed him in 1564 as 'old-fashioned'; Philip's informed taste favoured sophisticated Italian masters of the rank of Titian and Tintoretto. Although superficially influenced by Leonardo's smoky palette (the *sfumato* technique), which Morales probably knew from prints, his style remains essentially late Gothic. His boneless, heavily sentimentalized although often elegant, figures express an asceticism and mystic yearning rarely seen in Italy – or in Spain for that matter. The most plausible explanation for this is that Morales (perhaps as 'Morais') acquired his bizarre style during a youthful apprenticeship in nearby Portugal. He was working in Elvas in 1576, and his wife's maiden name, Chaves, is Portuguese. In extant paintings by Portuguese artists such as Nuno Gonçalves, Frei Carlos, Grão Vasco, Cristovão de Figueiredo and Gregorio Lopes, a Portuguese predilection for pathos-ridden expression, gloomy atmospheres, and limp, even amorphous forms is apparent. Portugal was always keen to remain culturally distinct from its more powerful and aggressive neighbour; these artists' works provide the closest formal parallels for Morales' mannerisms, which seem not very Spanish after all.

Spanish portraiture of this period represents a much more rigid and hieratic version of Italian Mannerism; the example of Agnolo Bronzino comes particularly to mind. In mood, these aristocratic icons mostly reflect the constraints upon leisure-class etiquette prescribed in Count Baldassare Castiglione's *Book of the Courtier* (1528). In Spain, where a notoriously chill social decorum was *de rigueur* at the Habsburg court, Castiglione's recommendation that an ambitious courtier should adopt a 'grave and sober' mien, that he should dress, 'if not in black, then at least some colour on the dark side' was closely adhered

74 Alonso Sánchez Coello, *Princess Isabel Clara Eugenia*, 1579

75 Antonius Mor van Dashorst, known as Antonio Moro, *Queen Mary Tudor*, 1554

to. Castiglione demands that 'our Courtier's dress will show that sobriety which the Spanish nation so much observes, since external things often bear witness to inner things'. The complex ceremony of the House of Burgundy was introduced to Spanish court life in 1548, and shortly afterwards a prime example of the approved representation of aristocratic etiquette in Habsburg Spain is found in a sombre court portrait by Antonius Mor van Dashorst (*c.* 1519–1575), who was known as 'Antonio Moro' to his Spanish clients. Mor's 1554 portrayal of *Queen Mary Tudor*, the second wife of Philip II, established a formula for ceremonial state portraits at the Spanish court, combining monumental scale with meticulously rendered even ornamental detail, hieratic stiffness of posture, sombre coloration and neutral, de-spatialized backgrounds. There was even a certain measure of psychological insight in Mor's portraits: the contemporary viewer perhaps took

103

Queen Mary's haughty stiffness and rather sour expression as a sign of saintly forbearance, whereas a modern viewer might recall her notorious inflexibility in matters of religious belief. Nonetheless, in all such official state portraits the individual sitters are of far less consequence than their elevated dynastic office and near-divine status. According to Luis Carrera de Córdoba, the monarch's portrait was an object 'worthy of absolute veneration'; like a holy icon, 'it was saluted with reverence'.

THE AGE OF PHILIP II

Although initially much influenced by the Dutch emigré Mor, later sixteenth-century court portraits commissioned during the long reign of Philip II, particularly those commissioned to decorate the Escorial, become emblematically Spanish in their autonomous formal peculiarities. In a prototypical rendering of *Princess Isabel Clara Eugenia* (1579) by Alonso Sánchez Coello (*c.* 1531–1588), poses remain rigid and ritualized, analysis of decorative details of costume and jewelry is almost microscopic and everything but the subject's facial features is given a flattened treatment. Interior settings are spaceless, and a taste for restrained, almost drab, coloration predominates. These exalted beings were seen thus in real life: in 1605, the court chronicler Sigüenza observed that, during a public appearance, 'the magnanimous Prince [Philip II] would make no movement nor manifest any sign of sentiment, which is a great privilege of the House of Austria; among other reasons, so as not to lose by any happenstance the serenity of his face nor the gravity due to the Empire'.

As built between 1563 and 1584 according to the wishes (and close supervision) of Philip II, the Escorial is the central Imperial icon, an austere and awe-inspiring monumental structure which simultaneously functions as a palace, a basilica, a monastery and a royal pantheon. Even though the ground plan is an immense rectangular grid with a great basilica at its heart, the immediate ideological precedent for its purist geometrical plan is the Palace of Charles V at Granada. The idea was germinating in Philip's mind long before he ascended the throne in 1556, and from the outset he planned it as a sepulchre-temple to the memory of his father, the Emperor-Architect of Universal Christendom. A building of enormous importance in the history of architecture, as early as 1594 it was dubbed 'the eighth wonder of the world'.

The ground plan was initially worked out by Juan Bautista de Toledo (d. 1567), who had worked with Michelangelo on the

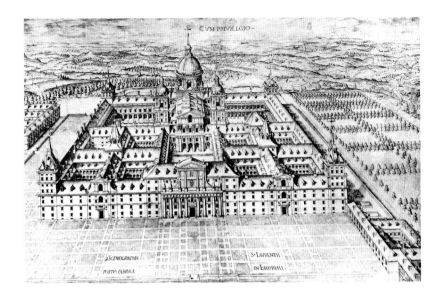

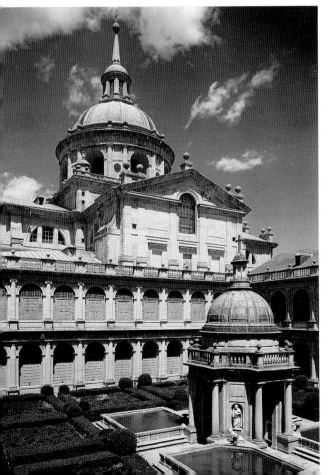

76 (*above*) Juan de Herrera, The Escorial, 1563–84, aerial view. Plate VII from Juan de Herrera, *Sumario*, 1587

77 (*left*) Juan de Herrera, The Patio de los Evangelistas at the Escorial, 1563–84

construction of St Peter's, Rome, but the elevations were the work of Juan de Herrera (1530–1597). They include massive towers with slate roofs in the traditional Flemish manner so beloved of King Philip. Construction of the great building was largely funded by revenues from the American colonies. Like the macrocosmic Empire itself, this architectural microcosm ideally expresses, as Sigüenza explains, 'a well-proportioned body of parts that assist and respond to each other', so constituting 'a whole of good measures and corresponding parts'. The result was the *estilo desornamentado*, an unadorned and mute, abstract style. Like Machuca before them, the architects of the Escorial favoured the Tuscan order and the primordial rhetoric associated with it, but saw no need to resort to any further figurative embellishment. On a scale never realized before, the Escorial is an exercise in pure geometry, as well as Christian metaphysics. Besides its role as a palace-pantheon, a residence for monarchs dead and alive, the Escorial was (and still is) an Augustinian monastery. Key Augustinian terms, embracing both visible form and transcendent meaning, are equality, harmony, congruence, concordance and correspondence. Echoing both Vitruvius and Augustine, Sigüenza says that the great beauty of this building 'is seen in how all its parts imitate one another...the whole is in all the parts'; always the key terms are reason and propor-

78, 79 Pompeo Leoni (*left*) Monument of Charles V and his Family; (*right*) Tomb of Philip II, 1591–8

tion. The rigorous visual style of the Escorial thus exemplifies its ideo-
logical framework: a specifically Christian, orthodox and truly
contemporary classicism with specific moral applications of purity.

As George Kubler, a historian of the Escorial, has remarked,
'Whenever a King builds, Solomon comes to mind'. So too does
Jerusalem, and indeed chroniclers of the Escorial refer to the building
complex as either 'Nueva Jerusalén' or 'Jerusalén Celestial', the 'City of
God' described by St Augustine. Philip II was himself named 'Rey de
Jerusalén'. A reference to Jerusalem is evident inside the Escorial and
re-creates the New Testament successor to the Temple of Solomon, the
Holy Sepulchre. As conceived by Herrera around 1576 and later
sculpted by Pompeo Leoni, two huge sepulchral monuments, depict-
ing the families of both Charles V and Philip II larger than life, are
placed on either side of the great basilica gazing towards the altar
much as Master Mateo had done at Santiago de Compostela centuries
before. The result, as Kubler notes, is to transform the sanctuary into
'a triptych, with lateral wings to contain orant figures including the
donor'; he also records a contemporary calling it a 'royal theatre and
split stage-setting'. A print published in 1589 under Herrera's supervi-
sion illustrates the entire, indissoluble and scenographic ensemble of
sculpture and architecture in the Capilla Mayor; it is fittingly entitled
Perspectiva. The vanishing point of all this Renaissance perspective is
the giant Custodia containing a mini-custodia, the receptacle for the
Host. This symbolic tabernacle is both the tomb of Christ and the site
of his Resurrection, the Anastasis. Sigüenza explained that the cult of
the Holy Sacrament was indeed the principal object for the 'piedad y
devoción' of Philip and his Escorial, and thus the Custodia on the high
altar was indeed 'the objective and centre of the whole edifice'. So, in
Spain at least, Renaissance perspective is shown to be as much spiritual
as it is geometrical.

THE MYSTICAL WORLD OF EL GRECO

The only Spanish painter of the sixteenth century to enjoy universal
fame today is Domenikos Theotokopoulos, known as El Greco, 'the
Greek' (1541–1614). He arrived in Spain when he was over thirty-five,
by which time he was already a mature artist in his own right. His
mentality was very different from that of his provincial Spanish col-
leagues. He was a true 'liberal artist', extremely well read and
thoroughly grounded in contemporary Mannerist art theory. He pos-
sessed a library attesting to his erudite tastes. Born in Khanià, the

capital of Crete, it was there that he was initially trained as an icon-painter in the non-classical mannerisms of a still-living Byzantine artistic tradition. Some time before 1568, he arrived in Venice, of which Crete was then a colony. He later spent two years in Rome and then returned to Venice, where he stayed until 1576. During his Venetian period he came under the influence of Titian and perhaps even studied with Tintoretto.

Although documentation of his Italian activities is sparse, the stylistic evidence of El Greco's work shows him acquiring from Titian both the 'grand' painterly manner and a taste for rich coloration and supple brushwork, and from Tintoretto a taste for Mannerist plays of flickering lights and darks and an equivocal use of perspective. During his Roman sojourn El Greco became acquainted with the prestigious work of Michelangelo, from which he absorbed ideas about the expressive power inherent to isolated but heroic figures with emphatic gestures locked in twisted poses and seemingly burdened by fate. Also to be learned in Rome was the current notion, stated in 1548 by Michelangelo's confidant, Francisco de Holanda, that 'Painting is, according to Tridentine Decrees, living scripture and doctrine for the unlettered.' So prepared, and seeking a lucrative court appointment, El Greco sailed to Spain, and is recorded in July 1577 working on commissions in Toledo.

In Spain he is mentioned first in the capital, Madrid, but only a couple of months later he took up residence in Toledo. He failed to win royal favour at the Escorial with his *Martyrdom of St Maurice and the Theban Legion*, a painting which nonetheless proves very appealing to twentieth-century taste, mostly because of its expressive brushwork, its colour scheme and its nervous agitation and self-consciousness. Philip II preferred the native qualities of narrative explicitness, unadorned emotional gravity and decorative reticence manifested in commissioned court portraits. According to regal tastes, a collective martyrdom fit for public display should not be in El Greco's emotionalized but bloodless style, but rather, as we shall see, the more naturalistic style of Navarrete. His professional ambitions momentarily frustrated, El Greco settled down in Toledo, where he was to reside until the end of his life. The absence of any established artistic convention in Toledo, and the lack of any serious professional competition, enabled him to pursue his own increasingly imaginative directions without the censure of local precedent. In Toledo he was reasonably successful, befriended distinguished ecclesiastics and scholars, and lived in aristocratic comfort.

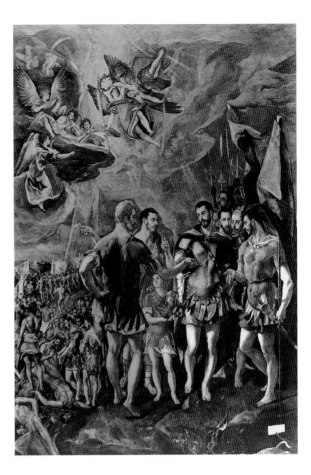

80 El Greco, *Martyrdom of St Maurice and the Theban Legion*, c. 1580–2

Recovered from the Muslims in 1065, Toledo, the original capital under the Visigoths, was again, until 1561, the political centre of Spain. Although the intellectual capital of the nation, when El Greco first knew the city it had become an economic backwater whose population was declining. Aristocratic and austerely ecclesiastical, its slumbering, provincial intensity proved congenial to the thoughtful Greek. His famous *View of Toledo* (c. 1610) belongs to a new Renaissance genre, the symbolic city-view; its sophisticated painter even borrows its chorographic details from contemporary cartography. Toledan architectural monuments are shown topographically displaced and disproportionately large. El Greco chose instead to present the eternal spiritual and historical face of the ancient Spanish capital,

81

the symbolic union of Church and State in Toledo, rather than to render exactly its mundane urban physiognomy. Contemporaries referred to Toledo as the 'Imperial City', a 'new Rome' and a 'new Jerusalem'.

El Greco shows the ancient capital under a dramatically lit sky, covered by cold green and blue storm clouds scudding above a tumbled landscape which itself seems rent. Eliminating two-thirds of the modern city from his composition, the artist shows us only the easternmost part of Toledo, dominated by its exaggerated heights and crowned with a royal palace, the Alcázar, of which we see only the more characteristic northern face. Placed on the metaphorical 'right' of the Alcázar (which represents the State or the Spanish Monarchy) is a complementary architectural symbol of the Church or ecclesiastical authority in Spain: the bell-tower of the Metropolitan Cathedral. In a topographically accurate scene, the Cathedral would have been placed so far to the right that it would have fallen outside the picture plane. At the bottom is the River Tagus, spanned by the Roman-built Alcántara Bridge, providing a classical pedigree for the ancient capital city. To the left ('right'), El Greco places another ecclesiastical symbol, a dreamlike apparition of buildings resting on a simulated cloud. Modern scholarship identifies this complex as the long-vanished Agaliense Monastery, where St Ildephonse, Visigothic patron saint of Toledo, took spiritual retreats. These were described in a book, *El glorioso doctor San Ildefonso* (1618), whose author, Pedro de Salazar de Mendoza, owned El Greco's *View of Toledo*.

In 1586, El Greco was commissioned to execute a representation of the *Burial of the Count of Orgaz*. This mystical work was placed in a chapel in the parochial church of Santo Tomé in Toledo. In this very church a miracle occurred during the burial of a fourteenth-century knight, Don Gonzalo Ruiz de Toledo, posthumously the Count of Orgaz: 'While the priests were preparing to bury him…St Stephen and St Augustine came down from the heavens and interred him with their very own hands.' The contract for the painting also survives; besides giving the text for the epitaph and describing the miracle, it stipulates that the artist must also depict 'a great many people placed around [Orgaz] and watching, and above all this there must be shown the heavens opening up in glory'.

Although the earthly aristocrats in the lower zone of the *Burial of the Count of Orgaz* clearly represent living Toledan contemporaries of El Greco, their exact identities have proven largely elusive. Nonetheless, according to an eyewitness writing in 1612, the locals liked to visit Santo Tomé to see those vivid portraits of their fellow citizens. Some

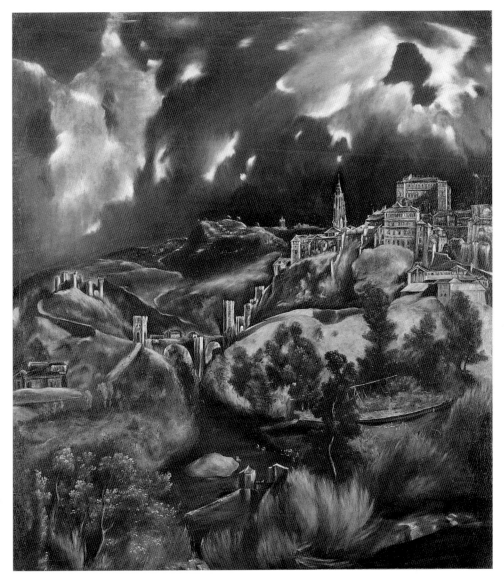

81 El Greco, *View of Toledo, c.* 1610

of the worthies are vaguely identified by their clothing as representative members of the three orders – Franciscans, Augustinians and Dominicans – who customarily attended the funerals of sixteenth-century grandees. Only two people look directly at the viewer. We know that the little boy, the artist's son, is Jorge Manuel Theotocópouli, bearing a kerchief with his father's signature; the cloth bears a date, 1578, the year of his birth. His graceful gesture, pointing to the exemplary burial, indicates the didactic function of the picture. A reddish-bearded gentleman whose head is directly above that of St Stephen and directly below the Virgin appears to be El Greco himself. The priest shown on the far right, who alone looks up towards the Gloria, must be the parish priest of Santo Tomé in 1586, Andrés Núñez de Madrid; he it was who ordered the picture from El Greco, a parishioner of the church. One other person has been securely identified in the earthly crowd: the humanist scholar Antonio de Covarrubias y Leiva, the elderly man in profile with a grey goatee aligned with Núñez's left arm, whom El Greco depicted in two other portraits.

The refulgent Gloria above the *Burial of the Count of Orgaz* – and any number of other Glorias unique to El Greco's painterly vision – corresponds strictly to the 'Celestial Hierarchy' described long before by Dionysius the Pseudo-Areopagite, a Greek author whose mystical writings were in El Greco's library. At the centre of El Greco's Gloria, we see the incandescent figure of Christ, with Mary next to him, clad in a phosphorescent, ruby-red robe surrounded by swirling clouds, blown about by mysterious winds and flashing with flickering lights. In contrast to the sombre, mostly black-and-white tonalities of the earthly zone of the *Burial of the Count of Orgaz*, the Gloria is lurid in its coloration: reds, yellows, greens, golds and silvers abound. All of these effects have their unique textual precedent in the Pseudo-Areopagite's mystical treatise.

83 One of El Greco's first works in Toledo, the *Holy Trinity* (*c.* 1577–9), destined for the *retablo* of the church of Santo Domingo el Antiguo, shows clear evidence of that 'modern style', a skilful Italian-learned blend of Venetian colourism and Michelangelesque sculptural anatomy, which still remained largely unavailable to native Spanish

84 artists. In the later *Agony in the Garden* (*c.* 1585), we can appreciate a reversion to Byzantine style which overcame the painter in Toledo and here produces an electrifying rendition unprecedented in either Spain or Italy. The illumination is distinctive and unsettling; a cold, lunar light bleaches out highlights on brilliant reds and blues which colour the robes of an oddly encapsulated Christ, figuratively removed from

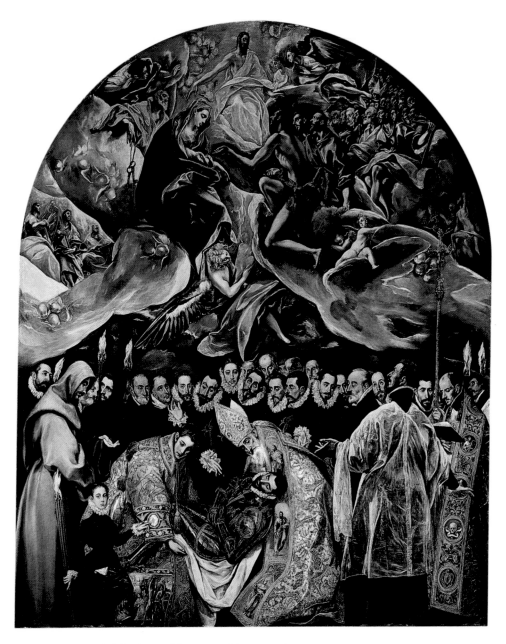

82 El Greco, *Burial of the Count of Orgaz, c.* 1586

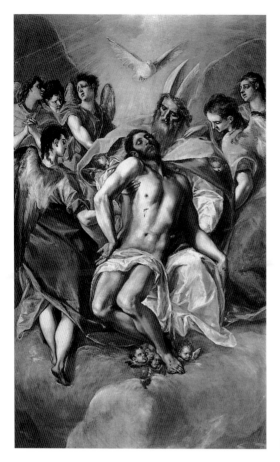

83 El Greco, *Holy Trinity*, c. 1577–9

distant, similarly encapsulated, writing apostles. A preference for harsh angularities over curves is apparent, reducing natural forms to abstract design features, and the composition is broken into unconnected colour fields, which have their own decorative significance, often in discordant relationships to adjacent areas. Spatial definition is deliberately ambiguous and landscape is reduced to a symbolic minimum. There is a marked absence of either foreshortening or superimposition and so the ground planes are deployed in a manner which defies both three-dimensional and narrative logic. The desire for an overall, pattern effect becomes obvious; the sharply delineated areas and short brush-strokes recall the tesserae used to make Byzantine mosaics. El Greco's feverish and undisguised brushwork, in which

priming can often be seen in marginal areas, reveals a consistently unfinished technique which marks the advent of a spontaneous *alla prima* method in Spain. Though criticized at the time, this approach was later to be employed to different ends by Velázquez and, to a more marked degree, by Goya. Also true to Byzantine and Spanish tradition is El Greco's use of painting as a vehicle for ideas rather than as an art for its own sake.

Two late works reveal how El Greco's unrestrained and unconventional search for the most personal spiritual statement led him to ever more revolutionary, anti-classical and anti-naturalistic creations. In these last visionary departures he also asserts his independence from Spanish pictorial traditions. His only known essay in classical mythology, the *Laocoön* (*c.* 1610), shows the noble priest and his martyred sons 85 strangled by serpents near Troy. The expatriate artist treats the subject of that well-known piece of Hellenistic statuary – a significant formal

84 El Greco, *Agony in the Garden, c.* 1585

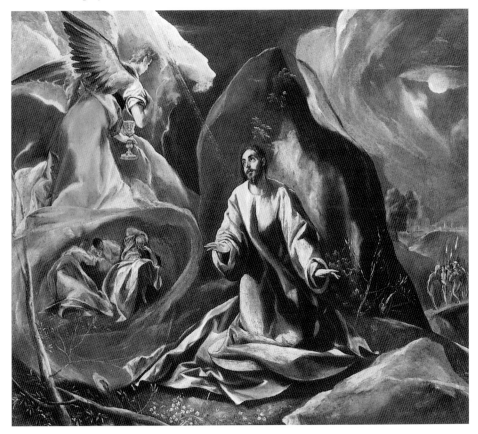

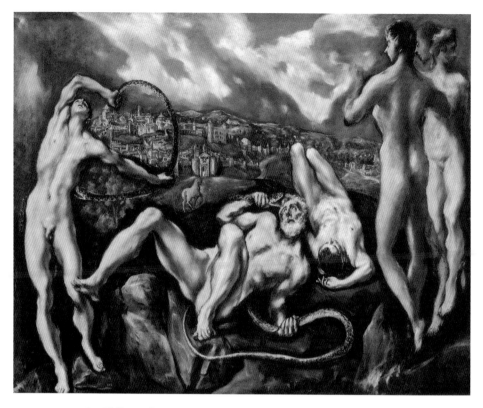

85 El Greco, *Laocoön, c.* 1610

86 (*right*) El Greco, *Adoration of the Shepherds, c.* 1613

influence for Alonso Berruguete, in addition to many of the Italian Mannerists, including Michelangelo – in a manner which almost caricatures the anatomical complexities and agonized postures shown in the original model. In El Greco's version, the stricken victims are shown dying in front of Toledo, bathed in a flickering, other-worldly light.

The singularity of El Greco's 'pagan-classical' subject matter in this work within his otherwise orthodox Catholic *œuvre* has long puzzled scholars. The simplest explanation is to examine the way that Laocoön was discussed in contemporary Counter-Reformation texts, some of which were actually in the painter's possession. Notable Italian writers on the new religious doctrines, such as Giovanni Andrea Gilio and

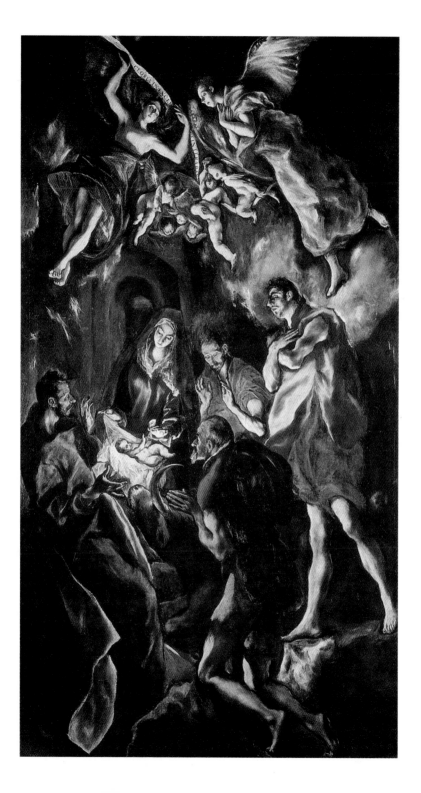

Antonio Possevino, referred to Laocoön's uncommon punishment as an exemplary 'model of pain', or a moral prototype of physical suffering. Accordingly, what they called anguish, pain and torment proved most fitting for depictions of the Passion of Christ and Martyr-Saints of the Church. Fittingly, the face of Laocoön is the same type that El Greco had employed for the *Repentance of St Peter*. Moreover, since local tradition had it that Toledo had been founded by descendants of the Trojans, Telamon and Brutus, just as Rome had been founded by Aeneas fleeing Troy, then a venerable Castilian 'nueva Roma' becomes a fitting setting for a Trojan martyrdom. Since we also know that El Greco's *Laocoön* was originally hung in the Alcázar in Madrid, we might suppose that it was originally commissioned for the spiritual edification of the Court.

86 Another late work, the *Adoration of the Shepherds* (c. 1613) – conceived for the artist's family chapel in Santo Domingo el Antiguo in Toledo and now in the Prado – is also characteristic of El Greco's extremist, hallucinatory approach. The noted Spanish philosopher and critic, José Ortega y Gasset, noted that these final works look alarmingly like 'a little matter ready to ignite'; Francisco Pacheco, however, felt that El Greco 'didn't know how to paint'. El Greco depicted the *Adoration* as a night scene, allowing himself to exploit a highly dramatized, intense and brilliantly coloured chiaroscuro; the light-source is in fact an incandescent Infant Jesus. Nina Ayala Mallory has observed acutely: 'Venetian technique is here taken to lengths that probably would have horrified Titian; El Greco's expressionistic handling of paint is comparable only to that of works painted in the late nineteenth century or in our own.' El Greco enjoyed a certain amount of posthumous prestige in artistic circles in central Castile until the middle of the seventeenth century, but, with the rise of naturalism and the marked aversion to Mannerism manifested in the Baroque period, his work fell into relative disfavour and eventual oblivion.

His reputation was first revived in France in the 1840s, when he was recast as a Romantic hero, an individualist and a rebel. His idiosyncrasy was only to be positively re-evaluated during the anti-naturalism of the Symbolist period, when he was hailed as a formal innovator and an audacious colourist. Early twentieth-century Expressionism led to a scholarly revival of interest in Mannerism in general, and in El Greco in particular; he was the first artist associated with Mannerism to be considered of major importance. The late Renaissance was afterwards interpreted in the anguished psychological terms pertaining to modern Expressionism. Later discussions of

Mannerism have, on the other hand, preferred formalistic interpretations, and so have placed much less emphasis upon the 'neurotic' element. Now the proper emphasis is placed upon Counter-Reformation orthodoxy: El Greco's contemporary content.

ART AND THE COUNTER-REFORMATION

With hindsight, we can begin to appreciate El Greco's distance from the essential qualities of Spanish art, and particularly those most characteristic of the later sixteenth century. This great exponent of Mannerism executed his most typically 'Expressionist' works after the Baroque style was well under way and was thus, in several ways, an anachronism. One can date the first evidence for a reaction against Mannerism to the middle of the sixteenth century in Italian and, particularly, Spanish painting. This proto-Baroque reaction against the overly intellectual, allegorical and anti-naturalistic complexities of Mannerist art has been called, logically enough, 'anti-Mannerism'. In its Italian phase, 'anti-Mannerism' may be properly thought of as a neo-Renaissance movement, but such a description would not altogether apply in the case of Spain, given that classical expression never really took root there. During the Council of Trent (1545–1563), in which the Spanish clergy exercised a major role, rulings were made which advocated a return to more traditional forms of art. According to Tridentine principles, art was to be moral and didactic in purpose. Clarity in subject matter, logic and order in narrative exposition, a classical sense of decorum, and dramatic effects encouraging the viewer's empathy and participation were actively encouraged. Works of art were henceforth to be 'salutary examples set before the eyes of the faithful'. Thus Mannerism was considered anathema as art was given a populist purpose and non-aristocratic inclinations. Operating as the visual component of the *propaganda fide*, paintings and sculptures were to be used to inform the illiterate.

Reform within Spanish painting was neither consistent nor universal. The Fleming, Pedro de Campaña (Pieter Kempeneer, 1503–1580), like his Italian contemporary Savoldo, intermingled Mannerist and proto-Baroque tendencies. Campaña's *Deposition* 87 (*c.* 1547) shows his artistic assimilation into his adopted culture with its earthen colorations and Andalusian ethnic types. A leader of the emerging Sevillian School, Campaña achieves a warm humanization with a credible spatial sense, and some striking pre-Caravaggio tenebrist effects. Compared with Machuca's work, his composition is more

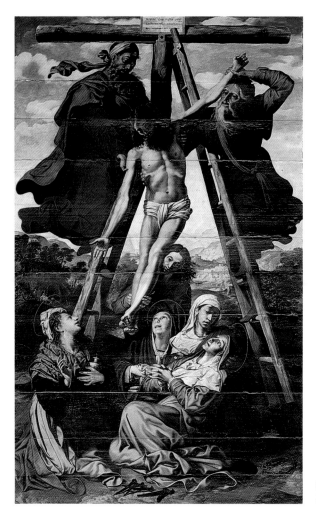

87 Pedro de Campaña,
Deposition, c. 1547

inclined towards the classical pyramidal mode. Another Sevillian, Luis de Vargas (1526–1568), treats similar subject matter in a tenderly characterized and monumental manner; his crowded figure groupings now seem decidedly 'popular' in type. Given such artistic precedents, it is not surprising that the Sevillian School was later to produce the Baroque warmth, naturalism and humanity of Velázquez and Murillo. The Valencian School, particularly as exemplified in the work of Juan de Juanes, also produced some notable 'anti-Mannerist' works.

Juan Fernández de Navarrete (*c.* 1520–1579), nicknamed 'El Mudo'

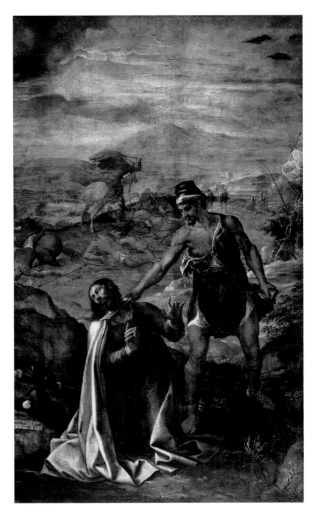

88 Juan Fernández de Navarrete (El Mudo), *Martyrdom of St James*, c. 1571

because of his deafness, was one of a group of court artists, including several Italians, associated with the decoration of the Escorial. An undeservedly forgotten figure, in his day he was considered the premier painter in Spain. Many important works by Titian in the royal collections were made available to Navarrete for close study, so that he could conform to the official taste of the Habsburg court. He became perhaps the first Spaniard to adopt consciously Venetian painterly techniques, employing intense colourism, monumentally scaled figures, and spatial settings with distant, atmospheric effects. Navarrete's

detailed and monumentally scaled depiction of the *Martyrdom of St*
88 *James* (*c.* 1571) concentrates with cruel objectivity upon the essential
incidents pertaining to martyrdom (as opposed to displays of merely
'artistic' effects). Accordingly, Sigüenza lauded Navarrete's 'devotional
images, before which you can pray and which actually inspire prayer',
a fundamental requirement of Counter-Reformation artistic policy.
In 1576, Navarrete was commissioned by Philip II to paint an exten-
sive series of altarpieces depicting paired saints which were to be
installed in the Basilica of the Escorial, where they may still be viewed.
By the time he died, only three years later, Navarrete had already com-
pleted eight large canvases portraying the four Evangelists and the
twelve Apostles. Typical of the technical quality distinguishing the
90 entire series is *St James and St Andrew*. In both his mastery of tech-
niques and his acute psychological awareness, Navarrete stands out as
the most progressive and accomplished of all the Italian and Spanish
court painters working at the Escorial.

Evidently impressed by the prestige by then posthumously
attached to Navarrete's Escorial commissions, several years later El
Greco was himself to embark upon a series of large-scale paired saints,
whose patron is not documented. They were probably a speculative
commercial venture, devotional pictures conforming to Navarrete's
format intended for monastic, perhaps even private, contemplation. El
91 Greco's boldly brushed *St Andrew and St Francis*, with its odd colour
discords, its stormy and unsettling sky, and the markedly elongated,
even emaciated, aspect given to the mutely gesticulating saints, differs
completely from Navarrete's painting. Also distinctive is an anachro-
nistic, or indecorous, aspect; El Greco's two saints belong to quite
different historical settings, one from the early Christian era, the other
from the thirteenth century.

Navarrete's weighty compositions aim for simplicity of effect and
narrative legibility, qualities quite distinct from some wholly secular
works commissioned at the time. For instance, his colleague in the
Escorial, Gaspar Becerra (1520–1568), is mainly remembered for his
Michelangelesque, late Mannerist frescoes, with pagan mythological
themes centred on the story of Perseus; reminiscent of the School of
Fontainebleau, these were produced around 1563 for the Pardo Palace
outside Madrid. Evidently paintings with profane content, admittedly
much rarer, were not subject to the same Counter-Reformation zeal.

The 'anti-Mannerist' movement in Spain has been discussed at
some length to recover the local cultural context motivating the work
of, for instance, Ribalta and Ribera, and the subsequent development

89 (*right*) Gaspar Becerra, *Danaë*, detail of a ceiling fresco-cycle in the Pardo Palace,
Madrid, *c.* 1563

90 Juan Fernández de Navarrete (El Mudo), *St James and St Andrew, c.* 1577

91 *(right)* El Greco, *St Andrew and St Francis, c.* 1590

of Baroque painting in Spain. This art-historical context demonstrates that later, and much better known, Golden Age artists had before them certain professionally approved models, alike in intent and mood if not stylistic particulars, which had arisen from a native 'anti-Mannerist' reaction. Additionally, we now understand the extrinsic causes – largely Tridentine recommendations and the authoritative example of an established court art – behind those prescriptions. At the Escorial, the officially imposed paragon of painterly correctness was Navarrete, who seems to be now as forgotten as El Greco is famous; he should be accorded his proper art-historical significance. By 1575, he had come to represent an institutionally sanctioned model for what would eventually evolve into the Baroque style. The irony in art history (as opposed to art appreciation) is that El Greco, a foreigner and a failed court painter with only a provincial clientele to support his increasingly heterodox artistic ambitions, has now become the archetypal Spanish artist of the Renaissance.

The National Style and the Golden Age of Spanish Art

Although the term 'Golden Age' (Siglo de Oro) was mostly used by later generations to refer to Spanish art of the sixteenth and early seventeenth centuries, as early as 1621 a court chronicler referred to a 'golden age which is for Spain the reign of the king our lord Philip IV', who ruled from 1621 to 1665. El Greco, Ribera, Zurbarán, Velázquez and Murillo are all now familiar names to art lovers. Before the mid-nineteenth century, however, only Murillo enjoyed any great fame outside Spain; an artist not always congenial to modern taste, it could be argued that Murillo is the most characteristically 'Baroque' of all Spanish artists. Figures whom we now consider the greatest Spanish Baroque painters – Ribera, Zurbarán, Velázquez – became well known only after 1838, when the Galerie Espagnole of the Louvre opened. This rediscovery of authentic Spanish art occurred during the Romantic period; its immediate effects on some European masters, particularly Manet, are well documented. El Greco's present fame was only to evolve some fifty years later, during the hermetic taste of the Symbolist era in European art and letters.

In the wider European perspective, the seventeenth century is now called the age of the Baroque, even though the term was an afterthought, first being employed in 1797 as *barroco* by an Italian Neoclassical theoretician, Francesco Milizia, in order to denigrate an anti-classical style. In Spain itself, the term *barroco* was not used until late in the nineteenth century. As Pierre Francastel remarked in 1951, 'Baroque is not born in Italy but is a consequence of the forceful penetration of certain religious forms that arrived from Spain and [is] . . . linked to the social order imposed by Hispanicization.' Given the political power exercised by the Habsburg Empire in the early seventeenth century (akin to the power of the United States in the second half of the twentieth century), how could it have been otherwise?

Especially in Spain, the term Baroque signifies an amplification of Counter-Reformation concerns, both religious and imperial; their artistic manifestation now becomes even more expressive and monumentally scaled. As contemporary writings attest, Baroque art was conceived as a thoroughly classical art, but we now recognize that this

92 Francisco Pacheco, *Immaculate Conception with Miguel Cid, c.* 1622

classicism is Imperial Roman, not Hellenic. Moreover, a trait shared by all European Baroque cultural expression is a common acknowledgment of a social purpose pertaining to all the arts, written or visual. In brief, the governing motto held that each medium should 'delight, instruct and move'. They should 'delight' their targeted audience with a virtuoso technical handling of artistic media and, once the attention is captured, the artist should 'instruct' the onlooker's intellect and thereby spiritually 'move' him to some desirable moral purpose. Perhaps more than most of their European contemporaries, Spanish artists zealously subscribed to this didactic strategy in their visual arts.

Antonio Palomino – in his *Parnaso español pintoresco laureado* (1724), a pioneering emulation of Giorgio Vasari's *Lives of the Artists* – describes the generation of Spanish artists born in the second half of the sixteenth century as creators of a forthcoming 'National Style' and equates this with an 'unornamented style', essentially a direct narrative

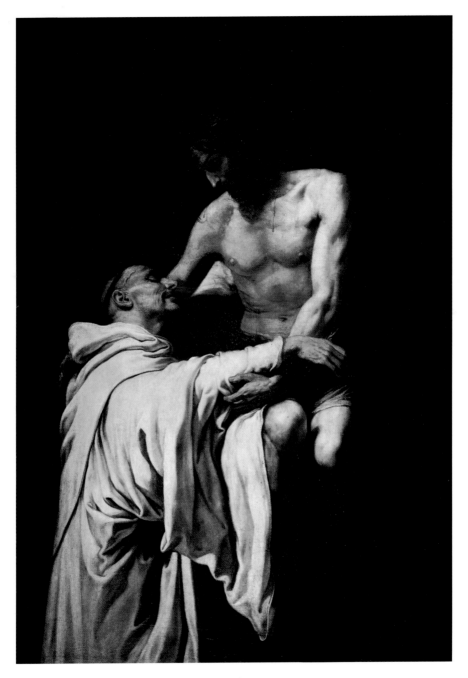

93 Francisco Ribalta, *Christ Embracing St Bernard*, c. 1622

94 Francisco Ribalta,
Vision of St Francis, c. 1620

exposition using unaffected naturalism. The terminology was first associated with the Escorial, whose chronicler, José de Sigüenza, had presented its imposing architectural style in 1605 as a paradigmatic Christian classicism, a primordial and reductive style purged of unnecessary ornament and thus able to express contemporary Catholic orthodoxy. The Sevillian painter Francisco Pacheco (1564–1644) whose influential *Art of Painting* was only published posthumously in 1649, revealed himself to be a true follower of the Tridentine rulings when he gravely announced that 'the ends of painting, in general, will be, by means of imitation, to represent a given subject with all the power and propriety possible...The principal goal [of the artist] will be to achieve a state of grace through the study and practice of this profession.'

Pacheco's canvases, though not particularly significant in themselves, stress plastic form and verisimilitude to further their devotional

purposes. A case in point is his emblematic depiction of an exemplary
92 Counter-Reformation subject, the *Immaculate Conception with Miguel
Cid*. In his *Art of Painting*, a treatise which oddly mixes both humanis-
tic and theological cultures, Pacheco fixed the iconography of the
Immaculate Conception into a stereotyped format which was to be
given its greatest popularity later by the more accomplished Murillo.
As is typical of Pacheco's rustic art, a stylistic dichotomy between ide-
alization and naturalism is manifested in different ways; Pacheco treats
the Immaculata, whose appearance corresponds to a heavenly appari-
tion, quite differently from the truncated figure of Miguel Cid, whose
verism is due to the fact that he is an earthbound donor. Even at this
late date, in Spain the aristocratic privilege of portraiture is only
extended to provincial personages if they show themselves to be pious
and generous donors. Pacheco's intention was doctrinal accuracy, *el
decoro*. As he affirmed, 'as all educated people know, this painting was
inspired by, and has all the characteristics of the mysterious woman
seen in the Heavens by Saint John', a reference to the ultimate textual
authority, the twelfth chapter of the Book of Revelations.

A realist rendering and an ethical content of transcendental ideal-
ism were successfully combined in the evolving National Style by
Francisco Ribalta (1565–1628). Later to be a major contributor to a
new, Baroque phase of the Valencian School, it appears that Ribalta's
actual training was in the Escorial, where he probably studied with
Navarrete. Ribalta's earliest known work, a *Crucifixion*, was signed in
Madrid in 1582. Some of his rare youthful works closely copy praise-
worthy compositions by the deaf court painter of the Escorial, to
whom Ribalta was particularly indebted for a sense of decorous pathos,
a rich Venetian chiaroscuro, and grandly scaled figures. The salutary
94 effect of these lessons is apparent in a mature work like his *Vision of St
Francis* (*c.* 1620), in which Francis physically embraces Christ, who ten-
derly places the crown of thorns on his head. Here the significant truth
that human psychology underlies religious ecstasy is revealed through
simple gestures and unaffected spiritual communication.

TOWARDS THE BAROQUE: FAITH AND VISION

This direct contact between god and mortal achieves more credibility
and an even greater psychological concentration in Ribalta's brightly
93 lit and snapshot-like *Christ Embracing St Bernard* (*c.* 1622). Since the
meaning once attached to the work is not immediately obvious to the
modern, secular viewer, some contemporary documentation is

required. In this case, Ribalta's emotionally affecting painting illustrates an account by Abbot Ménard, who was told by an eyewitness that when St Bernard was praying in a church, 'he prostrated himself upon the paving stones before the altar [and] the crucified Christ appeared to him. The blessed man worshipped Him and embraced Him fervently. And then the Divine Majesty detached his nailed arms from the cross and seemed to embrace the servant of God, clasping him to his bosom.' It seems probable, however, that this moving anecdote was directly relayed to Ribalta by a Spanish authority, Pedro de Ribadeneyra, who gives a similar account in his *Flos sanctorum* (1599).

Compositionally, the psychological effect was expressed by Ribalta with plain, monumental forms dramatized by coherently focused tenebrist illumination, lighting effects which had already become routine among Spanish painters sponsored by royal patronage at the Escorial. One need not look exclusively to Caravaggio to explain the advent of tenebrism in Spain. A spiritual chiaroscuro had long since been a staple of Spanish mystical texts. Their iconographic significance is also obvious; as St John of the Cross had stated, 'Faith, because the night is dark, gives light to the soul lying in darkness.' In the strictly formal sense, Ribalta's native art relied upon post-Tridentine naturalism. His imagery, and more particularly its composition, makes for an informative comparison with, for example, Berruguete's and Machuca's agitated paintings of a hundred years earlier, painted directly from Florentine Mannerist formats. Until the end of the sixteenth century, the visionary experience was not a common preoccupation of Spanish artists, but thereafter it became something of an obsession. El Greco, although largely restricted to a provincial clientele, was the early exponent of a new, ecstatic mode of portraying spiritual visions. Beginning with the Tridentine dictates, religious authorities began to exploit the visionary experience with increasing emphasis in the seventeenth century. Previously, such close encounters with divinity had been considered dangerous for allowing direct communication with the Sacred without an intermediary of the Church or priesthood.

According to St Thomas Aquinas, 'vision' embraces two possibilities: that which the eye perceives externally and that which the imagination may perceive internally. Pacheco expanded upon that thought as it related to his profession: 'Bodies that art can represent as elaborated by thought are the product of what the soul sees', and 'bodies that come from the mind are those that the imagination manufactures…in this last category we place the imaginary and spiritual

95 Juan de las Roelas, *Martyrdom of St Andrew*, c. 1609–13

visions perceived and described by the Prophets and which artists are in the habit of depicting.' In the case of a religious or 'privileged' vision, such as that experienced by a saint, the painting of the apparition, now institutionally sanctioned in the seventeenth century (although the precedent had been set in the sixteenth by St Teresa of Ávila among others), becomes a living testimony, a spiritual document. Ribalta's format, the opposite of El Greco's, puts the divine apparition upon the same physical plane as the human recipient, who may now even directly 'embrace' God in a literal sense. Heaven has been brought to earth, and vice versa. The spectator witnesses the privileged visionary, often a mere mortal becoming an intermediary of spiritual insight; he or she becomes the medium by which the transcendence is revealed to us, so making us equally 'privileged'.

In seventeenth-century Spanish terminology a lively dialectic between 'deception' (*engaño*) and the enlightened 'discovery of deception' (*desengaño*) was recognized; when confronted with the visionary experience, mundane Renaissance pictorial techniques, particularly scientific geometric perspective, often proved insufficient. The ecstatic visions of, for example, Zurbarán have often been criticized for their apparent lack of perspective, but that lacuna in no way signifies that it is being ignored, rather that its limitations have been superseded.

The Sevillian artist Juan de las Roelas (*c.* 1560–1625), sometimes known as the Spanish Veronese, exhibited 'proto-Baroque' characteristics in his monumental canvas, the *Martyrdom of St Andrew*. Such works established a large, dramatic but harmoniously composed scene densely populated by Andalusian ethnic types, tied together visually by a controlled use of bright colour and an *estilo vaporoso* (luminous manner). Thus, Roelas anticipated Murillo's better known atmospheric effects, and his popular genre groups. Francisco Herrera the Elder (*c.* 1590–*c.* 1656) was cited by Palomino as the major innovator of the unornamented National Style in Andalusia. Employing psychological verism and an impasted paint surface, Herrera exhibits his characteristic manner best in the solemn *St Bonaventura Received into the Franciscan Order* (1628). Also to be noted are signs of the national genius, a characteristic Hispanic taste for a spare narrative naturalism which represents an essentially anti-classical approach and is manifested in a

96 Francisco Herrera the Elder,
*St Bonaventura Received into the
Franciscan Order*, 1628

direct and passionate focus upon individual character – and its contextual significance – at the expense of both idealism and compositional resolution. Herrera's solidly modelled figures often look sculptural.

Documents attest that in Spain at that time sculpture, typically polychrome, was generally held in higher regard by the ecclesiastic authorities than painting. It was valued because it was 'real', literally three-dimensional, and properly 'decorous', in that it provided an exact simulacrum of divine apparitions. Given that most sculpture of this time in Spain was religious in theme and wholly conventionalized, tending to stick to a small repertoire of shared compositional formulas, it does not prove particularly congenial to modern taste, which tends to worship originality rather than transcendental divinity.

A representative example of this ubiquitous, and truly 'popular' (non-aristocratic) imagery, is the *Cristo de la Clemencia*, carved some time after 1603 by Juan Martínez Montañés (1568–1649), and now exhibited in Seville Cathedral silhouetted against a patterned, bright red silk hanging. Rendered with the formal equilibrium and anatomical fidelity of the Italian Renaissance, it is carefully carved from wood, not marble (typically as a piece of Spanish sculpture), over which coats of gesso were attached, so allowing meticulous applications of paint to simulate illusionistically a diversity of materials – flesh, blood, cloth, wood, thorns – whose textures the viewer could 'feel'. Finely crafted works such as this were hugely expensive, something undoubtedly appreciated by their sentient but mostly impoverished worshipping public. According to the contract, the sculptor's crucified Christ must be 'represented in such a way as to look [down] at anyone who might be praying at His feet, as though he were speaking to that person, lamenting the fact that He was suffering for the one praying to Him.' A similar response is evoked by the blood-stained, outstretched cadaver of the *Dead Christ* by Gregorio Fernández (*c.* 1566–1636) in the Capuchin Convent of El Pardo near Madrid, where the aghast viewer looks down upon a martyred Saviour with half open but sightless eyes.

Another type of three-dimensional Baroque imagery which was first made popular in Andalusia is *estofado*, 'quilted' sculpture. A prime example is the celebrated *Virgen de la Macarena* (*Nuestra Señora de la Esperanza*) attributed to the workshop of Pedro de Roldán (1624–1700). Found in the Church of San Gil in Seville, this is a famous and locally venerated image, especially worshipped by anxious bullfighters, who croon to her a popular ditty, 'La Macarena'. *Estofado* imagery designates wooden figures with literally 'incarnated' painted surfaces (*encarnación*) which also typically include clothing draped

134

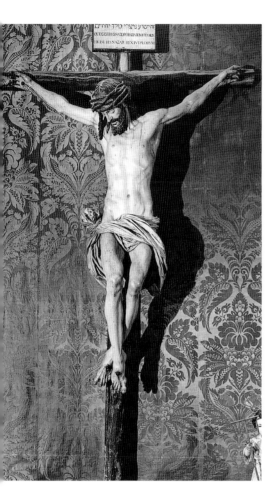

97 (*left*) Juan Martínez Montañés,
Cristo de la Clemencia, c. 1603

98 (*above*) Workshop of Pedro de Roldán,
Virgen de la Macarena, c. 1695

99 (*below*) Gregorio Fernández,
Dead Christ, 1605

upon the illusionistic idols. Some of these have movable limbs, glass eyes, real hair and changeable fashion accessories. Needless to say, this far exceeds the European art critics' canonical limits for sculptural media, but *estofado* sculptures belong to the realm of every-day reality, not to the otherworldly theoretical domain of 'art'.

THE MONASTIC ART OF ZURBARÁN

Revelations of pronounced quietistic impulses operating in early Spanish Baroque art are to be seen in the work of another, now celebrated, Sevillian painter, Francisco de Zurbarán (1598–1664). He was born in Extremadura, and although he died in Madrid, he spent most of his professional life in Seville, then the most populous city in Spain which derived great wealth from its near monopolistic trade with the Indies. Zurbarán's art is best described as monastic; it employs Hispanic veracity and earnestness to provide documentary, almost eyewitness, records of the solitude and inwardly directed spiritual passion of secluded monasteries. It is quietist inasmuch as it relates to a contemporary religious culture dedicated to an abstraction from worldly interests and exalting passive but intense contemplations of divinity. The particular intentions behind the quietist lifestyle are revealed in the *Spiritual Guide* (1675) by Miguel de Molinos: 'The soul gains more in prayer, in complete withdrawal of the senses, and in mental power than through penitent exercises, disciplines, etc. All this punishes only the *body*, but by withdrawal the *soul* is purified.'

Like the 'Expressionist' El Greco, Zurbarán is an artist whose reputation suffered a near-complete eclipse until the nineteenth century, when it was revived by modern art critics, albeit for wholly different reasons. The Romantics forged an enduring legend of Spain in the mid-nineteenth century, at precisely the time that Zurbarán was rediscovered by the French art critics. His uncompromising art was publicly acclaimed to be the perfect visual expression of the piety of Spanish culture of his day; thus the distinguishing features of 'authentic' Spanish art for nineteenth-century French *littérateurs* were uncompromising realism, religious intensity and material austerity. A century later, modern minds were impressed by Zurbarán's extreme concentration upon tangible form, something which verges on the surreal. These traits are brilliantly exemplified in Zurbarán's minutely detailed depiction of the *Apparition of the Crucified St Peter to St Peter Nolasco*, perhaps the finest of several canvases commissioned from Zurbarán in 1628 for the Convent of the Merced Calzada in Seville.

100 Francisco de Zurbarán, *Apparition of the Crucified St Peter to St Peter Nolasco*, c. 1630

Nailed to his cross, the Apostle Peter floats upside-down upon a phosphorescent orange cloud which emanates mysteriously from profound darkness. Kneeling in amazement and dramatically illuminated by a sudden burst of bright light, the white-robed Mercedarian saint sees a privileged vision of his namesake, so allowing the viewer the same privilege, an instance of spiritual 'enlightenment'. This exemplary image has nothing to do with modern Surrealism; the real impulse is 'spiritual realism', a literal transcription of uniquely perceived but culturally endorsed heavenly apparitions. As quotations drawn from contemporary texts demonstrated, any number of exact counterparts exist to Zurbarán's 'visions' in para-liturgical texts, publications which were widely read at all levels of Spanish society and today provide essential keys to decipher the meaning of much Golden Age painting.

Palomino said of Zurbarán's work, 'those who see it, and do not know it is a painting, believe it to be a work of sculpture'; an example to substantiate this observation is Zurbarán's quietistic, starkly sculptural rendition of the lonely and dramatically illuminated martyrdom

Frontispiece of *St Serapion*. Here a cropped, 'close-up' presentation, dramatically enhanced by a sudden flash-bulb illumination, anticipates modern tabloid photography. The emotional immediacy of this moving image may also be usefully compared with a later work of sculpture (*c.* 1663), now exhibited in Toledo Cathedral, by the Andalusian artist Pedro de Mena (1628–1688), whose work resembles Zurbarán's 'sculptural' figures. Mena chose to depict his *St Francis* standing prayerfully in the same frontalized pose that Zurbarán had earlier used in his *St Francis in his Tomb* (*c.* 1640), also with the saint's eyes locked upon some heavenly apparition known only to him. Bathed in light – spiritual illumination, a metaphorical element difficult for the sculptor to control unless he is also the designer of the architectural setting of the piece – Zurbarán's enraptured saint is both an ecstatic visionary and a paragon of humility, clothed in a worn and patched simple brown habit which covers his body except for his intently expectant face.

Both works illustrate the same grisly but profound subject. In order to prove the posthumous incorruptibility of the body of St Francis (*c.* 1181–1226; canonized in 1228), in 1449 Pope Nicholas V ordered his tomb in Assisi to be opened and, just as Pacheco stated in his book (which was probably known to Zurbarán), the saint's corpse was discovered, 'as if he were alive…in his tomb, standing up, feet apart, the soles well implanted.' According to eyewitnesses, Francis's hands were clasped together and covered by the wide sleeves of his woollen habit.

Such a simultaneous vision shared equally by sculptors and painters testifies to a homogeneity of artistic aim and explicit function which is rare outside Spain in the Baroque period: for example Alonso Cano (1601–1667), like Velázquez a pupil of Pacheco, was acclaimed as much for his polychrome sculpture as for his paintings. Zurbarán's figures are extremely (perhaps even literally) 'statuesque'; as a painter he also had means at his command foreign to the sculptor's art: controlled light effects, abstract colour patterns and two-dimensionality. Zurbarán often achieved his planarized, or specifically painterly, effects by using multiple vanishing points. Rather than dismissing this trait as mere ignorance of 'correct' or one-point perspective systems, Vicente Carducho informs us, in his *Diálogos de la pintura* (1633), that it is a consciously applied technique, 'a more appropriate method', used to re-create the dematerialized, gravity-defying world traditionally

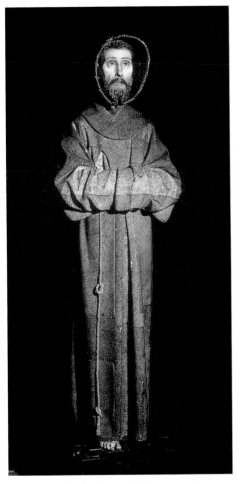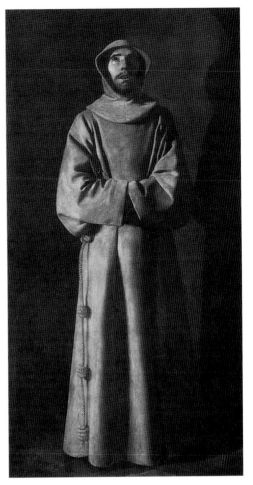

101 Pedro de Mena, *St Francis, c.* 1663

102 Francisco de Zurbarán, *St Francis in his Tomb, c.* 1640

belonging to the mystical experience. Whereas individual figures may have a real (or sculptural) presence, the unreal spatial arrangements of their environment express the transitory nature of this world which, contrasted to eternal spiritual verities, is but a temporary abode.

Zurbarán's late style was deflected from its characteristic sculptural yet 'de-spatialized' mode, perhaps because he tried to emulate the extremely popular types and *estilo vaporoso* of Murillo, the stylistic and

thematic antithesis of Zurbarán's early work. Nonetheless, Zurbarán's late manner, whether or not it is specifically 'Murillesque', works best with softer subject matter such as the Virgin and Child. This softening was not restricted to Seville; throughout Spain, the mood of religious art in the second half of the seventeenth century became less austere, more idealized and emotionalized, and more sensuous and gratifying to the educated eye. In short, after around 1640, Spanish art was absorbed into the international Baroque; thereafter the stark National Style fell into disfavour during a Golden Age which nostalgically celebrated former imperial glories.

The sacramental aspects of Zurbarán's art were even manifested in an apparently non-narrational category of painting: the still life. The Spanish name for this genre is *bodegón* (from *bodega*, storeroom or tavern) which refers in its larger sense to the representation of the common objects of daily life, frequently including edible items; if a *bodegón* contains figures it roughly corresponds to genre painting, with more or less explicit narrative content. Obviously, the term *bodegón* and its possible significance was elastic. Zurbarán's only signed *bodegón*, dated 1633, is a sober *Still Life with Lemons, Oranges and a Rose*. As is the case with his overtly religious compositions, which are generally rendered with crystalline clarity and illuminated by a sharply focused and raking light, his severely frontalized, sculpturally tangible objects emerge from an inky black background. The oranges and lemons almost function as regionalist emblems; citrus fruits were first grown in Europe in Islamic al-Andalus. Their choice was probably not accidental. Julián Gállego has pointed out that oranges are sometimes substituted for an apple held in the hand of the infant Jesus; a lemon, the standard symbol of fidelity in love, was often associated with the Virgin, as was a pink rose. Water itself symbolized spiritual life and salvation and, more particularly, the Virgin of the Immaculate Conception. A contemporary would almost certainly have understood this humble still life to be a pious offering to the Virgin.

'SIGNIFICANT SECRETS': THE STILL LIFE

Had Zurbarán so desired, then he could have escaped the onerous sales tax (*alcabala*) on his picture by explaining the potential symbolic significance of his objects. Alfonso Pérez Sánchez has recently recognized that, 'in a society so impregnated with the presence of religion and so moved by sermons in church, it would not be difficult for canvases conceived as simple imitation of Nature to be "read" and glossed as

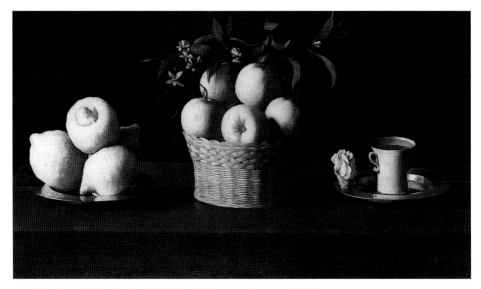

103 Francisco de Zurbarán, *Still Life with Lemons, Oranges and a Rose*, 1633

repositories of significant secrets at certain times and by determined glossarists.' The workings of this culturally ingrained, deciphering attitude are revealed in the aptly titled *Introducción al símbolo de la fe* (1583) by Friar Luis de Granada; a veritable encyclopedia of such poetic conceits is to be found in a widely read, later treatise by Baltasar Gracián, *Agudeza y arte de ingenio* of 1640. The Golden Age is the great age of 'élite erudition' (*culturanismo*) and 'conceptualism' (*el conceptismo*), and Gracián defines the *concepto* as 'an act of comprehension exposing the [hidden] correspondences existing between objects'.

The manner in which the Spanish artist was able to inject an intensity of expression and potential significance into material objects, characteristic in themselves of an innate sense of ascetic idealism, was earlier exemplified in the eloquent still-life compositions of a Carthusian monk, Juan Sánchez Cotán (1560–1627), which, in their bold concentration upon the tangible, parallel Zurbarán's later efforts. We may again suspect a symbolic intention; when he became a monk in 1603, Sánchez Cotán inventoried his 'eleven paintings of fruits, vegetables, birds and flowers', pointing out that these additionally constituted 'offerings to the Virgin'. Both Zurbarán and Sánchez Cotán employ a similar compositional formula: a black background silhouettes humble objects aligned frontally upon a shallow foreground plane, usually a

141

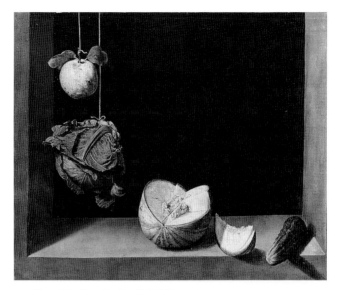

104 Juan Sánchez Cotán, *Still Life, c.* 1602

parapet. However, in his *bodegones*, Sánchez Cotán performs exercises in solid geometry and plane, with vegetables held in place by a parabolic curve, and perhaps even arranged upon principles which allude to musical harmony. A taste for the purity of abstract (and 'platonic') geometry and arithmetic became commonplace among the Spanish intelligentsia after the founding of the Academy of Mathematics in 1582 by the architect of the Escorial, Juan de Herrera. A similar fascination with proportionate relationships as the interpretive key to all genuine art is found in an illustrated manual, Juan de Arfe's *De varia comensuración* (1585), which appears in the inventories of nearly every Spanish artisan. As defined by Vitruvius for architecture and Boëthius for music, geometry – with symmetry and proportionality – represented the royal road to classical theory. As defined at the Escorial by Philip II and Herrera, geometric proportionality points in addition to profound Christian verities. Doubtless Sánchez Cotán's painting was influenced by the strong Augustinian precepts embodied within that building complex. This painting was probably one of those veiled 'offerings to the Virgin' inventoried in 1603; the Virgin was frequently called a *fenestra coeli*, a 'window to heaven', one who also provides 'spiritual food' to needful believers.

142

José (Jusepe) de Ribera, Il Spagnoletto (1591–1652), was noted by his countrymen for the impact he made upon Italian art. His reversal of the normal flow of influences indicates the appropriateness of certain areas of the Spanish temperament to European Baroque taste. We have seen how since the fifteenth century Italian influences had customarily entered Spain from Naples via Valencia; now with Ribera an Iberian influence was to leave a lasting mark upon Neapolitan painting and Italian Baroque art. Born in Játiva (Valencia), Ribera studied in the provincial capital although not, apparently, with Ribalta. When he was around twenty, he went to Italy and is documented living in Rome in 1615. A year later, he settled in Naples, where he died in 1652 after enjoying much fame and many honours in his adopted country. Naples, of course, was ruled by Spanish viceroys, and had been since 1442; in effect, Ribera had chosen to settle in Philip IV's easternmost province.

The distinguishing formal attributes of Ribera's art are gestural expressiveness, supple brushwork, a realism in the depiction of textures and volumes, intense chiaroscuro, and psychological acuity. As is aptly illustrated by his spiritual portrait of an emaciated *St Andrew*, whom he 105 portrays with historical accuracy as a poor and aged fisherman with hands deformed by hard labour, the psychology associated with an often painful asceticism and solitary meditation is defined by a pictorial system grounded in personal particulars. For us, Andrew becomes a living presence; touched by God, his spiritual grandeur raises him above his physical decrepitude. Like Zurbarán, Ribera strove to suppress narrative superfluity by concentrating action, reducing backgrounds to a stage-like minimum and employing light in a spotlight-like focus. Ribera's technique is much more painterly than Zurbarán's. Ribera worked quickly, in the *alla prima* manner, employing a loaded brush to create a corrugated, extremely tactile and literally sculptural surface. Tangible signs of agony and suffering are etched into the dried, cracked skin of the world-weary, the aged and the martyred.

In Ribera's celebrated depiction of a passionate surrender to God's will, the *Martyrdom of St Philip* (1639), the tortured saint's gaunt yet 107 powerful body is brutally inserted into a composition otherwise regulated by lucid geometry and classical balance, and described in every detail: hair, skin, and every muscle and sinew. There is also detailed psychological description; the various attitudes of the spectators express a

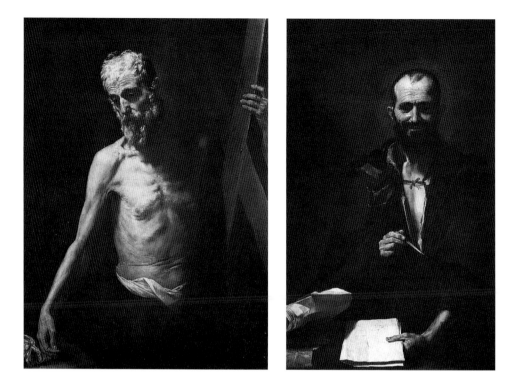

complete range of possible emotional reactions: compassion, curiosity, melancholic resignation, even indifference. Innovative scenographic characteristics include a limited depth in the pictorial space and the employment of contrasting diagonal accents in a scene which is brilliantly illuminated by daylight, rather than set in the crepuscular darkness of a painter's studio. These compositional traits later appear in paintings by Francisco Goya where they enhance similar dramatic intentions.

Jusepe Martínez, in his *Discursos practicables del nobilísimo arte de la pintura* (c. 1675), lauded Ribera as 'a close imitator of nature'. This mimetic instinct becomes particularly significant in his naturalistic treatment of mythological subjects, vital themes in classicistic Italian art. But Ribera was wont to treat the Olympians and other antiquarian subjects, Bacchus especially, with a rather disrespectful, mock realism. Such an approach, 'euhemerism', a secularization of once idolized pagan gods into mere mortals, is a characteristic trait of Velázquez's mythologies as well as those of most of his Iberian compatriots. In a

144

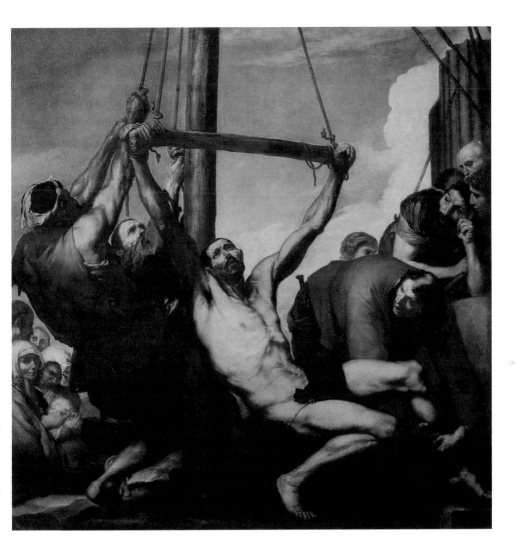

105 (*far left*) José de Ribera, *St Andrew, c.* 1632

106 (*left*) José de Ribera, *Archimedes*, 1630

107 (*above*) José de Ribera, *Martyrdom of St Philip*, 1639

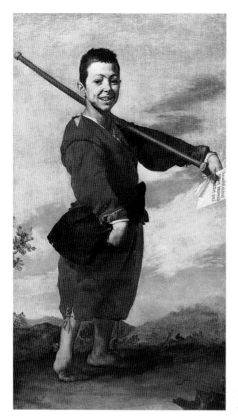

108 José de Ribera,
Boy with a Club Foot, 1652

106 like vein, Ribera's historical depiction of *Archimedes*, a revered geome-
ter with compass in hand and folios, treats him as though he were a
ragged beggar snatched from one of the teeming alleys of Naples. But
so ambiguous is his ironic expression, unbefitting an ancient scientist,
that some scholars think the bearded sceptic might instead be the cyn-
ical classical thinker Democritus, popularly known as 'the Laughing
Philosopher'. Whoever he is, his presentation departs drastically from
the Renaissance norm of idealized portraits of philosophers.

 Hispanic psychological realism – a 'picaresque' characterization – is
usually directly taken from life and based upon a keen sympathy for
the individual, regardless of his social station, particular foibles or phys-
ical disfiguration. Such is the case with Ribera's *Boy with a Club Foot*.
The counterparts to this hardy lad in Spanish literature are legion,

from the anonymous *Lazarillo de Tormes* (1554) to Cervantes' *Don Quijote* (1605). As depicted by Ribera, the crippled and ragged boy gallantly marches with his crutch through a sunny landscape and greets the passer-by with a cheerful smile. That there is a moral message to be conveyed here is shown by a paper he displays with a Latin text: 'Give me alms for the love of God.' Hence the picture's message is one of charity; the club-footed boy expounds the value of poverty itself as one of the paths leading to redemption and points to the function of the needy in the salvation of the Christian soul. That generic *alma cristiana* becomes the viewer's, who can thus partake of redemption and salvation through this monumentally presented reminder of his charitable obligations.

The stylistic changes within Ribera's painting demonstrate how he and his Spanish contemporaries echo different periods or generations within the larger development of the Baroque style. From 1620 to 1635, Ribera employed a harsh tenebrist style. The next five years saw a lighter, more transparent use of colour and more gentle, suave brushwork. From 1640 to 1655, Ribera's modelling became yet more fluid and individual details were relinquished in favour of monumental effects. His subject matter became calmer and lighter in mood and his colours silvery and vaporous. These formal mutations correspond neatly to those associated with the early, high, and late international Baroque styles.

VELÁZQUEZ: THE HIGH WATERMARK OF SPANISH PAINTING

The work of Diego Rodriguez de Silva Velázquez (1599–1660) is universally recognized today as the high watermark of Spanish painting. Virtually unknown outside Spain for two centuries, Velázquez was to become especially valued in the later nineteenth century, particularly by Impressionist critics, as a master of optical illusionism. Although a contemporary of Zurbarán, Velázquez was quite different: a born aristocrat, he became a worldly and well-educated courtier, and eventually the intimate associate of rulers and pontiffs. And yet between the two – the court favourite and the provincial monastic – there is, for all their stylistic and social differences, a close spiritual kinship. Their art employs an anti-idealistic emphasis on individual dignity and inner awareness, contemplative sobriety, meticulous craftsmanship and intense narrative focus. Further, they both exemplify that democratic outlook (though not in any strictly political sense) which is a hallmark of Spanish society: the Spaniard feels that he can address

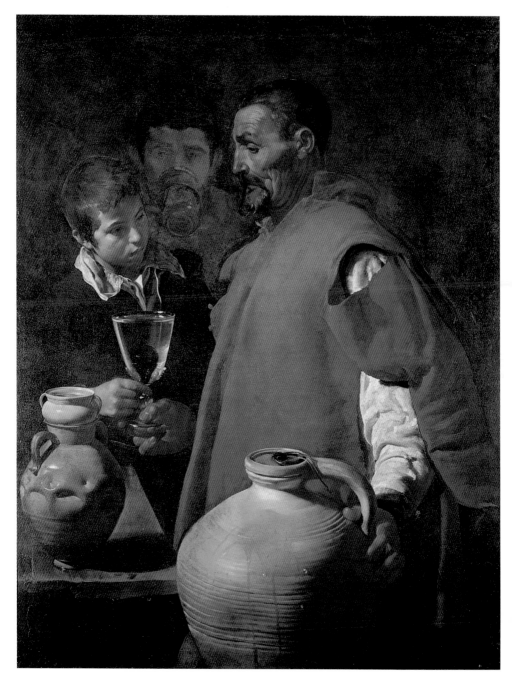

109 Diego Velázquez, *Waterseller of Seville, c.* 1619

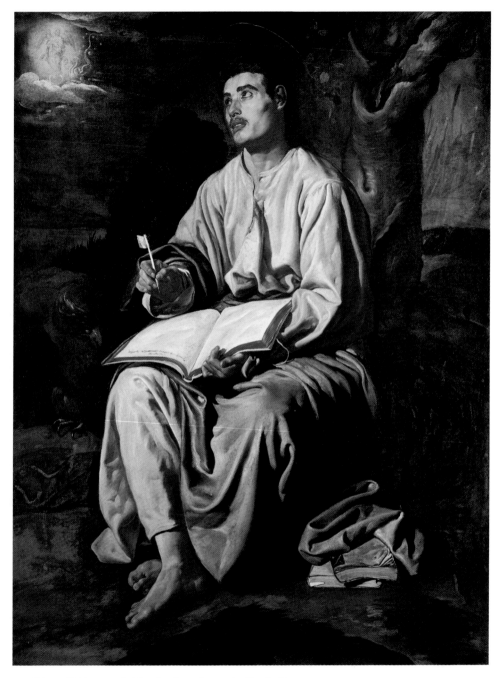

110 Diego Velázquez, *St John the Evangelist on the Island of Patmos, c.* 1618

either king or Christ himself on intimate and direct terms. This preference for unaffected empathy and direct psychological projection has often made the artificial distance imposed by the canons of idealized art difficult for Spanish artists to understand. The mature Velázquez learned to reconcile both mentalities.

Velázquez's parents, originally from Portugal, had settled in Seville. At the age of eleven, possibly after a brief apprenticeship with Herrera the Elder, he moved into the studio of Francisco Pacheco, who was later to become his father-in-law. Here he was introduced into a learned artistic circle, a quasi-academy, and thus at an early age became thoroughly conversant with current artistic theory and humanist thought. In *El Museo pictórico* (1724), his biographer Antonio Palomino remarked upon Velázquez's studious preparations and exceptional erudition: 'He read Albrecht Dürer on the proportions of the human body; Andrea Vesalius on anatomy; Giovanni Battista della Porta on physiognomy; Daniele Barbaro on perspective; Euclid on geometry; Moya on arithmetic; Vitruvius, Vignola, and other authors on architecture. Like a bee, he carefully selected what suited his needs and would benefit posterity. On the nobility of painting he looked at the treatise of Romano Alberti…he worked out his *idea della bellezza* with the help of Federico Zuccaro…Vasari inspired him with his *Lives of Famous Painters* and Borghini's *Il Riposo* described how to be a learned painter. He completed his education by reading the Bible and ancient classics and other important things, thus fertilizing his mind with erudition and wide knowledge of the arts.' Velázquez was not merely an incomparable technician or a superb observer of the world but was also always a profound thinker; current scholarship increasingly reveals the measure of the intellectual content propelling his unique approach to the art of painting.

Consummate erudition was expected from an artist working for such lofty patrons as the Habsburg monarchs. Velázquez first learned about the idea of the scholarly, and thus subtle, artist from his master Pacheco, who told him (and his other readers) that 'artists should know, and not superficially, humanistic letters, and even divine ones, in order to ascertain the manner in which they must paint the things that are offered to them'. Velázquez's early period is characterized by naturalist and tenebrist interests, as seen in carefully composed and rendered genre studies such as the *Waterseller of Seville*, painted towards 1619. Three carefully differentiated figures — a youth, a mature individual, and an old man — emerge from inky darkness into bright light in order to share in an almost liturgical fashion a glass of water

109

contained in a most un-proletarian crystalline goblet. Although at first glance it may seem merely an exercise in the precise depiction of physical particulars, this superb composition has been identified by Leo Steinberg as an emblematic representation of the familiar secular allegory, 'The Three Ages of Man'.

In overtly religious matters, the early tenebrist manner finds its eloquent application in the impressive *St John the Evangelist on the Island of Patmos*, which, in the terminology of the time, could be called a *bodegón a lo divino*. As it was originally viewed in the church of the Carmelites in Seville, this picture was flanked by a Pacheco-like rendering of the *Immaculate Conception*, the actual content of John's vision, today in the National Gallery in London. The viewer witnesses the interruption of the writing of a sacred and authoritative text by a collateral vision. Pen poised as he is suddenly seized with inspiration, the Evangelist occupies almost the entire composition; his vision is relegated to an extremity. A phosphorescent apparition of the woman 'dressed in the sun' attacked by the seven-headed serpent emerges on the upper left of the painting.

In the spring of 1623 Velázquez was given an opportunity which was to change the course of his career from that of a provincial painter in Seville into that of an artist of world standing. A fellow Sevillian, Don Gaspar de Guzmán, Count-Duke of Olivares, secured a court appointment for the talented youth. Thus he became acquainted with the then nineteen-year-old Philip IV, who was to become his lifelong friend and protector. By 1625, Velázquez's professional star was firmly in the ascendant. In late 1628, the Flemish master Peter Paul Rubens (1577–1640) arrived in Madrid on a diplomatic mission and Velázquez was privileged enough to share his studio for eight months. The Spaniard's unusual interpretation of the *Triumph of Bacchus* represents, at least in the formal sense, an unmistakable response to the solidly modelled, brightly lit, and humanistically informed paintings of Rubens. The Fleming further encouraged the young Velázquez to broaden his cultural and artistic horizons by going to Rome, the most significant artistic centre of the moment. In Italy from 1629 to 1631, Velázquez familiarized himself equally with the expansive Venetian 'painterly' manner and the Roman 'sculptural' sense of harmonious and varied figure composition.

In a series of dour court portraits painted at regular intervals, Velázquez was to record the gradually eroding appearance of Philip IV from his youth until his dotage. Compared with earlier Spanish court portraiture, this is a much more subtle way of presenting the royal

112 Diego Velázquez, *The Surrender of Breda (Las Lanzas)*, 1634

icon. Throughout the series, Velázquez set the King against a neutral
dark background, standing him upon a tilted floor-plane and giving
him greater three-dimensional presence by means of raking shadow.
However, in a later example, dating from around 1635, colour has
increasingly come to the forefront. The monarch is dressed in a brown
and white costume shining with silver-thread embroidery, a colourist
effect enhanced by a ruby drapery in the background and a scarlet
tablecloth. The brush-strokes suggest rather than meticulously
describe, dissolving into amorphous colourist fragments close up but
becoming illusionistic textures from a distance; as Gracián put it, we
are optically performing the 'act of comprehension'. In this case, as in

111 *(left)* Diego Velázquez, *Philip IV in Brown and Silver, c.* 1635

many other 'Impressionist' renderings by Velázquez, the tyranny of drawing (*disegno*) imposed by Renaissance and Mannerist art theory is decisively overturned in favour of colour and optical suggestiveness. The larger meaning of such portraiture in its courtly context is clear; according to the court painter Vicente Carducho, 'portraits of great men are like idols made for worship', and 'majesty' is itself 'divinity'. But such ideas were by then essentially an international common-place, and Carducho acknowledges his dependence upon Italian art treatises, especially Giovanni Paolo Lomazzo's *Trattato dell'arte* (1584).

112 Three or four years after his return from Italy Velázquez executed *The Surrender of Breda* (*Las Lanzas*) which synthesizes much of what he had learned from both Rubens and his studies abroad. Painted in 1634, it was to be the centrepiece of a cycle of dynastic portraits and twelve battle paintings to celebrate recent imperial victories commissioned for the Hall of Realms attached to the Buen Retiro Palace in Madrid. In a dignified, graceful and yet spectacular fashion, it deals with the surrender of the Dutch city of Breda, following a long siege in 1625. The narrative action is enhanced by an expansive landscape and con-centrates upon the chivalry of a victorious Spanish commander, displayed in the Genoese general Ambrosio de Spínola's gracious acceptance, from the defeated Justin of Nassau, of the keys to the fortress. A 'moral' characterization is achieved by purely formal means: a disciplined bank of Spanish lances (*las lanzas*) and the calm, compact ranks of the victors, neatly boxed by a *repoussoir* device, the horse. Hispanic order contrasts with the irregular, undisciplined silhouettes of a loosely composed and spottily lit knot of defeated Dutchmen. The painting's distinguished artistic treatment is complemented by a subtle underlying chivalric programme; the combination is one of the most impressive historical re-creations ever committed to canvas.

114 Another well-known example of court portraiture from Velázquez's earlier period is the *Equestrian Portrait of the Count-Duke of Olivares*. The equestrian genre was a standard vehicle for broadcasting political messages throughout Europe in the Baroque period; the domineering rider was to be seen as a ruler while his leaping mount stood for a recalcitrant people, untamed and thus needing a generous but informed application of reins and spurs. Velázquez's ambitious work derives much from an esteemed work in the royal collections, Titian's mounted *Charles V at the Battle of Mühlberg* (1548, now in the Prado) but is ultimately based upon the famous ancient Roman bronze equestrian statue of Marcus Aurelius placed on the Campi-doglio by Michelangelo. Certain changes in the composition of the

regal rider depart from Titian's standard arrangement, but it would be wrong to suppose that Velázquez was obliged to use a difficult and oblique pose to disguise the subject's notorious obesity. Instead, his immediate pictorial model was a moralizing print contained in one of the later editions of Andrea Alciati's widely consulted *Liber Emblemata* (*Book of Emblems*, first published in 1531), a work perhaps more popular in Spain than elsewhere. Many Spanish scholars have published studies showing in detail how Golden Age pictorial culture adapted itself so well to emblematic imagery. The print and Velázquez's equestrian portrait (for both images are exactly similar in the twisted poses of both the rearing horse and its masterful rider) characterize the imperiously mounted Olivares as 'He Who Remains Ignorant of Flattery' (*In adulari nescientem*, the title of Alciati's 35th emblem). That would be, of course, a most fitting and flattering compliment to a dedicated and presumably incorruptible prime minister.

In the realm of court portraiture, Velázquez is also noted for his sympathetic treatment of fools, dwarfs and buffoons. In his near-clinical analyses, he shows an impressive ability to capture likeness, mood and movement, and also a unique degree of compassion. A particularly

113 Diego Velázquez, *The Court Fool Calabacillas*, c. 1638

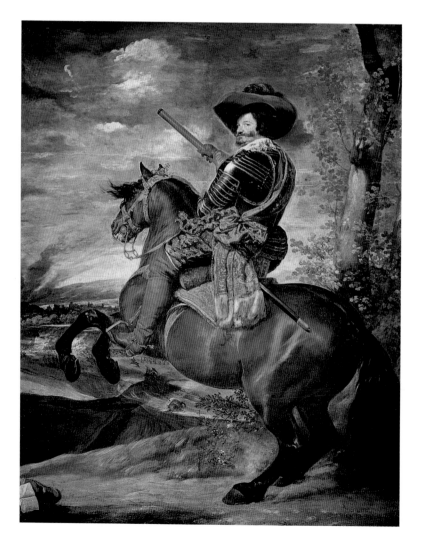

striking example of this genre is the empathetic portrait of *The Court Fool Calabacillas*, surrounded by his eponymous calabashes. Well before the advent of modern psychological sciences, this is an exceptionally accurate clinical study of autism: captured by painterly virtuosity, the dwarf's eyes swim sightless in their sockets as he wrings his hands mindlessly and endlessly.

The celebrated *Feast of Bacchus* (*Los Borrachos*), with its overtly classical-mythological content, opens the issue of the painter's relation to humanistic literature. This canvas is usually cited as an example of Velázquez's lifelong and almost sceptical attitude towards mythology, a trait, as we have seen in the contemporaneous case of Ribera, which

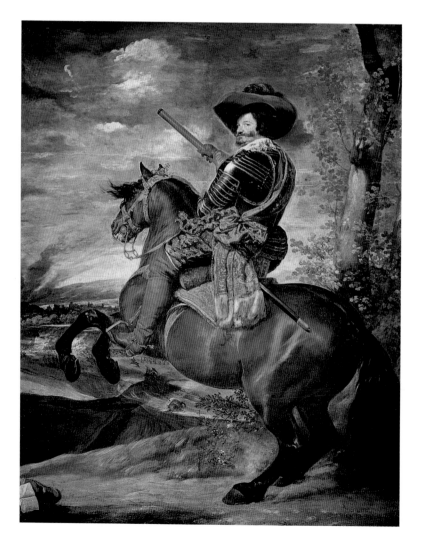

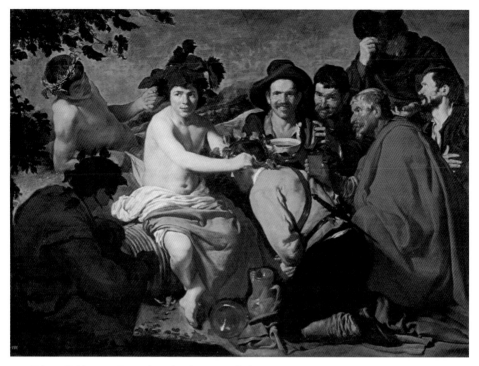

115 Diego Velázquez, *Feast of Bacchus* (*Los Borrachos*), 1629

had various precedents in native traditions. The meanings of these mythological pictures are best explained by books known to have belonged to the painter. Particularly important is Juan Pérez de Moya's *Filosofía secreta* (first published in 1585), an odd exegesis on Ovid's *Metamorphoses*. Moya's elaborately detailed mythographic manual provided a self-acknowledged and allegorized reading of all the familiar pagan fables. According to this standard interpretive practice, a euhemerism shared by many other mythographers and poets of the time, myths were considered to be grounded in 'real' historical fact. The pagan gods were thought to be mortals who eventually became opportunistically elevated to symbolic status as gods in order to illustrate allegorically various significant moral and even religious ideas. Moya tells us that Bacchus should be read as wine, like the Eucharistic sacrament (an idea popularized by Berchorius), a divine gift brought to humble folk to alleviate their fatigues.

114 (*left*) Diego Velázquez, *Equestrian Portrait of the Count-Duke of Olivares, c.* 1633

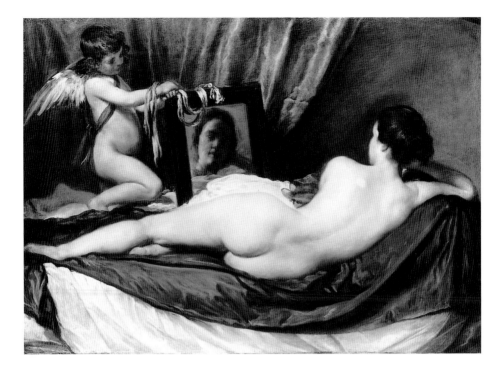

The euhemerist tradition also helps to explain the famous, but otherwise anomalous, 'Rokeby Venus' which was painted around 1647, evidently for the Marquis del Carpio. Technically, it is an artistic *tour de force*; a glowing meditation on diaphanous rose-and-pearl tinted flesh, it exhibits a remarkably graceful *contrapposto* and subtle allusions to a physical beauty too potent to be viewed other than obliquely, in a mirror. In Spain at this time, paintings of the female nude are rare indeed, occurring mostly in a sanctioned scriptural context. This lusciously rendered *Toilet of Venus* is the only one of a quartet of paintings of Venus by Velázquez to have survived. Venus, whose looking-glass is supported by her son Cupid, conforms to the description of the goddess given in the *Filosofía secreta*, 'whom the poets make the mother of two cupids, as Ovid states'. The Spanish mythographer takes pains to explain that her nudity need have no lascivious connotations: she had been 'born within the sea and clothes are not needed in the water; love, whether good or bad, can not remain covered for long.' Unique to Pérez de Moya's moralization is the citation of a variant, wholly chaste, type of the goddess. This Venus 'had been venerated by virgins

and wives who remained faithful and chaste…they believe she had the power to transfigure women's hearts, causing them to distance themselves from evil thoughts; Pliny and Valerius Maximus make mention of her.' This Venus alone would be appropriate to Spanish *decoro* because 'a love without sexual pleasure is understood; hers is the love we hold for God and our homeland…This is termed celestial or pure love, unblemished by sensuality…Since matrimonial union is identified with her, hence her son Cupid is legitimate.'

Other late works with mythological content such as the unusually pensive *Mars* (c. 1641) show, despite their shifts from solid modelling to a suggestive pictorial 'Impressionism', that the basic euhemeristic interpretation was to change little. We know that this largely unprecedented depiction of Mars was commissioned to hang in a royal hunting lodge, the Torre de la Parada near Madrid, rather than at court; therefore, a less public venue might again permit some interpretive licence. It is significant that this painting was conceived only after news was received in Madrid of the disastrous recapture of Breda by

116 (*left*) Diego Velázquez, *Toilet of Venus*, the 'Rokeby Venus', c. 1647

117 (*right*) Diego Velázquez, *Mars*, c. 1641

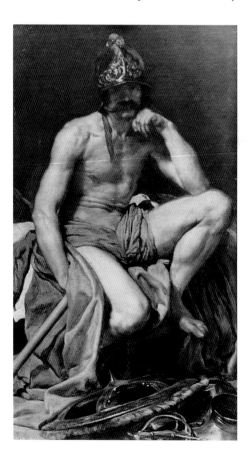

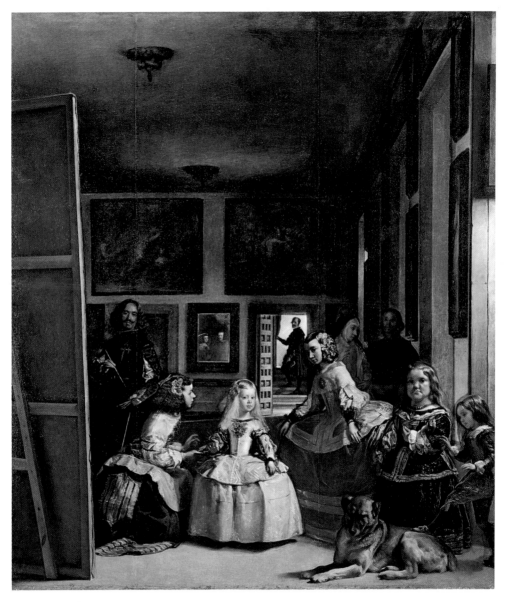

118 Diego Velázquez, *Las Meninas*, 1656

the Dutch in 1637. Velázquez's near-naked god of war appears in a most unmilitary and dejected attitude. His seated pose, with shadowed face and chin resting on his hand, conforms to the portrayals of Melancholy which appear in standard iconographic handbooks, especially Cesare Ripa's *Iconologia* (1611), a source known to have been in Velázquez's library. A brief citation from Pérez de Moya's text indicates the customary interpretation of such mythological matters during the Golden Age: 'The operations of Mars concur with the effects of blood…Farmlands over which the campaigns [of Mars] pass are destroyed, blood pours over the plants and they perish; trees are knocked down, even fortresses are reduced to dust, and the contestants die, victims of their own wrath. Signified by Mars are the greed and disputations fostered by war.' As before, mythology remains for Velázquez an adjunct to a decidedly unidealistic, but essentially moralized, expressive mode. His euhemerism remains beholden to his taste for sympathetic psychological veracity presented in conjunction with a distinctive mode of optical realism.

Painted in 1656, the Prado's *Las Meninas* is unquestionably Velázquez's best-known – and most extensively discussed – work, and deservedly so. The diverse pictorial effects of *Las Meninas* were assembled with an unprecedented rigour of balance and sense of pattern; this abstract formal layout was then coupled to a uniquely palpable atmosphere and latent action. In the next generation, Palomino gives valuable information about Velázquez's striking pictorial effects: 'On occasion, he used long-handled brushes, which enabled him to paint at a distance from the canvas. Thus, when you look at it up close it is hard to see what is going on, but from a distance it is a miracle…The figure painting is superior, the conception new, and in short it is impossible to overrate this painting because it is truth, not painting.' He also mentions that the paintings seen within *Las Meninas* in the rear and side (east and south) walls were copies of works by Rubens, the courtier-artist whom Charles I of England had knighted in 1630. The mythological subjects by Rubens featured Minerva and Arachne, Pan and Apollo, and Prometheus and Vulcan; thus representations of the four ancient arts appear: tapestry and music above, with the 'manual' arts of metalwork and sculpture properly below. The 'modern' art of painting is represented by Velázquez, a contemporary artist thoughtfully at work on *Las Meninas*.

Entitled 'the picture of the [Royal] Family' in later palace inventories, Velázquez's masterwork represents an unusual hybrid of genre painting and group portraiture from the life. As we know, the painting

was destined to decorate the King's private study in the palace. By descending two floors from his offices down to Velázquez's studio in order to observe progress on his painted likeness, the King tacitly confirmed the titles 'Liberal Artist' and 'Knight of Santiago', both eagerly aspired to by Velázquez and recorded by the probably posthumous addition of the red Cross of St James to the artist's tunic. The shining figure of the Infanta Margarita becomes the focus of a canvas depicting minor domestic activities in an identifiable room of the Alcázar in Madrid, so recording a transient moment like a snapshot. The psychological centre of the composition is Philip IV himself, reflected in a mirror placed at the rear of the long room with his wife at his side: the painting records *his* view of his beloved daughter, her court attendants and his most favoured visual chronicler. Palomino also states that Velázquez was also working on a (now lost) double-portrait of Philip with his Queen; thus both the work in progress and the finished *Las Meninas* were collectively to represent 'the Family'.

The assumed dimensions of the canvas Velázquez is shown working upon (2.75 metres high and perhaps 2.55 metres in width) only approximate in his known *œuvre* those of *Las Meninas*, which however measures 3.18 × 2.76 metres. Modern research therefore provides further evidence for Palomino's distinction between a (lost) work in progress, a matrimonial double-portrait, and the work we actually see today, *Las Meninas*. Standing in a distant doorway is the 'aposentador' José Nieto, and so, from foreground to background, a hierarchy of palace rank is depicted: from the god-like monarchs (known only by reflection, like the 'Rokeby Venus'), to their royal offspring and their personal retinue, to their administrative director and painter, and, lastly, to his administrative assistant. The whole social system is defined with a rigorous application of geometric perspective and proportionate light gradations, the scientific attributes of painting as a 'liberal' (or intellectual as opposed to manual) art. In Spanish terms, as befits a Habsburg icon, this artistic science probably reflects in paint the Augustinian aesthetics of the Escorial.

Recent scholarship has identified the setting of *Las Meninas*: a rectangular chamber, the 'Pieza principal', just outside the painter's studio, the 'Obrador de los pintores de cámara'; both rooms were then situated on the ground floor of the Alcázar in Madrid. This exact topographical identification also reveals, through comparison with measured ground plans for the building, the scientific accuracy of Velázquez's re-creation of his chosen architectural setting, including proportionally accurate representations of paintings once displayed in

the room and described there in an inventory of 1686. Besides reclaiming the dimensions of Velázquez's work in progress, we can now establish that the height of the rear (east) wall was 4.4 metres and that it was 5.36 metres in breadth, and that the entire (and invisible) length of this room, running west to east, was 20.4 metres.

In order to attain such measurable accuracy, 'scientific' verisimilitude, Velázquez must have used an optical instrument often employed by other Baroque artists, most notably Vermeer: the *camera obscura*. This suggestion, probably based on documentary evidence since lost, was first made in 1800 by Juan Agustín Ceán Bermúdez, who observed that Velázquez 'proposed to exhaust every means by which to observe the workings of nature, and the surest means he encountered was camera obscura', by means of which 'one perceives both a precise graduation of lights and darks in the distances and the marked increase of chiaroscuro in the foreground' – precisely the pictorial effects which appear in *Las Meninas*. Even so, we must rid ourselves of that lingering notion, tenaciously implanted by nineteenth-century Impressionist art criticism, that Velázquez functioned in the efficient but thoughtless manner of the modern photographic camera.

By including himself with poised brush in the scene, the painter has established a direct unity of thought and action; the stage is set, but our attention is quietly drawn to the realization that the entire ensemble records a conscious and deliberate idea in the mind of either Velázquez or Philip IV. By his aristocratic pose and his intimate proximity to royalty, Velázquez additionally advanced the idea of the nobility of painting. Thus he reaffirms that true artistic creation must be an act of the mind, before being one of the hand. Therefore, as based on science, painting is a liberal, or 'free', rather than a merely mechanical, art. With its erudite references, *Las Meninas* represents the subtlest and most profoundly compact statement of the doctrine of Ut Pictura Poesis ('as in poetry, so too in painting'), the reigning humanist theory of art. We have only touched on the variety and genius of Velázquez, a quintessential representative of European Baroque culture, for whom the physical and mental were indivisible, thereby creating a seamless duality within his art.

MURILLO AND SPIRITUAL BEAUTY

A suave late Baroque style characterizes the art of the Sevillian master Bartolomé Esteban Murillo (1617–1682). Rococo taste in the eighteenth century, especially in England, valued his art more than the

techniques of either Titian or Rubens. A disapproving Palomino felt that Murillo had abandoned the National Style, stating that he 'charms by sweetness and attractive beauty', but that in his adoption of 'the great seductive power of colour for winning popular favour', he was to be faulted for abandoning 'drawing, that excellence of all that is most refined and transcendental [which] does not move the masses.' Besides recognizing that Murillo's art was popular (perhaps even proletarian), Palomino ascribes both Murillo's later reliance upon the sensual aspects of colour, and thus his resulting popularity abroad, to foreign taste; they 'do not want to concede fame to any Spanish painter who has not passed through an Italian customs-house.' With hindsight, the problem vanishes: Murillo's later art is truly Baroque, and conforms to an international lingua franca of painterly style.

Murillo's initially naturalist and tenebrist style, which he formed without leaving Seville, quickly changed to a diaphanous luminism following two visits to the Spanish court in Madrid. The first occurred around 1642 with another in 1658; he was exposed to esteemed masterworks by Titian, Rubens and Van Dyck which he assiduously copied. Thereafter, practically single-handed, Murillo established a new, synthetic and forcefully modelled style which was to dominate mainstream Spanish painting until the time of Goya. In Seville he formed a busy and efficient workshop after the model of Rubens; besides producing several notable pictorial cycles for local religious foundations, he also received commissions for portraits and genre paintings. Despite Palomino's negative opinion, Murillo was a superb draughtsman: there is much more to his work than meets the eye, especially a modern one.

An excellent example of Murillo's mature style and his imaginative way of treating conventional religious subject matter is the *Holy Family with a Bird*. Probably today the most popular of all his pictures in Spain, it was painted around 1650 for an unknown client. At this stage of his career, he relies heavily upon the Sevillian tradition of chiaroscuro, a technique which imparts great plastic vigour and presence to the three figures set before a richly coloured but shallow and dark background. The composition shows his familiarity with Renaissance classicism, and employs two triangular groupings, a mother contrasted to a father and son. The massive figure of Joseph is centrally situated, seated in front of a carpenter's bench which disappears into the darkness. The brightly lit figure of the Infant Jesus, linking his mother and father, holds up a goldfinch and smiles as he looks down upon an eager lap-dog pointed out to him by his father.

164

119 Bartolomé Esteban Murillo, *Holy Family with a Bird, c.* 1650

As pictured by Murillo, and according to reigning Counter-Reformation doctrine, St Joseph is a vigorous and youthful paradigm of fatherhood, no longer the decrepit greybeard previously depicted in religious art. To the right, Mary, a paragon of maternal virtue, interrupts her sewing and spinning to regard her family with a pensive smile. Whereas a modern viewer might respond to the homespun sentimentality of a mundane domestic scene, a contemporary Catholic would have read quite a different message into this group portrait, a 'Holy Family'. For the seventeenth-century connoisseur, the implicit message was one of forthcoming tragedy, the inevitable death of God's Son upon the cross. An immediate interpretive key, a prefigurative motif, would have been the goldfinch, which, according to pious legend, owes the red spot on its breast to a drop of Christ's blood acquired after it drew a barb from the crown of thorns on the road to Calvary. Even Mary's role as a seamstress alludes to her coming sorrow: another

165

120 Bartolomé Esteban Murillo, *Aranjuez Immaculata*, c. 1650–60

pious legend discussed her fabrication of the sacred veil of the Temple, a piece of cloth which was rent at the moment of Christ's death, and Pacheco – demonstrating the communality of such apocrypha among artists in Seville – also credited her with spinning the 'seamless tunic' stripped from Christ by Roman soldiers, who then cast lots for it.

In his many Immaculatas Murillo created a classic type of devotional image. One of his numerous repetitions of this theme is the *Aranjuez Immaculata*, painted in the 1650s and now exhibited in the Prado. It is an excellent example of the vaporous technique he made so famous, a 'modern' mode which is diametrically opposed to the dry and by-then archaic style which characterizes Pacheco's Immaculatas. Mary's garments are more voluminous and intensely coloured, and the heavenly setting pulsates with light and atmospheric effects. A classic of Counter-Reformation iconography, Mary's youthful beauty and

121 Bartolomé Esteban Murillo,
Beggar Boys Throwing Dice, 1668–72

122 Bartolomé Esteban Murillo,
Girl and her Dueña, c. 1660

innocent expression are the visual expression of the still-contested doctrine of her exemption from original sin at the very moment of her birth; dry theological dogma is here given great psychological immediacy and appeal. Miguel de Molinos's *Spiritual Guide* defines different Spanish approaches to religious imagery: 'There are two ways of praying – tenderly, fondly, lovingly and full of feeling – or humbly, dryly, comfortless and darkly.' Murillo's luminous approach is clearly the former.

However, Murillo's genre studies, which remain popular today outside Spain as his religious compositions do not, perhaps best exhibit his stringent and acute psychological acumen. His democratic sense is best appreciated in these once-acclaimed celebrations of lower-class life. He was a master of the non-conformist, anti-heroic scene in which the people are the central protagonist. The most exemplary subjects here are children, who were infrequently depicted until this period. Characteristically, Murillo portrays them, mostly boys, with unadorned naturalism and dramatic chiaroscuro effects. In spite of their ragged clothing and evident poverty, they are generally presented in a light-hearted fashion: they sell fruit, play dice, eat vegetables, and so forth. Vividly rendered scenes of contemporary street life such as these were later to captivate early modern painters, like Edouard Manet.

Since genre painting was at best unusual in Spain, we might ask who Murillo's clients were. Even though documentation is lacking, it would be logical to suppose that these pictures were mainly purchased by the large community of Netherlandish merchants and traders resident in Seville, for such subject matter, pure genre, was a commonplace in contemporary Dutch art. An interesting variation in Murillo's genre production is his *Girl and her Dueña* (*c.* 1660), which shows two women architecturally framed and greeting a passer-by, in a manner most characteristic of contemporary Dutch genre pictures. Also foreign to Spanish taste is the apparent content of this picture which, as scholars have recently suggested, treats the theme of an overt flirtation with the viewer. Since aggressive feminine eye-contact was frowned upon in Spain, these women's attitudes are at best indecorous, even suggesting to some that the real subject of Murillo's fetching picture was love for sale. While taste, especially regarding matters of content, will always conform to the vicissitudes of time and fashion, the delightful freshness and emotional vivacity of Murillo's vigorous modelling and sensuous paint surfaces remain the most constant, and commendable, features of his art.

123 Claudio Coello,
Holy Sacrament of Charles II
(*La Sagrada forma*), c. 1690

Spanish painting during the last half of the seventeenth century, particularly that sponsored by the court in Madrid, largely conformed to an elegant and virtuoso neo-Venetian manner, characterized by bright and clear hues, free and spontaneous brushwork, idealized figure types, and asymmetrical, agitated compositions. This exuberant Baroque style, a pan-European manner, seems completely unrelated to the native National Style of the first half of the century. Although grandly composed in the reigning theatrical manner, a provocative reversion to earlier modes is seen in a royal commission by Claudio Coello (1642–1693). The monumentally scaled *Holy Sacrament of Charles II* (*La Sagrada forma*) records, like a documentary photograph, the installation of a Sacrament displaying miraculous stigmata upon

the altar of the sacristy in the Basilica in the Escorial in 1684, including the devout veneration accorded to it by the pious King and his humbled courtiers. The painting was installed in 1690. Using a painted extension of real space by means of a rigorous application of both linear and atmospheric perspective (signs of the science of painting as a liberal art), Coello places the omnivoyant observer in the position of an eyewitness to the miraculous transubstantiation of the Eucharist. Coello's painting was itself movable, being lifted on Corpus Christi and other feast days to reveal a chamber containing the miraculous wafer. Although the moment is more solemn and profound in its ritual and imperial implications, Coello's pictorial prototype was clearly Velázquez's *Las Meninas*. The painting is another monumental variation by a court painter on the group portrait and genre-setting format developed by the most famous of all Spanish court painters some forty-five years earlier.

The monarch depicted here, Charles II (1661–1700), was the last of the Habsburgs; with him the Golden Age drew to its ignominious close. He was the sorriest of the imperial line, a mentally feeble, inbred and sickly invalid; labelled 'bewitched' by his troubled subjects, he presided like an effigy over a leaderless nation in economic and political ruins. Since he was impotent, his will (written in October 1700) designated the French Bourbons as legitimate heirs to the Spanish crown. Philip V, the first Bourbon, came to the throne in 1700, and thereafter Spain, in some significant ways, ceased to be wholly Spanish. This trend had already become apparent in its art. After the middle of the seventeenth century, having so skilfully accommodated international cultural and artistic fashions, Spanish art had already begun to lose its unique flavour, a situation that was only to change a century later with the art of Goya. Outside sophisticated court circles, a pattern of native Baroque 'excess' (as some contend) would remain the norm.

SPIRITUAL MICROARCHITECTURE

A famous family of Spanish sculptor-architects has lent its name to an English term, Churrigueresque, whose implications, namely 'fantastic and barbaric', can be misleading. This opprobrium was put about by certain Spanish Neoclassical critics (Ponz, Jovellanos, Ceán Bermúdez) who belonged to an élite social class which subscribed to contemporary French rationalist ideas. Churrigueresque architectural decoration serves other purposes; being ecclesiastic and democratic (literally, but not politically), it was a popular art, greatly enjoyed and

170

124 José Benito Churriguera, The *retablo major* at San Esteban, Salamanca, begun 1692

acclaimed in its time and specifically conceived for the spiritual indoctrination and elevation of the masses. Like Antoni Gaudí, a later Hispanic designer of emotionally stirring architecture, the Churriguera tribe was originally Catalan: offspring of the patriarch Josep de Xoriguera had moved from Barcelona to Madrid before 1665. Castile, especially Salamanca and Valladolid, was to be the location of future Churrigueresque production.

A quintessential example of this body of work, with its countless Latin-American offshoots, is the giant retable erected in 1692 at the Convent of San Esteban in Salamanca to designs by José Benito Churriguera (1665–1725), who received the considerable sum of 13,000

ducats for his trouble. Rising to a height of nearly 30 metres, it seems to burst out of the polygonal apse. The details are finely finished and covered with scintillating gold leaf, and the whole employs a standard classical architectural vocabulary of broken cornices and entablatures which advance and recede with great spatial drama. Statues of two monastic saints, Francis and Dominic, are lodged in the receding walls and flanked by convulsively twisted Solomonic columns; in the upper storey two angels gyrate as they flank a later painting by Claudio Coello: *The Stoning of St Stephen*. As at the Escorial, the spiritual focal point is the micro-architectural Custodia with the Sacred Host, itself a symbolic conflation of Old Testament Tabernaculum and New Testament Anastasis. Repeating the Solomonic leitmotif, it was later further embellished with the *Ascension of the Virgin* by Antonio Palomino.

Thus Churriguera created the typically Baroque sense of dynamic plastic space found in other contemporary European edifices, but of a sort rarely encountered in coeval Hispanic façades. This is, in fact, a truly antiquarian and classical creation with a well-known architectural precedent on Spanish soil, the Roman Theatre at Mérida, which likewise uses angled colonnades and entablatures to create a quintessentially Baroque spatial drama. In both examples, besides the shared classical architectural vocabulary, the common link is drama; the goal is that defined by Aristotle long before in the *Poetics*: to induce catharsis, an emotional transfiguration, in the viewer-recipient. Like all good drama, Churriguera's architectural vocabulary is eloquent and easily read; the narration is wholly Christian. The Solomonic leitmotif alludes to the famous columns of the great Temple in Jerusalem, and also to the twisted columns with floral embellishment that originally supported the Tabernacle raised over the tomb of St Peter in his great Roman basilica, recently re-created by Gianlorenzo Bernini in his towering bronze Baldacchino (1624–33). The refulgent gold leaf and the weightless, ascending quality of Churriguera's architecture illustrate and encourage spiritual elevation.

A similarly misunderstood quasi-architectural masterwork is Narciso Tomé's *Transparente* in Toledo Cathedral, built between 1721 and 1732. In 1772, Antonio Ponz condemned this work as 'vulgar', a mere caprice 'conceived to sully eternally' the venerable Toledan see, and presenting to Ponz's finely wrought, classical taste only 'architectural confusion and barbarism'. This otherwise well-informed Spaniard had failed to grasp the Catholic didactic content motivating this brilliantly conceived and executed ensemble. The structure constitutes the rear wall of the Retablo Mayor of the Cathedral and functions actively as a

supplementary sacramental altar. Across the ambulatory and above is a chamber aligned upon the *trasaltar*, with an oculus window facing east – the 'transparente' – this constitutes the second part of an indissoluble composition. East (*oriens*) is where the Sun-Christ daily rises and casts spiritual light upon earthbound mortals, so metaphorically 'orienting' their lives. An inscription on the ceiling cites Revelations 4, and so we know that this chamber represents 'a door opened in heaven', and that beyond it God 'sits on the throne' behind 'a sea of glass'. When the half-blinded, mortal viewer looks up from the ambulatory into the light-filled oculus-chamber above him he sees four dark silhouettes outlined against the refulgent *lux divina*. They are the Prophets – Daniel, Isaiah, Jeremiah and Ezekiel – who look down upon the incarnation of the 'New Light' of their prophecies, Christ himself at the Last Supper at the moment of the Institution of the Eucharist. Penetrating the oculus, celestial light illuminates a magnificent Gloria, with golden rays and flying angels, set in the middle of the altar wall. At the centre of the Gloria is a pane of glass which protects the Host: Tomé's Gloria is a Custodia. The Host is treated as a spiritual vanishing point in another demonstration of transcendental perspective.

George Kubler once noted that 'in elevation the entablatures sag at the centre to establish a perspective recession'. As viewed from the oculus window, God's viewpoint, the perspective is quite correct. Particularly to be adjusted from this heavenly viewpoint is a fine rendition of the *Last Supper* placed by Tomé above the Gloria; the artist composed this conceit by employing anamorphosis, a game of perspectival distortion employed by many Baroque designers, usually for religious subjects. When God the Father looks down upon his Son at the celebration of the Eucharist (at a 45-degree angle), everything, especially the architectural framework, appears in perfect proportion, in a properly hierarchical progression. The celestial vision moves down to the intermediary Host, then to a statue, the *Virgin and Child*, set within a column-framed tabernacle with an altar as its seat and with its own vanishing point adjusted to the earthbound viewer's vision. We are placed at the very bottom of a staggered composition, which appears progressively deformed to us as it ascends. Only God can perceive simultaneously all parts of the divine plan.

Revolution and Tradition in Bourbon Spain

In 1700 Philip of Anjou was proclaimed King Philip V and the Spanish throne passed to the French house of Bourbon. The next year saw the beginning of the War of the Spanish Succession, which lasted until 1713, when the Peace of Utrecht deprived Spain of most of her European possessions. Although the rest of Europe was experiencing an Age of Enlightenment, south of the Pyrenees the eighteenth century began as a period of political humiliation, waning military power, and material and intellectual privation. Consequently, a period of decline in the arts commenced as many elements of native culture gave way under foreign influences; Palomino made Velázquez, long dead, the hero of his pioneering history of Spanish art. This was an era of academicism: an Escuela Nacional for architects was founded in 1744 and the Real Academia de Bellas Artes de San Fernando opened in 1752. It was an age, too, of artistic control: a royal decree prohibited the construction of any public building whose plans had not been previously approved by the Madrid Academy. The many foreign artists introduced to the Bourbon court – Mengs, Tiepolo, Juvarra, Houasse, Van Loo,

126 Filippo Juvarra and Giovanni Battista Sacchetti, Garden façade of La Granja, 1735–64

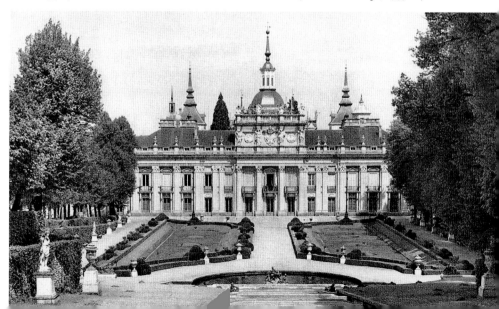

Ranc, among others – forced native talent either to conform or, as it were, go underground.

In the courtly culture created under Bourbon sponsorship, the National Style traits of austere simplicity and iconic veracity were superseded in favour of Rococo complexity and artifice. The motivating idea was reform, in all cultural sectors, of the perceived decadence suffered under the last Habsburgs. The architectural embodiment of this new regal taste is Felipe's summer palace, La Granja ('The Grange', near Segovia, 1735–64), seemingly the very antithesis of the Escorial. Even though La Granja evokes Versailles, particularly in the strict axial alignment of palace and formal gardens laid out in the manner of Serlio, the plan of La Granja – a rectangular grid-plan with towers at the corners – does in fact conform to the traditions of Spanish royal palaces, including the Escorial. The gardens include (as at Versailles) a mythological and allegorical sculptural programme, including Psyche, symbol of the soul, and Apollo, a poet-musician who embodies the sun and is surrounded by adoring muses, just as the enlightened patron-king surrounded himself with court artists. The

126

127 Luis Paret y Alcázar, *Charles III Dining Before his Court, c.* 1775

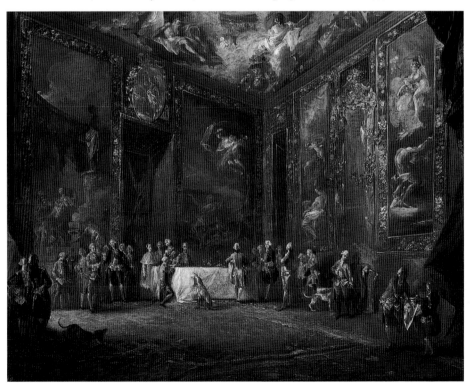

128 Francisco Bayeu, Sketch for *Olympus: The Battle of the Gods with the Giants*, *c*. 1790, a ceiling painting at the new Palacio Real, Madrid

two architects responsible, Filippo Juvarra (1678–1736) and Giovanni Battista Sacchetti (1690–1764), later designed the new Palacio Real in Madrid (1738–64), which conforms to the same rectangle-with-courtyards scheme. The new Palacio Real is even more conspicuously 'Roman' in style, and includes a complicated sculptural programme with subjects drawn from national history. This is public art, both regal and theatrical, with a centrally directed political programme; accordingly, the inscriptions appear in Castilian and not Latin.

The same policy shift is also apparent in royal portraiture. Although a contemporary of Goya, Luis Paret y Alcázar (1746–1799) seems to owe much to Fragonard. His theatrical depiction of *Charles III Dining Before his Court* exhibits a new relaxed political rhetoric which is clearly opposed to the hermetic and iconic Habsburg mode. The Bourbons present themselves to their subjects as a public institution, a healthy and vigorous family as opposed to the previous distant and impotent regime. Francisco Bayeu (1734–1795), Goya's teacher and brother-in-law, painted frescoes with mythological subjects in the airy manner of Tiepolo. Bayeu's sketch (*c*. 1790) for a ceiling painting of *Olympus: The Battle of the Gods with the Giants* to be installed in the new Palacio Real exemplifies the virtuoso Rococo conceptualizations absorbed by his most uncharacteristic pupil, Goya. Policy changes are

129 Luis Meléndez, *Still Life with Melon and Pears*

also manifested in categories of painting placed well below the official 'history' mode. Luis Meléndez (1716–1780), sometimes called the 'Spanish Chardin', is noted for his many humble *bodegones*. For all their obvious charm, these still-life studies, if compared to those of Sánchez Cotán or Zurbarán, show a relaxation of concentration, a lightening of mood, and a loss of symbolic significance; the asceticism of the 1600s and the policies associated with it were by then outdated. Accordingly, the term *bodegón* has by now been replaced by the term *diversión*. A political inference may be noted: these arrangements of food are designed to make the mouth water; evidently the Spaniards were better fed by this time. Another category of painting well beneath history painting in prestige is genre depiction. The Bourbons decorated their palaces with numerous series of paintings and tapestries depicting a new bourgeoisie sporting in the open air, in parks and villages now all made amenable because of the Pax Borbonica. This was the bucolic milieu that initially shaped Goya's career.

Against this backdrop of foreign domination and national debilitation, the art of Francisco de Goya y Lucientes (1746–1828) seems astonishing. Goya's artistic evolution points to a delayed reaffirmation of the familiar Spanish spontaneity, direct expression and ethical naturalism. This last term perhaps deserves further explanation: realism is a specific way of painting which intends to depict the subject with the utmost optical fidelity whereas naturalism is an attitude which seeks to capture life as it is, without the distortions of idealism or other a priori impositions. Particularly in his expressionistic later works, Goya transcended mere realism in order to impose his naturalistic commitment – hence, ethical sense – upon perceptions of a disillusioning world. By his increasing attachment to social commentary, including an implicit proletarian self-identification, Goya returned to that native tradition which considers painting a vehicle for moral instruction as opposed to the concept of painting for art's sake. In so doing, Goya seemed in retrospect to have invented one of modern art's underlying convictions, nihilism, thereby propelling much of its anarchic pessimism, irrationality and anti-conventionality. He was enthusiastically recommended as

130 Francisco Goya y Lucientes, *The Parasol, c.* 1777

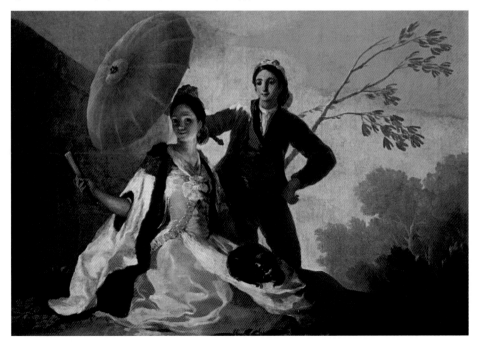

'a terrifying artist' and so a 'modern spirit' by the first great spokesman for modernism, Charles Baudelaire. Also precocious is the similarity between Goya's 'terrible' vision and the best of modern journalism, both bearing objective witness to disastrous, and typically inglorious, contemporary circumstances.

Goya was born in the village of Fuendetodos in the province of Zaragoza (Aragón). He was in Madrid by 1763 and a resident by 1766 (his reasons for leaving, and most other aspects of his life, have been distorted by a great deal of romantic embroidery). By 1771, he was in Rome and so became cognizant of the latest international trends in painting. He returned to Madrid in 1775, and a year later began to produce cartoons for the rejuvenated Royal Tapestry Factory, so embarking on a career which was to bring him great success. His early career as a court artist, beginning in 1786, was formed during the relatively enlightened reign of Charles III (1759–1788), a period which finally saw the abolition of the confining sales tax (*alcabala*) on artworks without religious subjects. This seemingly trivial (and now forgotten) fiscal adjustment freed the imaginations of native artists, including Goya. Goya was eventually appointed Principal Painter to the King in 1799, and by then his work was well known and appreciated by his contemporaries.

Earlier however, late in 1792, due to an unknown illness – most likely plumbism, or lead-poisoning – he, like Beethoven, became deaf and introspective, and as a result clinically and chronically depressed. This recurrent physical condition was probably instrumental in causing him, as he himself noted, increasingly to 'make observations for which commissioned works generally have no room, and in which fantasy and invention have no limit.' In the broader sense Goya's art provides a microcosmic, but emotionally magnified and 'terrible', vision of the collapse of the utopian optimism of the Age of Reason and Enlightenment. Goya's outraged (and endlessly reproduced) etching entitled *The Sleep of Reason Produces Monsters* almost seems an illustration of Pope's prophecy:

> With terrors round, can reason hold her throne,
> Despite the known, now tremble at the unknown?
> Survey both worlds, intrepid and entire,
> In spite of witches, devils, dreams and fire?

This is but one of a series of 84 images which make up Goya's *Caprichos*, on sale from February 1799. According to an advertisement

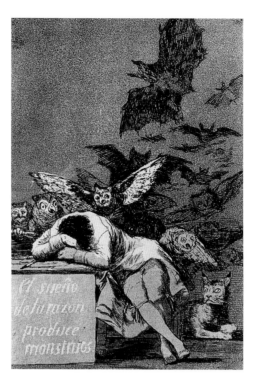

131
Francisco Goya y Lucientes,
*The Sleep of Reason Produces
Monsters*, no. 45 of *Los
Caprichos, c.* 1797

written by the artist, the intention was 'the censorship of human errors
and vices'; historians have remarked upon how well Goya's explicitly
moralizing, even acerbic, content fits in with that of contemporary
social reformers.

Goya's early painted tapestry designs from before the onset of his
plumbism (a total of sixty-six over a period of fifteen years) largely con-
cern themselves with the idle diversions of the common people. As we
should expect from the work of a salaried court painter, they tend to
convey a forced *joie de vivre* which reflects the Bourbons' vision of the
bucolic life enjoyed by their Spanish subjects, who were perhaps a
contemporary Iberian embodiment of Rousseau's 'noble savages',
innocent of civilized refinement and so representative of the primitive
moral sources of pristine human experience in the lost Golden Age.
Goya stresses native qualities in clothing and manners, in his earthen
colours, and, later in the series, in occasional glimpses of pain and
hardship, as in his depictions of *Winter* and *The Wounded Mason*. All
these traits come brilliantly to the fore in his rendering of two rustic
dandies, a *majo* and his *maja*, in *The Parasol*. Goya seems to have gleaned 130

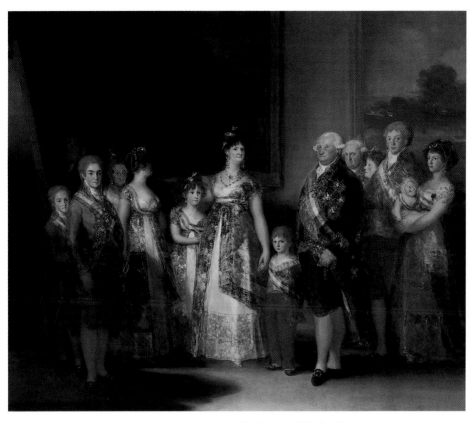

132 Francisco Goya y Lucientes, *The Family of Charles IV*, c. 1800

certain stylistic traits, which he was not to relinquish, from the exigen-
cies of the weaving medium: a general sketchiness, schematized colour
areas, simple silhouettes in chiaroscuro, diaphanous backgrounds, and a
narrational focus which suppresses irrelevant details.

He prepared his canvas with a warm under-painting which lent an
earthy tonality to the whole and would employ sweeping, liquid
brush-strokes, applying pigments with a palette knife, a wide spatula,
a sponge, or even with his fingers. Obsessed by the inherent drama of
light and shade and striving to capture visual rather than structural
phenomena, Goya's style might be considered somewhat Impression-
istic. He tends not to favour a finished aspect and, apparently, usually
worked without any preparatory sketches. He did not modify his

canvases, unlike Velázquez in whose work many corrections can be discerned which indicate his precise approach. To achieve his famous mother-of-pearl luminosity, Goya used lead white in massive quantities, and also cinnabar (a mercury compound) over his lead primings. Since he ground his own pigments, Goya must have inhaled a great deal of both lead and mercury dust; it has been estimated that he absorbed three times as much of these toxic substances as other painters, most of whom preferred to pay lowly apprentices to do their menial preparations.

133, 134 Francisco Goya y Lucientes, *Naked Maja, c.* 1798; *Clothed Maja, c.* 1798

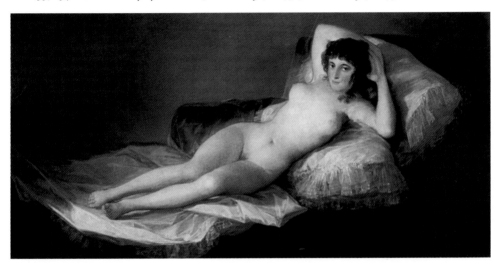

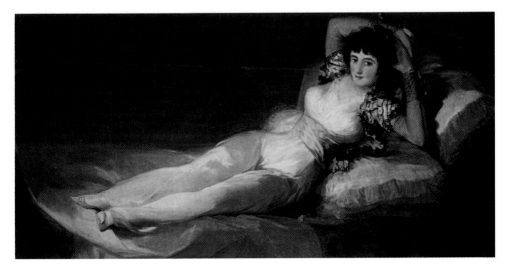

Goya's major portraits are of the highest interest as they show a new emphasis upon psychology over physiology, and psychic immediacy over the signs of rank. They are neither ironic nor satirical in intention, as some critics wrongly assume, especially when confronted with the unheroic, bourgeois banality of *The Family of Charles IV*. Goya's self-portrait at the easel makes reference to its ultimate model, *Las Meninas* by Velázquez. Goya's unidealized and anecdotal narrations are the culmination of the Spanish predilection for accepting people as they are: monarchs are reduced to a human scale, and family values are reinforced, thus additionally institutionalizing a new, bourgeois pattern of European regal portraiture. Even at the height of his popularity and prestige, in academic circles Goya seemed the very incarnation of anti-art and anti-culture. Yet his works were widely admired by the intelligentsia for their boldness and freedom, often precisely because they were not understood.

In addition to institutional commissions, portraiture was Goya's principal source of income and, especially in his depictions of women, he can convey a sense of expectation and mystery that is quite bewitching. By far the most notorious and enigmatic of these is his paired depiction of a proletarian *maja*, once shown clothed and then naked. This odd coupling of two canvases with nearly identical dimensions demands enquiry, particularly given the singularity of a naked female in Spanish art without scriptural mitigation; the only well-known profane precedent is Velázquez's *Toilet of Venus*, the 'Rokeby Venus', a glowing figure sanctified by euhemeristic decorum. Goya's *Naked Maja* (*c.* 1798) was viewed differently: in November 1814 the Inquisition made enquiries into these two 'obscene' paintings, wishing to know their authorship, when they were painted, and for whom; unfortunately the results are lost. We do however know that they belonged at one stage to Manuel Godoy, once the favourite (and perhaps the lover) of the Queen; by 1814 Godoy was in political disgrace and exiled. Perhaps the model was Godoy's mistress, 'la Tudo'. The first documented reference, by Pedro González Sepúlveda in 1800, puts the *Naked Maja* alongside Velázquez's 'Rokeby Venus', a recent gift from the Duchess of Alba. Unlike Velázquez's Venus, Goya's frontalized naked lady stares boldly at the viewer, as Manet's aggressively modern *Olympia* would half a century later. A slightly later inventory of Godoy's possessions, dating from 1803, cites 'a clothed maja' linked to 'a Venus upon the bed'; perhaps the odd pairing was due to a prestigious art historical topos: Pliny immortalized nearly identical sculptures of 'Venus' made by Praxiteles (*c.* 365 BC), one clothed and

the other nude (*Aphrodite of Kos* and *Aphrodite of Knidos*). In 1808 however, a French visitor calls the two women 'gypsies': a marginalized, non-Spanish underclass. It has often been surmised (but never documented) that the *Clothed Maja* (perhaps executed later) was made to be 134
hung in front of the *Naked Maja*, with the draped version being suddenly lifted in order to unveil dramatically the naked truth lying beneath clothing. Even as they are viewed today in the Prado, side by side, the unsettling result is reminiscent of a strip-tease.

Goya, in another similarity to his contemporary, Beethoven, had originally been an admirer of Napoleon. But, in 1808, the Spanish 'War of Independence' suddenly began as the people of Madrid spontaneously rose against the oppressive French mercenaries occupying the capital, thereby unleashing six years of primitive passions and bloody guerrilla warfare. In 1814, due to a governmental commission, Goya captured the outbreak of the hostilities in his epic canvas, *The Second of May, 1808 (Uprising)*, in which the outraged inhabitants of 135
Madrid do battle with French mercenaries in the Puerta del Sol. The next canvas, *The Third of May, 1808 (Executions)*, re-creates in horrifying 136
detail the vengeance of the French against mostly innocent civilians. In these two large-scale canvases, Goya invents a wholly modern variant on the traditional genre of history painting which might be called the 'atrocity picture'. Most of the dramatic motifs in Goya's epic canvas, especially its faceless firing squad, appeared in a 1770 engraving by Henry Pelham of the 'Boston Massacre' (later plagiarized by Paul Revere, among others). Whereas the traditional history painting typically celebrated a triumphal dynastic conquest, Goya's modern mutation now puts a conventional Christian subject, the Massacre of the Innocents, into a wholly contemporary context which is anonymous but secular and specifically politicized (like Pelham's print). Goya, profoundly moved and horrified by this ultimate sleep of reason, went on to compose a brutal series of etchings, the *Disasters of War*, 137
the first universal anti-war statement in art.

Some time after 1808 Goya painted the frighteningly enigmatic *Colossus*, an almost Surrealist depiction of panic and mass terror. 138
A similar sense of unfocused horror and nightmare lies behind a programme of wall paintings in the Quinta del Sordo, Goya's rarely visited cottage outside Madrid. Among this unprecedented series, now installed in the Prado (unfortunately not in their original sequences), the most disturbing is the still inexplicable *Saturn Devour- 140
ing his Children*. No less horrific, but equally enigmatic, is the savage scene of *A Duel to the Death with Clubs*, an unforgettable image of 139

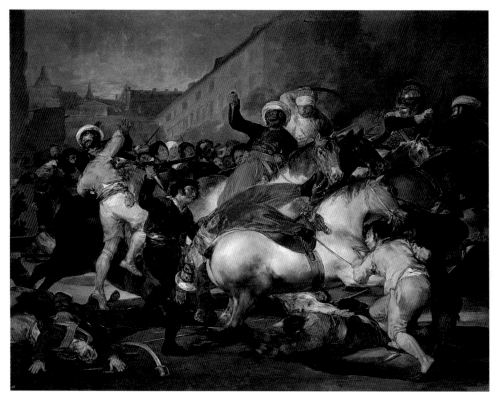

135 Francisco Goya y Lucientes, *The Second of May, 1808 (Uprising)*, c. 1814

retaliatory stupidity and violence of the sort that was to be revived in the Spanish Civil War. These works were executed early in the 1820s and collectively deserve the appellation 'Expressionistic'. These 'black paintings' (*pinturas negras*) are not frescoes but rather oils, directly and hastily applied to bare walls. Not intended for public exposure, they are the sub-verbal soliloquies of a man cut off from the world by his deafness and tortured by visions of a world gone mad, where 'reason sleeps'. Not surprisingly, they seized the collective European artistic imagination when they were finally exhibited in Paris in 1878. They were subsequently bequeathed to the Prado, and thereafter widely reproduced. As Nigel Glendinning explained, 'A model Romantic for the Romantics; an Impressionist for the Impressionists, Goya later became an Expressionist for the Expressionists and a forerunner of Surrealism for the Surrealists.'

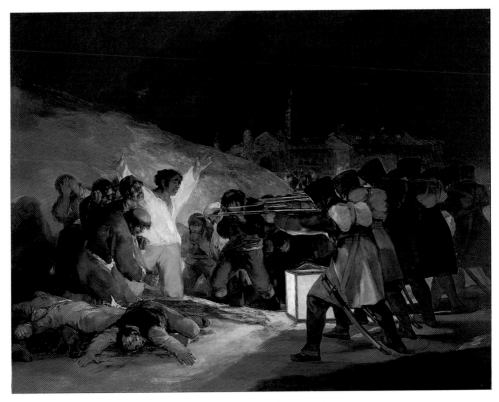

136 Francisco Goya y Lucientes, *The Third of May, 1808 (Executions)*, c. 1814

137 Francisco Goya y
Lucientes, *What More Can
be Done?* Etching from the
Disasters of War, before
1820

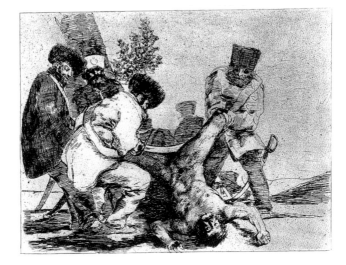

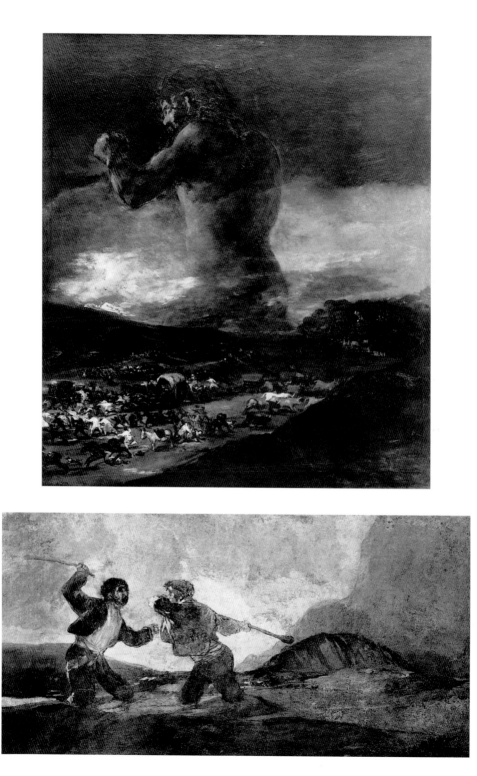

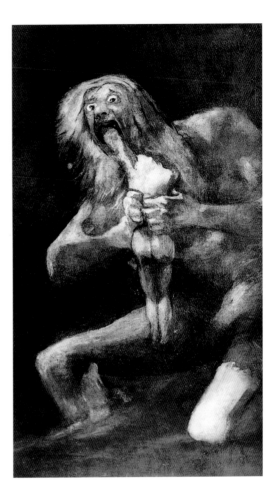

138 (*left, above*)
Francisco Goya y Lucientes,
Colossus, c. 1808–12

139 (*left, below*)
Francisco Goya y Lucientes,
A Duel to the Death with Clubs,
c. 1820–2

140 (*right*)
Francisco Goya y Lucientes,
Saturn Devouring his Children,
c. 1820–2

AFTER GOYA: THE NATURE OF SPANISHNESS

After Goya, art in nineteenth-century Spain seems – inevitably – rather tame. This is especially the case in sculpture, where a century-long sequence of monochromatic marmoreal exercises unfolds by sculptors such as Mariano Benlliure (1862–1927), Damián Campeny y Estrany (1771–1855), Jerónimo Suñol (1839–1902) and Agapito Vallmitjana y Barbany (1830–1905). The majority of their subject matter is Neoclassical: Campeny, for example, favoured pagan mythology, although some of his later works feature religious subjects. Benlliure, however, executed complex bullfight compositions, hardly very Neo-

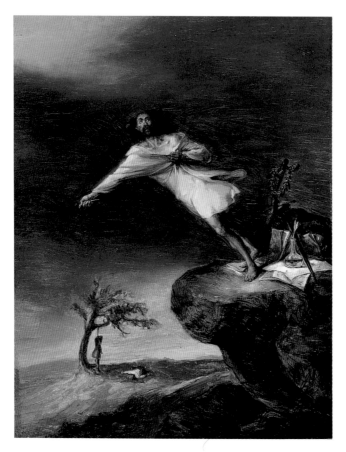

141 Leonardo Alenza,
¡Los Románticos!, c. 1835

classical subject matter, and was much praised during Franco's era as
a formal inspiration for complex Falangist 'Spanish' iconography.

Painters, however, were more original. Evidence for an early Span-
ish aversion to the excesses of the Romantics is to be seen in the
splendidly ironic *¡Los Románticos!* of Leonardo Alenza (1807–1845), in
which an impassioned and emaciated Romantic poet, clad in a toga,
prepares to stab himself as he flings himself off a precipice. The back-
ground contains the entire melodramatic apparatus of Romantic
scenography: stormy skies, barren landscape, a tree with a hanged man,
and, on the rock itself, the impoverished poet's materials. However
appealing this painting may be to acerbic contemporary taste, it was
atypical of the artistic currents officially sanctioned at that time. Paint-
ings commissioned during the first half of the nineteenth century

142 (*right*) Eduardo Rosales, *Isabella the Catholic's Last Will and Testament*, 1864

mostly show a regressive tendency towards photographic accuracy and a blandness of content expressive of bourgeois decorum, a feature of most European art of the era. Representative of this taste is a lifeless re-creation by Antonio Esquivel (1806–1857) of *A Reading by the Poet José Zorrilla.* On the evidence of this decorous academic representation, we would never suspect Zorrilla to have been the author of a popular play, *Don Juan Tenorio* (1844), whose protagonist is the very embodiment of hot-blooded and anarchic Spanish 'machismo'.

More so than in the rest of Europe, academic painting in Spain favoured renderings of stoic political executions and large deathbed scenes. Typical, even quintessential, of the latter genre is Eduardo Rosales's *Isabella the Catholic's Last Will and Testament* (1864), where we see a beloved ruler in her last earthly moments, surrounded by her grieving husband, family and advisers. This canvas established the short-lived Rosales (1836–1873) as a fashionable history painter. His subject, Queen Isabella, consort of King Ferdinand, co-founder of a united Spanish kingdom and legendary sponsor of Columbus's voyages of discovery, was exemplary of both womanly and regal virtues. These were sorely lacking in the then-reigning Isabella II, who was forced in 1868 to abdicate the Spanish throne, and then, in 1870, sent into exile. Her frivolous and dissolute reign, begun in 1833, also marks the disastrous era of the Carlist Wars (1833–1876).

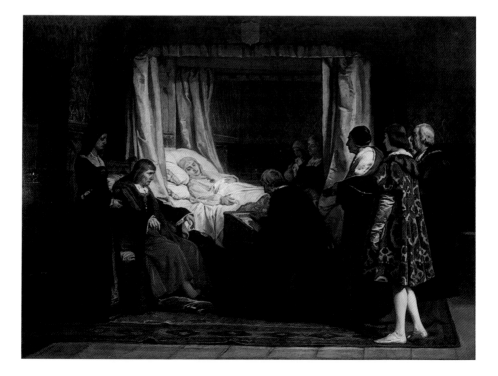

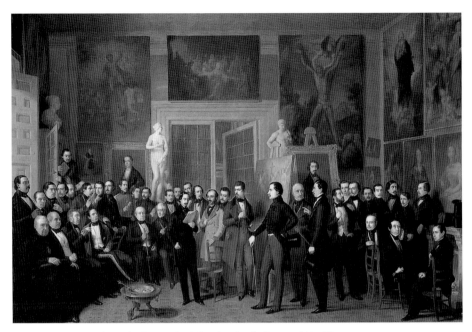

143 Antonio Esquivel, *A Reading by the Poet José Zorrilla*, c. 1846

A more specifically 'manly' exposition of virtue in the post-Isabella II era was embodied in the well-crafted representation of the *Execution by Firing Squad of General Torrijos and his Companions* by Antonio Gisbert (1834–1901), commissioned by royal decree in January 1886 and finished in June 1888. This scene commemorates the execution in December 1831 (while Queen María Cristina was acting as regent for the under-age Isabella II) of a group of fifty-three British-sponsored Spanish liberals who had endeavoured to put into effect a radical constitution. Gisbert's composition is a model of its kind: the accused, the epitome of admirably unflinching composure in the face of imminent death, are truly monumental figures; thus they are placed in the foreground, right in the viewer's psychic space. Perfectly characterized as stoic modern martyrs dressed in contemporary middle-class fashion, each has his own individual character, but all are united in righteousness against faceless tyranny. Their feelings, and those of the compassionate viewer, are evoked by the desolation of the pictorial setting, an arid, brown plain with a grey, louring sky overhead. In its day, this smoothly painted and quietistic work was thought far

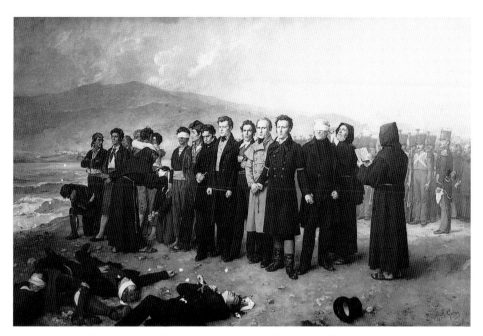

144 Antonio Gisbert, *Execution by Firing Squad of General Torrijos and his Companions*, 1886–8

superior to Goya's now-canonic execution scene, *The Third of May, 1808 (Executions)*. Its virtues then lay in its near-photographic, documentary realism, for the painter Pedro de Madrazo (in a review published in 1889) supposes that the individual figures all represented 'portraits'; above all, Gisbert represented a much better, or more 'noble', class of 'individualized' victim, presented here for identification by a viewer who would presumably also be middle class, and consider himself politically sensitive and dignified, even 'poetic'. According to Madrazo, 'The artist…is more correct in accurately conveying his empathy than was Goya, who presented to us the victims of *The Third of May, 1808 (Executions)* as though they were a pack of ugly and ignoble sneak-thieves dragged from the muck of the Madrid slums.'

Although typically given over to purely secular subject matter, the mostly government-sponsored genre of history painting accorded with traditional Spanish notions of art making and its functions. An anonymous art critic observed (in *La Época* in 1860) that 'in this century religious painting has been replaced by history painting'. Through eloquent gestures, the persons portrayed express conventionalized

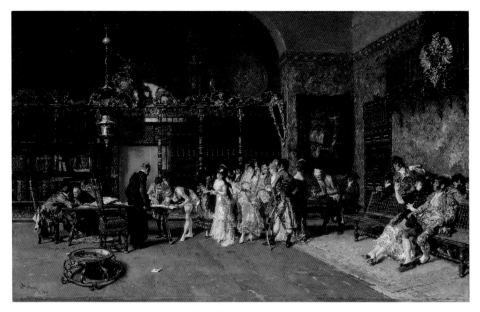

145 Mariano Fortuny, *The Vicarage*, 1870

emotions; the viewer feels these, and responds accordingly. Such emphasis on strictly emotional response and comprehension is a feature of the Romantic era, but had been implicit in Spanish art since medieval times.

In 1866 the art critic José García announced that 'the goal of this branch of art [history painting] is to teach: to make virtue attractive, to exalt goodness, to make moral statements, and overall to make the population more perfect.' As he had observed in *La Época* in 1862, besides 'civic history', it additionally illustrates 'the conquests of science, the march of the spirit through the ages, the shifts in fortune of society'. These sentiments were echoed by many other artists at the time, and although subject matter is now wholly secular, these descriptions of the function of history painting are reminiscent of Francisco Pacheco writing two hundred years earlier. There were even handbooks to guide the novice painter. As Francisco de Mendoza, in his *Manual del pintor de historia* (1870) explains, the artist 'must think hard on his choice of subject matter, especially so that it generates interest and so that an educated public can grasp it in a moment, and it should represent a page from history recalling a notable deed illustrating a larger concept, whatever that may be.'

In the second half of the nineteenth century a taste for genre painting, now called Costumbrismo, became ubiquitous. This 'indigenous mode', which then referred to a studied, anecdotal, and generally positive depiction of native life and contemporary customs, is also much evident in the literature of the period, beginning in 1822 with Ramón de Mesonero Romanos's *Mis ratos perdidos*. The foremost exponent of this rather flattering ethnic anecdotalism was the Catalan artist Mariano Fortuny (1838–1874). In his charming and stylish depiction of *The Vicarage* (1870), Fortuny consciously evokes the traditional Spain of Goya, peopled with clerics, courtiers and bull-fighters. Fortuny's small-scale and essentially narrative-less canvases react against the grandiloquent *cuadros de historia* just examined. Certainly they respond to the interests of the rising, art-collecting middle class whose wealth was created by business and manufacturing. Fortuny's little pictures are a fitting complement to the bourgeois furnishings of a new urban domesticity.

Even at its most ethnically authentic (*castizo*) level, Spanish art could scarcely distance itself from current European influences. Delayed reverberations from contemporary French Impressionism were brilliantly adopted by Joaquín Sorolla y Bastida (1863–1923), a master of *plein-air* effects of light sparkling off water and rosy flesh; his art remains very popular today. Unlike that of his French colleagues, his manner of modelling with paint, sculpting figures and even seascapes, is as tangible and solid as that of any Baroque master; it is just

146 Joaquín Sorolla y Bastida, *Children on the Beach*, 1910

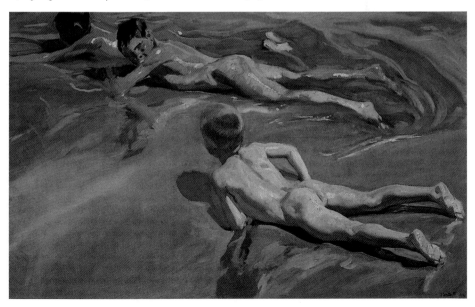

that his palette has brightened enormously. Also considerably lightened is the mood: his is a sunny, happy Spain. Not surprisingly, the amiable art of Sorolla y Bastida also found considerable favour with the new bourgeois clientele.

At the end of the century, the painting of Ignacio Zuloaga (1870–1945) is a conscious attempt to return to the mainstream of Spanish tradition. In Zuloaga's vigorously painted, darkly coloured canvases, the principal rhetorical elements are 'traditional' religion, poverty and regionalist customs. Zuloaga's art was a commercial success with wealthy cosmopolitan urban dwellers. Of greater interest perhaps is what is scrupulously *not* depicted by Zuloaga: the urban scene, the most progressive and most depressing sector of contemporary Spanish reality, swarming with dispossessed peasants desperately seeking sweatshop labour in congested industrial centres like Barcelona or Bilbao. Zuloaga's art implies that the Spaniard is a religious being by nature, defined by Catholic ritual: archetypal religiosity transforms physical appearance, having its own innate and typically anorexic physiognomy and a repertoire of theatrical gestures and intense psychological expressiveness. Were the theme not religious spirituality, then a sceptic might be forgiven for thinking the subject instead corporeal hunger or material poverty; in fact, Zuloaga celebrates poverty as a timeless attribute of his traditional, thoroughly idealized Spain. Zuloaga's solemn but essentially theatrical rendering of *El Cristo de la Sangre* of 1911 is a deliberate reversion to the religious intensity and solidly rendered, quasi-sculptural compositions of the

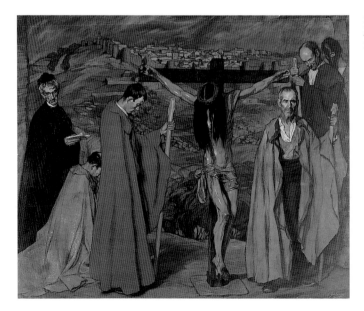

147 Ignacio Zuloaga,
El Cristo de la Sangre,
1911

148
José Gutiérrez Solana,
A Visit to the Bishop,
1926

Golden Age. Such paintings make perfect contextual sense, for this was the period when El Greco was first restored to his present-day fame in Spain as the putative and essentially imaginary embodiment of native ethical expressionism. Zuloaga's work, like the opportune critical revival of El Greco whose works Zuloaga collected, represents the major pictorial expression of the Generation of 1898, whose members included writers, historians, philosophers and scientists of European stature. After the disillusionment of the Spanish–American War, which in 1898 finally ended the long and mostly disastrous Spanish imperial dream, the Generation of 1898 collectively sought to re-examine the autonomous essence of native character and tradition, particularly its attributed 'tragic sense of life'.

One of the major goals of the Generation of 1898 was to define verbally the nature of Spanishness. The doctrine of national essence, *casticismo*, soon became part of the official curriculum for modern Spanish youth; up-and-coming artistic radicals – Pablo Picasso, Juan Gris, Salvador Dalí, Joan Miró – were all schooled in this immutable nationalism, as was Francisco Franco. Ramón Menéndez Pidal was one of the most eloquent investigators of the post-imperial age. In his writings, he emphasized an enduring factor of conservatism, a medieval tradition forged in the harsh crucible of Muslim–Christian warfare before the Renaissance. His distinguished contemporary Miguel de Unamuno explored the traditional Spanish character, identifying within it a close relationship to the harsh and abrupt forms of

the Castilian central plateau, with its sharply etched lines, treeless desolation, endless horizons and blinding sunlight. The landscape paintings of Aureliano de Beruete (1845–1912) seem a characteristic pictorialization of these contemporary concerns. In his 1898 monograph on Velázquez, Beruete describes: 'sites the [Golden Age] artist could contemplate from the very windows of the palace at El Escorial...the tones are always grey, bluish and cold.' It is worth noting however that a more progressive kind of landscape painting resembling contemporary French Symbolist art was being practised in Catalonia by artists such as Ramón Casas (1866–1932), Joaquim Mir (1873–1949) and Santiago Rusiñol (1861–1931), contemporaries and colleagues of the visionary architect Antoni Gaudí (1852–1926).

Menéndez Pidal often referred to a pervasive sobriety in the Spanish character, affirming that his countrymen were innately stoic and thus predisposed to exhibitions of dignity tempered by an almost cynical fatalism. Harshness and frugality were remarked on even in antiquity in Hispania, and were to become characteristics of a revolutionary art practised by twentieth-century Spanish painters, particularly the Analytical Cubism pioneered by Pablo Picasso and Juan Gris.

Another native offshoot of Costumbrismo, also with an initial literary impulse but having diametrically opposed artistic purposes, was Tremendismo, whose name conveys the ideas of awfulness and excess. By means of an almost journalistic naturalism, its painterly task was to describe the bleak realities of modern Spanish life. In this case, reality is considered wholly urban and contemporary, grim and dreary. The major representative of this variant of Spanish ethical realism was José Gutiérrez Solana (1886–1945). He too employs the 'national' dark palette favoured by Spanish artists from the tenebrists to Goya, and, like Goya, favours heavily impasted, even 'dirty', paint surfaces for the direct expression of moral misgiving and psychological malaise. The poet Antonio Machado called his friend a 'necromantic Goya', who 'paints with insane voluptuousness, treating life as though it were death, death as though it were life'. The literary equivalent of Solana's polemical art is found in the novels of Pío Baroja and Camilo José Cela, particularly the latter's *The Hive* (*La colmena*, 1951), for which he was eventually to be awarded a Nobel Prize. It also emerges in the revived 'Madrid Realism' practised currently by acclaimed artists such as Antonio López (b. 1936). The gritty and objective urban pessimism of the Tremendists in Madrid is indeed the most genuinely 'modern' or prophetic, and also the most socially accurate, of the artistic innovations produced by the decisive national defeat of 1898.

148

149 (*right*) Antoni Gaudí, Church of the Sagrada Familia, Barcelona, begun 1883

The Revolutionary Twentieth Century Mirrored in Spanish Art

As we have seen, at the turn of the century the Generation of 1898 intended to renew Spanish culture by performing retrospective autopsies upon its moribund traditions. At the same time, the members of another progressive group were seeking to formulate a 'modernistic' spirit to cope with the very different and untraditional world in which they found themselves. This sense of contemporaneity was later to acquire a political tonality as progressive and aggressive 'vanguard' expression. The major creative ferment took place in Barcelona, newly wealthy from its dynamic manufacturing economy and propelled by an outlook always more culturally energetic and European than dour and centralist Madrid. Recent researches into this fascinating period have uncovered a surprising store of buried *fin-de-siècle* treasure. The Catalans themselves were keenly aware that they were taking part in a *Renaixença*, a renaissance not merely artistic in its applications but also musical, literary, industrial, scientific and even political.

Such Catalan creative fervour is mainly known by the work of Antoni Gaudí whose anomalous and vigorously modelled Expiatory Church of the Sagrada Familia, begun in 1883 and left unfinished at his death, crosses the boundary between architecture and sculpture; a similar semantic problem has confused proper appreciation of the trans-media art of the (originally Catalan) Churrigueras and Narciso Tomé. Gaudí the architect saw himself as the humble instrument of a divine power, and considered each of his forms to be fraught with mystical symbolism. As he said, he must conform to 'the laws of Creation and Nature'; 'originality is the return to origins', and when architectural 'masses disappear, thus one achieves a spiritual result'. Thus his transcendental architecture properly leads to 'the physical revelation of Divinity'.

149

Behind the regionalist ideology, nostalgic neo-medievalisms (including a neo-*Mudéjarismo*) and other historicist reversions which inspired Gaudí's oddly organic religious Expressionism, there lies a tough, modern attitude: an assertion of the autonomy of the artistic vision and the establishment of a free rein for the artist to reconstruct

200

visual appearances according to his own convictions. In purely formal terms, Gaudí's work is said to correspond to Art Nouveau, but it specifically represents on a monumental scale a native artistic movement calling itself 'modernism', *el modernisme*, which itself represents the Catalan equivalent of the recognized, international literary-artistic movement elsewhere called Symbolism. Accordingly, Gaudí and his innovative artistic colleagues in Catalonia responded with native idioms to contemporary European cultural innovations, particularly to French Symbolist writers and artists who championed an autonomous creative expression that treated artistic materials as subjects in themselves.

THE PICASSO PHENOMENON

It was in this modernist milieu of passionate aestheticism and formal disintegrations and reintegrations that the young Pablo Picasso (1881–1973) took the first bold steps of his long career. In quantitative and often qualitative terms, Picasso was unquestionably an art-historical record breaker; in a widely publicized career lasting some seventy-eight years, the celebrated modernist Pantokrator is estimated to have created some 13,500 paintings or designs, 100,000 prints or engravings, some 34,000 book illustrations, and perhaps 300 sculptures and ceramics. It once seemed as though every painter entertaining any avant-garde ambitions went through a Picasso phase; some never emerged. This situation continued until the 1960s, when avant-garde artists adopted another art-historical role model: Marcel Duchamp (1887–1968). Thereafter, the Picasso paradigm was unceremoniously discarded by self-styled progressive artists. Such a radical shift in taste reveals a fundamental shift in modernist art-making: twentieth-century notions of creativity move from formal experiments to pure idea, leading to a sceptical questioning of the fundamental purposes of, and even the very need for, art. In short, the change in focus from Picasso to Duchamp comprehensively describes an evaluative art-historical trajectory moving from orthodox modernism to postmodernism.

Although he was later to be decisively shaped by the Catalan *Renaixença*, Picasso was proud of his Andalusian origins; his family had resided in Málaga for some time. When Picasso was ten, his family moved to the foggy Galician port of La Coruña and, four years later, in 1895, they moved again, to a very different cultural milieu: industrial, class-torn, anarchistic Barcelona, a bustling city whose tongue was Catalan and not Castilian. Accordingly, his later career is that of a very

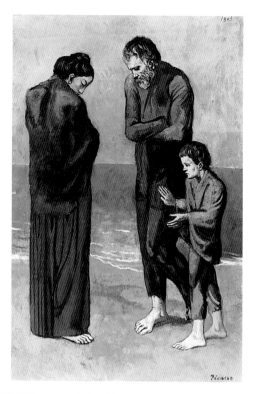

150 Isidro Nonell, *Repose*, 1904

151 (*right*) Pablo Picasso, *The Tragedy*, 1903

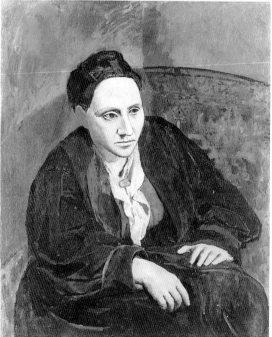

152 (*left*) Pablo Picasso,
Portrait of Gertrude Stein, 1905–6

153 (*right*) Pablo Picasso,
Les Demoiselles d'Avignon, 1907

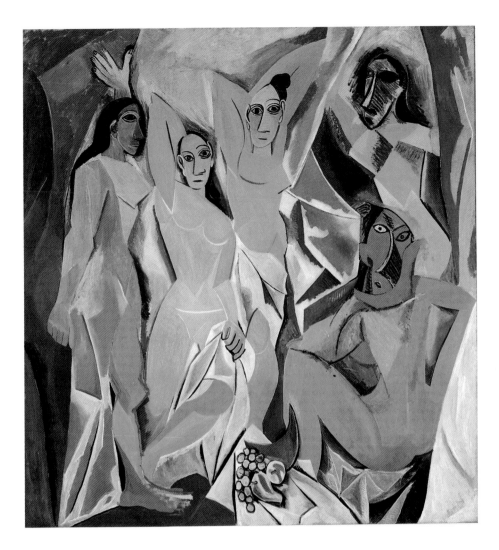

clever, sometimes rather negative, stylistic polyglot. Significantly, his domineering father, José Ruiz Blasco, was a professor of strictly academic art. Picasso's career began by briefly embracing such parentally-approved art, but after 1900, he stopped signing his name Ruiz, and likewise ceased painting his father's imagery. Thereafter Picasso can be seen as an uprooted sensibility, a cultural nomad. Just as in his formative youth, so in his raucous maturity the peripatetic Picasso never seemed able to attach himself to a particular area long

enough to identify himself fully with its very distinct geographical, historical and cultural circumstances. This allowed him a mobile eye with which to scan critically diverse artistic nationalisms, be they Castilian, Catalan or French.

Since Picasso often spoke of 'the several manners I have used', which he denied were 'an evolution or steps towards an unknown ideal of painting', we should begin by discussing them. He was initially caught up in fashionable late nineteenth-century excursions into the squalid lifestyles of the urban *demi-mondaines*. His Blue and his Rose Period exercises in proletarian pathos were directly influenced by the gypsy character studies of Isidro Nonell (1873–1911), who used acid colours and broken brushwork to highlight psychological effects. The larger subject behind Nonell's gypsies and beggars was Tremendismo, the excruciating anatomy of contemporary Spanish poverty. Nonell's gypsies, representing the archetypal racial 'other', were the most miserable of all – perhaps like young artists alienated from mainstream Spanish society in Bohemian Barcelona. Nonetheless, unlike other Tremendists, Nonell overlooked the exploited industrial proletariat who actually created the wealth of Catalonia. This native underclass was evidently deemed an unattractive artistic subject by both Nonell and Picasso. The other influence working on Picasso in Barcelona was the newly acclaimed work of El Greco; this makes its presence felt in Picasso's elongated figures, his ascetic psychological mood and, most particularly, his chilly azure chromaticism. Not surprisingly, this early work of Picasso, with its accessible sentimentality and apparent empathy with working-class misery, has proved extremely appealing to collectors.

From this earlier period, and throughout most of his career, Picasso consciously or subconsciously – despite his verbally expressed anti-historic attitudes – ingested various elements of traditional Spanish art. These include the jagged primitive vitality and simplified and block-like forms of Iberian art; the austere, linear patterns of Beato manuscript illuminations and Romanesque painting; the harsh, detached observation of medieval and Renaissance martyrdoms; the elongated, malleable forms of late Gothic sculptural expressionism; the Mannerists' sinuous and elegant distortions of reality; the 'Cubic' rigours of Herrera's Escorial; El Greco's colour discords; and even – on occasion – the monumentally undeviating vision of Zurbarán, Velázquez and Goya. Like Spanish art itself, Picasso proved himself eclectic and open to the most diverse cultural stimuli, even though in retrospect he seems to have chosen, for the most part, to forget the

ethical basis informing most traditional, pre-modernist, Spanish figuration. In Picasso's long and increasingly lionized career, manner usually triumphed over matter. This perception is itself due to a new art-historical critical perspective: post-formalist postmodernism.

In 1900, Picasso visited Paris and returned four years later to take up permanent residence in the French capital, which was increasingly becoming the cultural hub of an international avant-garde. The city's liberated and culturally stimulating atmosphere eventually brought Picasso out of his Harlequin series; so did his artistic collaboration with Georges Braque. Beginning in the summer of 1906, he began to play down narrative concerns in order to evolve a markedly sculptural style, pursuing the clarity of reductive formal relations with nearly monochromatic colour schemes. For a while, subjectivity and expressive self-dramatization were reduced to a minimum in the evolution of Picasso's art. To contemporary French stylistic references, mainly Symbolist, was added a new and decisive primitivism, that of ancient Iberian art. Already in his 1905–6 *Portrait of Gertrude Stein* Picasso had 152 shown himself inclined to annex this atavistic imagery, which had itself just been put on display in the Louvre. Thus, the impetus for Picasso's formal liberation, whereby (according to Christian Zervos) 'he put into question all previous aesthetic laws', was initially the primitivism of ancient Spanish stone sculpture; we know that early in 1907 Picasso purchased two Iberian statuettes recently stolen from the Louvre. Only later came the exotic and wholly foreign example of African sculpture in wood, which Picasso seems to have ignored until May or June 1907, when he visited the ethnographical museum at the Trocadéro.

The results of an odd anthropological synthesis were dramatically unveiled in an unfinished painting begun in spring 1907, *Les Demoiselles d'Avignon*. In this case 'Avignon' refers to an infamous street (the 153 Carrer de Avinyó) in Barcelona's red-light district once frequented by Picasso. The decisive formal shift in Picasso's use of colour originally operated under dual impulses: post-Impressionist sources, Cézanne in particular, and, more generally, Fauvism. Judged by the reigning academic standards of Picasso's father, besides being incomplete and formally unresolved, this is a defiantly 'ugly' picture, particularly as it is set in a brothel. In the art-historical sense, this Expressionistic, even angry work also marks an epochal moment in the evolution of twentieth-century art-making, which now responds to an anarchic, wholly autonomous, or even self-referential vision. In retrospect, *Les Demoiselles d'Avignon* seems inexorably to point to a quite different art,

154 Pablo Picasso, *Still Life with Chair-Caning*, 1912

namely the classic balance and muted serenity of Picasso's forthcoming series of Cubist masterworks.

Hindsight additionally suggests that none of this would have happened in Barcelona, certainly not on the Carrer de Avinyó. Just as Jusepe de Ribera had had to move to Naples in order to find professional liberation and recognition, Picasso moved to Paris and joined the long list of expatriate Spanish artists. Every 'famous' (or art-historically sanctioned) modern Spanish artist has emigrated; those who remained behind have ended up as regionalist footnotes, typically echoing (mostly verbally) Parisian currents known from avant-garde publications. Typical of those who remained in the homeland was the Madrid-based Arte Nuevo group which employed after the late 1920s a timidly Cubist formal language, later additionally propelled by a content of diluted *surrealismo*.

The subsequent evolution of Cubism after 1910, which probably would not have happened had Picasso remained in his homeland, decisively transformed European notions of creativity and was far more than a mere stylistic reaction. It represented a wholly new vision

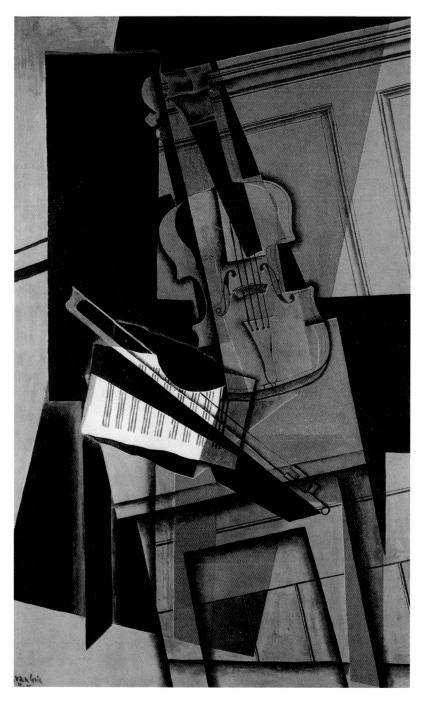

155 Juan Gris, *Violin*, 1916

of the concrete, comparable in many ways to the change of mind-set demanded by the Renaissance. In both cases, the identifying artistic element was perspective, the rational treatment of pictorial space. The Cubist intention was truly revolutionary in that it overturned the seemingly exhausted conventions of pictorial illusionism, which embraced both chiaroscuro and perspective, in order to restore a positive, so-called 'real' or 'concrete', modern vision that would apply a dialectical materialism to art. Just as perspective had been embraced in the Quattrocento as a humanist paradigm, so it was to be decisively rejected by a new and revolutionary modernist paradigm. Such a near-universal renunciation of perspectival construction – space itself – contextually negated a worldly human environment: this worldly element had also been suppressed by early Christian artists. Time, that sequentially unfolding, linear context for narration, was also collapsed in the Cubist vision. Since this anti-spatial and atemporal Cubist art is, like avant-garde creativity in general, no longer required to make a moralizing comment about human behaviour, nor even to refer to the real world, it becomes wholly autonomous. In either instance, the informed contemporary need not ask what it 'means'.

The pictorial seeds of this viewpoint were sown in France much earlier, by Courbet's defiantly proletarian Réalisme, and by Cézanne's post-Realist, rigorous and precociously 'deconstructive' investigations into the structure of natural appearances. Analytical Cubism accepted the modern world's essentially unnatural constructions and man-made industrial artefacts, and embraced an unembarrassed utilization of the 'found object'. With his initial invention of collage, by pasting papers into a drawing entitled *Le Rêve* in 1908, Picasso pioneered this particularly anti-traditional direction.

With the opportune invention of collage, real (or found) objects became physically incorporated into the painterly image. The archetypal Spanish traits of austerity and anti-sensuality were recognized by Gertrude Stein to be an essential part of the Cubist vision: 'Cubism is a purely Spanish conception and only Spaniards can be Cubists. In Spain over the centuries there was produced that which would be one day considered modernist novelty.' The monochromatic, brown, green and grey tonalities which characterize early Analytical Cubism, its taste for many-sided (or multi-faceted) solids inclining to flat patterns, and especially its subject matter, still life, specifically parallel the *bodegones* of the Golden Age of Spanish painting. All this may be seen in a superb example of Analytical Cubism, Picasso's *Still Life with Chair-Caning* (1912), which incorporates real caning. Although it suppressed the

154

emphatic three-dimensionality of earlier Spanish art, the Cubist innovation after 1910 was once again, as in the *bodegones*, to reject pictorial hierarchies and to restore objects to absolute equality, resulting in hyper-realism, as before. Picasso's Analytical Cubism, just as he turned thirty, represents his finest hour as a conscientious craftsman and a usefully innovative artist. We may agree with John Berger: 'The only period in which Picasso consistently developed as an artist was the period of Cubism between 1907 and 1914', when he adds, 'subjectivity was at a minimum'. The First World War was to bring all that to an end.

THE NATIVE SOURCES OF SPANISH CUBISM

It seems no accident that a major innovator of Analytical Cubism, and its most consistently intellectual practitioner, should have been the unfortunately short-lived Juan Gris (José Victoriano González: 1887–1927). Born in Madrid, and another voluntary expatriate in Paris, he was continually criticized by Arte Nuevo spokespersons in Madrid for practising a 'cold' and 'cerebral' style. Wholly traditional, Gris was primarily a methodical painter of superbly crafted *bodegones*. He was also traditional in his affirmation that 'I work with the elements of the spirit, with the imagination; I try to concretize that which is abstract. I go from the general to the particular, which means that I work from an abstraction in order to arrive at a real fact. My art is an art of synthesis, a deductive art…I consider that the structural side of painting is mathematical, the abstract part; I wish to humanize *el lado abstracto*.' A specifically traditional Hispanic formal element consistently evoked in his compositional manner was the *Mudéjar* mode of composition. Gris would have been repeatedly exposed to compositions with this abstract, carefully articulated and diagonally tilted geometrical patterning in his youth. In Madrid, as elsewhere, a fashion for neo-*Mudéjar* decoration was ubiquitous in contemporary brick architecture, much of which still remains highly visible in the Spanish capital; the Plaza de Toros, opened in 1874, is a good example.

The art of Gris is always satisfying, even exalting, particularly if one takes the time to study, and especially meditate upon, his intensely crafted compositions. As many critics have recently remarked, his small-scaled canvases breathe an air of purity, sobriety and humility; they have even been labelled as exemplars of renewed and exemplary *zurbaranismo*. Gris was as obsessed with geometry as Juan de Herrera and probably invested geometric figures with the broadly mystic implications seen in his predecessor's *Tratado del cuerpo cúbico*. Although

it has little specifically to do with art, perhaps the best procedural guide for a broad understanding of the Analytical Cubism of Juan Gris (and Herrera too) might be the *Spiritual Exercises* (1533) of St Ignatius of Loyola. Loyola's thoughtful point of spiritual departure was an intense, analytical 'contemplation of the visible object'. Ignatian vision deals with a wholly mental picture, or 'the representation of place'. Describing the meticulous procedure associated with this detailed mental representation, Ignatius says that the practitioner 'will see in his imagination its length, breadth, and depth...whether it is large or small, whether high or low, and just what it contains'. Just as was the case in medieval Spain and afterwards, one 'praises sacred images, and venerates them according to what they represent'; their very sacramental validity is due in large part to the intensity of their representation.

As had Picasso in painting, Pablo Gargallo (1881–1934) and Julio González (1876–1942) stimulated decisive and radical conceptual reforms of their medium, sculpture. The means of their reform was

156 Julio González,
Woman Combing her Hair, c. 1933–6

essentially material, iron; both were schooled in the venerable Catalan tradition of blacksmithing. Like Picasso, they too were products of the Catalan *Renaixença*. Gargallo was an active participant, creating fantastic, Gaudí-like sculptural programmes for the Hospital de Sant Pau and the Palau de la Música Catalana in Barcelona, both designed by the brilliantly imaginative architect Lluís Domènech i Montaner (1849–1923). González, on the other hand, was trained in Barcelona as a decorative metalworker, just as his artisan family had been before him. Although previously alien to academic sculpture, iron was a fundamental material in Catalan culture, whose fascination with locks and keys, gates and fences, armour and weapons, all made from forged, hammered and welded metal, had long been noted. This traditional craft produced vigorous and directly composed forms expressive of ductility, springiness, weight, sharpness and a fierce linearity. The humble Catalan ironmongers' art created a syntax of airy assemblage for the Cubists.

Gargallo shared a studio with Picasso in Barcelona in 1901 and 1906, before both men went to Paris. Picasso's first 'Cubist' sculpture, the bronze *Head of a Woman* (1909–10), was modelled in González's Parisian studio. Gargallo's first sculptures in iron date from 1911; mostly masks, they reflect Picasso's current interest in African ritual art made from wood and characterized by voids with loosely joined linear and planar elements. Picasso began working in sheet metal in 1912, producing a Cubist *Guitar*, probably the first 'constructed' (as opposed to carved or modelled) sculpture in the history of art. This is an art not of opaque solids, but of dematerialized shapes, bent and twisted lines and planes. González, the modest artisan, did not take up a full-time career as a sculptor until he was past fifty. Beginning in 1928, he helped Picasso to construct objects made from traditional metalworking materials: sheet metal, piping, rod and wire. Asking the master humbly for his permission to 'work in the same manner', González launched his own career, an art of scrap metal. The new credo manifested by his wiry and planar abstractions denies sculpture's traditional values of solidity, organic cohesion and narrative legibility. Ironically, the source of this revolution of established aesthetic values was the tradition-bound, theory-free, proletarian workshop of the Catalan artisan.

156

ART, POLITICS AND WAR

Given the modernist view of the artist as a spokesman for his troubled times, it seems significant that Picasso's art did not react to the barbaric

157 Pablo Picasso, *Guernica*, 1937

butchery of eight million soldiers taking place not far from his com-
fortable Parisian studio. From around 1920, when he began to enjoy
great financial success, his art turned its back upon the convulsed post-
war world and he happily returned to make art in the grand French
tradition, by emphasizing draughtsmanship, style and elegance. In so
doing, his aesthetic diversions paralleled the 'return to order' common
to post-war French culture. Perhaps the expatriate in him was also
responding to commonplace French xenophobia, particularly the
criticism directed at the School of Paris ('a barbaric invasion' by 'Ori-
entals'), which Picasso had helped to found.

In odd vacillations between Expressionism and Surrealism, even
overt Neoclassicism, the post-Cubist Picasso often shows himself to be
the arch neo-Mannerist artist: forms appear largely to be divorced
from content, and styles become mere drapery over a rather bare spiri-
tual armature. The sense conveyed by the obsessively recurrent motif
of the woman is especially telling. Picasso's women are characteristi-
cally naked, pin-headed and big-breasted: brainless sex-objects
voyeuristically rendered by an ageing master. The mellowing Picasso
also returned to the *bodegón* tradition, and used it to develop traditional

212

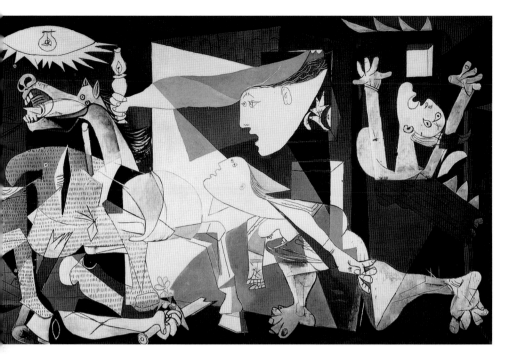

Spanish themes of blood, life and death; these he illustrated with a cat and dead bird or a severed bull's head, using standard Golden Age Vanitas motifs such as candles, lit and extinguished, and many skulls.

An exception among this often routine studio production is the epic canvas commissioned by the Spanish Republican government in 1937 and entitled starkly *Guernica*. In this monumental work, which measures nearly 4 by 8 metres, Picasso seems genuinely outraged at the recent slaughter of Basque civilians by bombs indiscriminately dropped by the German Condor Legion. Unquestionably a potent political totem, *Guernica* has needed to be protected by a bullet-proof plastic shield. Even though its iconography is related to a standard art-historical subject, the Massacre of the Innocents, its simple monochromatic character, a rendition *en grisaille*, probably represents a deliberate attempt by Picasso to simulate a grainy, black-and-white newspaper photograph. After this momentary excursion into genuine ethnic outrage, Picasso reverted to industrious, often elegant disquisitions on the history of art. The works of Ingres and Poussin, Titian, Velázquez and Vermeer, Delacroix and Manet, and even Goya, Van Gogh and Matisse all became stylistic grist for his hyperactive art mill.

158

158 Pablo Picasso, *Study after Velázquez 'Las Meninas'*, 1957

This production began in the Depression, and was continued during the Second World War and its paranoid post-nuclear aftermath, after which he embarked upon a complementary series of paintings with nostalgic Arcadian and Golden Age themes. Thus, once again, Picasso distanced himself from contemporary history and the real world, and prepared the way for a particularly pernicious aspect of postmodern art: ironic art-historical eclecticism and pseudo-erudition.

PARADOXES OF MODERN SPAIN

Another Spanish expatriate artist blessed (or cursed) with plentiful success was the Catalan painter Salvador Dalí (1904–1989). Far beyond any other artist working at that time, Dalí still symbolizes Surrealism to the collective public mind. But questions of Dalí's worth in the strictly art-historical sense seem increasingly pertinent. In the spring of 1926, when he still considered himself an anarchist, Dalí paid his

first visit to avant-garde Paris, and also went to Holland to see the canvases of Vermeer. This trip established the two poles of his subsequent imagery, namely Gallic ideological vanguardism, particularly its aggressively automatist doctrines, and Netherlandish artisan-like miniaturist realism. Dalí began as a rather tentative Cubist, but soon graduated to his self-imposed role as the showman, technician and all-round *enfant terrible* of Surrealism. In the final phases of his career, however, his creative imagination withered somewhat following his conversion from fervent Marxism to an equally fervent Catholicism. In this volte-face are indications of an ideological schizophrenia for which there is also abundant evidence in his work and his life. His mother, whom he adored, was a pious Catholic, his father an atheist and Republican. The ageing painter also declared himself a monarchist, and so became acceptable, even approved, in Franco's Spain, where his apparitional *surrealismo* became an orthodox mode deemed fit for Falangist graphic propaganda. Long since dubbed 'Avida Dollars' by a disgusted André Breton, in 1964 Dalí was awarded the Grand Cross of the Order of Isabella the Catholic.

Perhaps this dilemma reflects the disjointed, 'invertebrate' character of Spanish society itself, so described in 1921 by José Ortega y Gasset. On the other hand, perhaps Dalí was merely embarrassed by his abundant, although flawed, talents. Perhaps he would have been a better artist had fame not seduced him so early in a career that probably spanned far too many decades. Dalí's occasionally miniaturist style was used to create what he called 'hand-painted dream photographs' that recapitulated endlessly his fantastic, neurotic and megalomaniac childhood experiences. His technique manifests his adulation of the precisions and clotted colorations of nineteenth-century academicians such as Jean Millet, Arnold Böcklin and, most particularly, Jean-Louis-Ernest Meissonier. Dawn Ades has described his formal characteristics as 'a comparatively commonplace academic technique borrowed from despised nineteenth-century masters…now unfamiliar enough to be dazzling'. Dalí devoured Freud's *Interpretation of Dreams* as a student in Madrid, and his art was patently post-Freudian with elements of Italian *metafísica* and Picasso's 'neo-Neoclassicism'. Dalí had even formulated a theoretical stance for his production that he amusingly labelled 'paranoic-critical'. Ades also neatly sums up the conventionality of his famous subject matter: 'Dalí is in fact treating the iconography of the [modernist] science of psychoanalysis as though it were common property, in the way that religious iconography was common property in the Middle Ages.'

Besides typifying the look of the Dalí corpus, revelatory of the pathological essence of his content is the canvas entitled *The Metamorphosis of Narcissus* (1937). Another, probably similarly self-confessional, work was aptly called *The Great Masturbator* (1929). Posterity might more warmly recall Dalí's brief cinematic collaboration with Luis Buñuel (1900–1983) in *Un Chien Andalou* (1928) and *L'Age d'Or* (1930). Buñuel stated that their mutual purpose was to make 'a film deliberately anti-plastic, anti-artistic…the result of a conscious psychic automatism…it profits by a mechanism analogous to that of dreams.' Another reason for this assertion of Dalí's greater success as a cinematic artist is largely technical. 'Concrete' Surrealism seems better suited to film: the images pass so quickly that one does not have to dwell overlong upon them; closer scrutiny often reveals banality. Historically, the traditional Spanish taste for the popular theatre has ensured that *cine-drama* is well received in Spain.

In contrast to the extravagant and self-proclaiming Dalí, the Catalan artist Joan Miró (1893–1983) was a master equally of the Surrealist idiom and of painting itself. He grew up in Barcelona, enthralled by the Catalan Romanesque wall paintings exhibited there and by the omnipresent modernist architectural fantasies of Domènech i Montaner and Gaudí. In 1924 he became a long-term resident in France,

but remained in love with his native land and never felt any obligation to renounce Catalan tradition and its adventurous creativity, upon which he built in a uniquely flexible manner. His distortions are both meaningful and witty, and his consistent dedication to and belief in his art is impressive, regardless of its often breathtaking stylistic mutations, including his imaginative sculptural exercises. In contrast, Picasso and Dalí seem often merely industriously expressive manipulators, albeit endlessly clever and entertaining ones. Miró's art manages to be genuinely spontaneous and unpretentiously charming without descending to the melodramatic or the doctrinaire.

Stylistically, Miró began by using vivid, Fauve-like colour harmonies sometimes reminiscent of Cézanne and Van Gogh. In his 'folk-art' rendition of his family farm, *Garden with Donkey* (1918) he was also most appreciative of the naïve seriousness of critically accepted neo-folk artists such as Henri 'Le Douanier' Rousseau. Miró continued with a geometric and primitive realism until 1924, after which he moved into a uniquely convincing world of fantastic forms and situations. Miró's 'abstract' Surrealism, which he shares with André Masson in France among others, is variously known as 'biomorphic', 'organic', or 'absolute'. In wholly artistic terms, it represents a more convincing approach to the Surrealist goal of revealing unconscious dream states through conscious manipulation of artistic materials than Dalí's meticulous 'painted photographs'. Specifically considered as a creative doctrine formulated by André Breton, the primary spokesman for Surrealist doctrine, it represents pure automatism, *l'automatisme psychique*, a spontaneous act derived wholly from the artist's unconsciousness.

Helpfully, Miró left verbal testimony to his own automatist practice: 'Without letting myself be guided by any preconceived idea, I put

159 (*left*) Salvador Dalí, *The Metamorphosis of Narcissus*, 1937

160 (*right*) Joan Miró, *Garden with Donkey*, 1918

161 Joan Miró, *Canvas*, 1953

my brushes in petrol and, to dry them, I dragged them over the white pages of my drawing book. The blotches on the surface put me in a proper state and so provoked the birth of shapes: human figures, animals, stars, the whole sky, the moon and the sun. I drew all that energetically in charcoal. Once I attained a pictorial balance and got all the elements in the right order, I began to paint in gouache with the meticulous application of the artisan and the folk-artist; this labour took some time.' In its liberation from the material and the concrete and its unfettered response to artistic media verging on *Tachisme* ('action painting'), Miró's work set a strong art-historical precedent for Abstract Expressionism in America. Miró had been a regular exhibitor in New York since 1941 and, as leader of the 'organic' Surrealists, he made a profound impact on post-war American painters emerging from the artistic confines of 'Regionalist' and 'Social Realist' imagery which characterized the dreary era of the Depression.

Mention must be made of the 'Franco Aesthetic', if only because it was (and still is) omnipresent in Spain and because its Messianic milieu lasted some four decades. It is interesting to observe how a government-sponsored, Regionalist, Social Realist and symbolically 'American' iconography ideologically paralleled a similarly polemical art in Falangist Spain. As elsewhere, a localized *folklórico* imagery – with weathered peasants and heroic troopers inhabiting bleak, Castilian-heartland, pastoral landscapes – was favoured by the Franco government after the triumph of its 'Crusade' or 'National Uprising'

218

(known to the rest of Europe as the Spanish Civil War) and well into the 1950s. Progressive European artists emerging in the post-war period conceived a common strategy of turning their backs upon a government-sponsored national Social Realism. For them, Spaniards included, the most obvious artistic tactic was a defiantly international, anti-social and anti-realistic style. The positive legacy of Franco's 'nationalist' art is essentially spiritual, although it is not the one intended by the now defunct Caudillo (little chieftain): he gave maturing Spanish youth something concrete to revolt against. The artists who came to maturity in Spain during the 1960s and 1970s had all received a thoroughly propagandistic 'National Catholic' education. A ubiquitous slogan tendentiously described a Spain 'una, grande y libre', meaning with one will, doctrine, and leader, great for its spiritual empire, and free from control by 'Jewish-capitalist states'.

The visual products of the Franco regime were pure 'Propaganda Fide', a term used by E. Giménez Caballero as early as 1935. In architecture – for instance the Air Ministry in Madrid (1943–57) – the venerable model was the Escorial, mainly because it nostalgically symbolized Catholic imperialism. According to an unambiguous 1939 decree, in all cases 'Architecture expresses the power and mission of the State.' In sculpture (as in Mussolini's Italy and Hitler's Germany), the preferred style was Neoclassicism often with inadvertent Art Deco accents, but preferably with martial and/or *castizo* subjects, and the bigger the better; the virtuoso *toreros* of Mariano Benlliure were cited with approval. As initially conceived by Generalísimo Francisco Franco, the grandiose 'Valley of the Fallen', an exclusively Falangist pantheon begun alongside the Escorial in 1942 and inaugurated in 1958, employed both sculpture and architecture to advance the equally colossal and oppressive imperial Catholic platform. The approved mentor of painters, still living, was Ignacio Zuloaga, who executed a flashy state portrait of the Caudillo in Carlist, Falangist costume in 1941. Zuloaga was lauded as the established 'artist most disposed to place his pictorial values at the service of the State'. Among the younger generation, probably most prolific was Carlos Sáenz de Tejada (1897–1957), a vigorous draughtsman whose neo-Mannerist displays of anorexic warriors once filled innumerable state-sponsored publications. A seemingly more 'progressive' graphic art – that propagated by a now-Catholic Dalí – was practised by José Caballero (1916–91). An illustration from *Laureados de España* (1939) shows a heroic National Catholic soldier crouching in the Surrealist ruins of the Marxist University of Madrid. The soldier is saluted by a Daliesque airborne angel

162

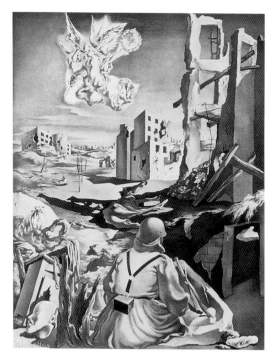

162 (*left*) José Caballero, *Falangist Soldier with the Angel of Victory*, illustration from *Laureados de España*, 1939

163 (*right*) Antoni Tàpies, *Black Form on Grey Square*, 1960

bearing mystical tokens of Franco's quest for *la Hispanidad*, his crusade against whatever was deemed 'anti-national, anti-traditional and *bolchevique*'.

The murderous physical and psychological devastation wrought by the Civil War, along with the continued ideological repressions of the Franco government and a collapsed post-war economy in Spain, restrained progress in the arts for over a decade. To make matters worse, after 1946, Europe self-righteously turned its back on the only Fascist regime to have survived the Second World War. Indeed, a blockade imposed by the victorious Allies threatened total economic disaster. Spain was treated as an international pariah and the immediate future seemed to promise only material bankruptcy and spiritual collapse. The end of this cultural stagnation was signalled by the founding in 1948 of group called 'Dau al Set' ('Seven-Spot Die' in Catalan). This presented yet another modernist 'School of Barcelona', like *el modernisme* half a century earlier. And, like the earlier movement, it too was fuelled by foreign sources.

The Dau al Set group was mainly propelled by poets and essayists in close contact with the French Surrealists. One of their leading

theoreticians was Juan Eduardo Cirlot (1916–1973), a parallel figure to André Breton in France. Like their Gallic counterparts, the Catalans celebrated dream-states and psychic automatism. For the most part however, the pictures produced by the Barcelona fellowship are derivative ruminations on the celebrated and impressively diverse imagery of Joan Miró, a revered Catalan father-figure, as well that of Paul Klee and Max Ernst. The iconographic significance of their symbol-laden paintings can easily be deciphered with reference to Cirlot's *Diccionario de símbolos* (1958). The artists associated with the Dau al Set group during its brief heyday were Joan Ponç (1927–1984), Modest Cuixart (b. 1925) and Joan-Josep Tharrats (b. 1918).

Today, however, the non-Spanish world mainly remembers Antoni Tàpies (b. 1923), and that is due to his embrace, after 1953, of a wholly different, post-Surrealist European imagery. As enshrined in his 'material paintings', this radical innovation only occurred after the dissolution of the Dau al Set group. A quintessential example is Tàpies' opaque canvas of 1960, descriptively entitled *Black Form on Grey Square*. A thick gritty texture suggests a wall encrusted with the graffiti of generations. Torn burlap and earthy impasto provide

meditational materials reminiscent of the expressive crudity of Goya's *pinturas negras*. Tàpies explained that he 'was obsessed with material-ism, the pastiness of phenomena, which I interpreted using thick material, a mixture of oil paint and whiting, like a kind of inner raw material that reveals a "noumenal" reality…the single, total and genuine, reality of which everything is composed'.

But official acceptance of, rather than passive permission for, the execution of radically abstract painting in Spain came to pass in the place where one would have least expected it, Madrid, and at a most unlikely time, the height of Franco's power. Until this point, there had been no official encouragement for radical avant-garde art movements operating within Spain: there were only expatriate vanguard artists individually working abroad. A sign of the rise of the culturally pro-gressive 'new Spain' was the Madrid-based El Paso group of painters. Formed in 1957, the group included Manuel Millares (1926–1972), Antonio Saura (b. 1930), Rafael Canogar (b. 1935) and Luis Feito (b. 1929). While determined to be 'modern' in the international sense, by their own admission they also tried very hard to remain Spanish.

Through the specific means of Informalism, they initially adopted a post-Cubist radical abstraction in which they questioned ethically the established principles of theoretical and doctrinaire compositional correctness. They opposed illusionism *per se* and the enshrined priority of elegance and attractiveness, and championed vigorously direct and unrestrained expression. They also insisted upon truth to materials and refused to deny the literal significance of objects and textures as things in themselves. The title of one of Saura's canvases, a vigorously painted and abstractly expressive *Imaginary Portrait of Goya No. II* (1967), where dynamic paint-swirls blossom like the unrestrained polychrome foliage of a Baroque *retablo*, provides evidence of a patent nostalgia for earlier, pre-abstract native modes. But Millares was the real pioneer of radical pictorial innovation. Explicitly referring to the España Negra of the Habsburgs, his *Sarcophagus for Philip II* (1963) is a 'painting' made from ripped and crudely stitched burlap embellished with blotches of smeared, emblematically industrial, enamel paints. Employing the waste materials of industrial society, this rude image is both pessimistic and modern, and thus revisits the Tremendismo so critical of 'Black Spain'.

These post-war, radical abstract artists collectively represent an Iberian appropriation and synthesis of American Action Painting and mainstream European Informalism. During the Cold War under Eisenhower, the United States eagerly welcomed Franco's equally

164 Antonio Saura, *Imaginary Portrait of Goya No. II*, 1967

165 Manuel Millares, *Sarcophagus for Philip II*, 1963

eager collaboration in its shrilly anti-Communist crusades, with the result that American military bases were installed on Iberian soil in 1953. Membership of UNESCO and the UN (1955) followed, and Spain benefited greatly from joining the Free World, rhetorically 'defending' European capitalist civilization against the aggression of a godless Soviet Union. Spain also needed to enhance its despicably reactionary cultural image. How better than to prove its progressive integration into the mainstream of the modern world than to champion officially, as it never had before, stridently modern art? Accordingly, in 1951, the Institute of Hispanic Culture mounted in Madrid the First Hispano-American Biennial and, in 1953, the First International Congress of Abstract Art was celebrated in Santander. In February 1957, the initial El Paso 'Manifesto' was published, announcing the foundation of 'a future art more *español* and universal'; this was needed 'in the present moment, because of a lack of constructive art criticism, a marketing apparatus, and exhibits to orient the public'. The concurrent expression of an overtly 'ideological formulation' was additionally noted by various writers, and the painter Antonio Saura stated in 1957 that in this 'future Spanish art...there should predominate certain characteristics preserved as constants in Iberian art of all times'.

The new Spanish painting made its first major impact on the international art scene late in 1957, at the prestigious São Paulo Biennial, and again the following year at the 19th Venice Biennale. In both instances the selection of artists was rigorously supervised by a government official, Luis González Robles, who wanted to present specifically 'Spanish characteristics'. Progressive European critics were seduced by what were called the 'typically Iberian' characteristics of 'austerity' and 'violence'. In June 1959, a French writer, L. Söderberg, described Spanish *casticismo*, an art made 'according to the intimate rites of a race unconcerned with the traditional canons of beauty...They unite in this way aesthetic renovation to an historical consciousness. At the very least they remain in contact with a certain Iberian tradition characterized by infinite gifts for invention, a limitless imaginative force linked to a flawless sense of reality accompanied by a formal expressiveness which can be traced from Velázquez, El Greco, Goya, and right up to Picasso.' This was the conventional European view of un-canonic Spanish creativity, a fulfilment of cultural stereotypes held since the discovery of Goya by Romantic writers in France a century before.

Immediately thereafter, the Museum of Modern Art in New York and some prestigious European cultural institutions purchased

canvases by Millares and other exhibitors; the rest is (art) history. A French chronicler of the El Paso movement, Laurence Toussaint, explains the zealous sponsorship by the Franco government of an art describing itself as antithetical to Fascist art, an 'anti-academic' and 'revolutionary-plastic' art given, by its own admission, to 'protests': because such painting was so 'abstract, due to its very hermeticism it could not propound any specifically revolutionary ideas. Even though informal art may have represented a shout of rebellion in the minds of its creators, it was unable to denounce any injustice. Because of its very abstraction, it could only express what the viewer wished himself to see in it. The government in Madrid understood that it was a waste of time to forbid it since, by its own definition, it was incapable of transmitting any subversive messages.'

The latent political message of Spanish Informalism was therefore that, in spite of appearances, Franco's Spain was not oppressive, and was fully in tune with the open-minded cosmopolitan currents of the Free World. Thus even the most oblique and hermetically self-referential avant-garde imagery could be absorbed into the larger political polemic of Spain's desperate attempts to liberate herself from the culturally despicable and economically disastrous period of Fascism.

FALLING INTO POSTMODERNISM

As in the rest of the Free World, by the late 1960s a 'post-painterly' reaction had also become fashionable in Spain; it was known specifically as 'anti-informalismo': a return to empirically identifiable or readily legible imagery. Mainly by drawing upon the international visual currency of Pop art and Super Realism, younger, rising painters attempted to express the modern mood by creating new variations on venerable native traditions while retaining a unique, national flavour. One such neo-traditionalist is Antonio López, whose work was first acclaimed in the late 1960s as a new 'Madrid Realism'. Like a Baroque master, he is proficient in realistic painting, also crafting polychrome wooden sculpture and complex assemblages. In a reiteration of Tremendist attitudes, his principal subject matter is the shabby and alienated way of life of dispossessed Spaniards who have moved to Madrid to seek a precarious living. In a similar vein, Juan Genovés (b. 1930) used the mass-produced photograph to make a chilling comment, as Goya might have done, on the role of 'mass-man' as victim; adopted by the Marlborough Galleries, he momentarily made himself a fashionable figure in the New York–London art world.

166

167

166 (*left*) Antonio López, *Taza de Water y Ventana*, 1968–71

167 (*below*) Juan Genovés, *El Foco*, 1966

168 (*right*) Equipo Crónica, *'El Perro' Posición, Autoretrato en Palacio*, 1970

Also emblematic of the Spanish art scene in the 1970s was the Equipo Crónica (Chronicle Team), which was founded in 1964. This was literally a 'team' – acclaimed and purchased even within Spain – based in Valencia; its captains were Manuel Valdés (b. 1942) and Rafael Solbes (1940–1981), and perhaps half-a-dozen artists worked on its production lines at a given moment. While it was probably the most blatant Pop manifestation in Spain, it seems in retrospect precociously postmodern (the term *postmodernismo* was perhaps first coined in 1934 by Federico de Onís while discussing a backlash in Spanish poetry). The group celebrated the mass media in a typically postmodern manner: images are portrayed as disembodied cultural 'signs'. Even more precociously postmodern was its blatant art-historical – and Spanish – self-referentiality. Equipo Crónica earnestly, and with considerable irony, recycled the canonic images of the venerable Iberian artistic patrimony. Although Velázquez was the group's principal subject (or target), the other great names of the national heritage became a source

227

for their didactic, but typically amusing, canvases too. El Greco, Ribera, Zurbarán, Goya, Sorolla y Bastida, Dalí, Picasso (especially in *Guernica*), and even Millares and Saura all became fitting targets for the group's reiterated professional criticisms of so-called classic Spanish painting. Above all, these pictorial polemics covertly criticized the Franco regime and its rejection of modern political realities.

If the main concern of the culturally rootless and aesthetically and stylistically confused mid-Atlantic artist has been an often heartless search for novelties, then the concern which now confronts the Spaniard in the dynamic but uneasy post-Franco era is a more fundamental one: *Renovatio*. Spain is no longer a static agrarian state, but rather an industrial nation, a society of consumers. By the time observers imagine that they have grasped the shape and significance of the avant-garde, post-mortems are being performed by the art-historical rearguard. The traditional, or archetypal (perhaps even mythic), Spaniard flourished mainly before the onset of our present postmodern condition, which seems coincidentally to have emerged everywhere in the so-called developed world in around 1975, an *annus mirabilis* that saw the death of Francisco Franco, that quintessentially orthodox modernist dictator. Now, in an exuberantly democratic nation headed by an egalitarian king, Juan Carlos, Spaniards seem determined to become 'modern', true Europeans.

In 1985, the most fashionable of the young painters, Miquel Barceló stated: 'I belong to a generation which, for the moment, has produced scarcely any poets, a few painters, many pop guitarists and, above all, a great many Yanks (*yanquis*).' Consequently, 'advanced' Spanish art now mostly resembles imagery currently prestigious in Europe and (especially) North America. Since the international avant-garde mentality is implicitly anti-popular, and certainly anti-traditional, it goes against the main interests of traditional Spanish art. Moreover, post-Franco Spain, like all other technologically advanced nations eagerly participating in the international capitalism, feels that progress, even in the visual arts, is usually best achieved by leaving behind a painful history. Particularly since the restoration of democracy in 1977, Spain has turned away from its tradition of introspection and is now determined to discover the novelties so eagerly consumed by the rest of the modern world.

These points may be illustrated by the representative work of artists recently acclaimed within Spain itself, who are now financially supported by both a culturally progressive, Europeanized government and new, middle-class art collectors, the latter historically unparalleled in

169 Luis Gordillo, *Adam Y Eva A*, 1973

Spain for either their number or enthusiasm. This economically charged 'renaissance' of Spanish painting and art-collecting took place during the 1980s, an era of feverish financial speculation which coincided with the Reagan–Thatcher era in the United States of America and Great Britain. In Spain, as the art historian Francisco Calvo Serraller acutely observed, 'Spanishness became the principal subject of contemporary Spanish art.' The broad cultural context for this is, he continues, 'an urban, industrialized and media-driven civilization which has progressively destroyed all anthropological consciousness of an artistic identity based upon local roots...[and]...instead transformed that into something mythical.'

A good example of the post-Franco, post-painterly mentality is Luis Gordillo (b. 1934). After having eclectically run through all the currently fashionable European styles – Informalism, neo-figuration, Pop, among others – Gordillo experienced a professional crisis. His solution was a synthesis of styles. He explains that his compositions are

initially derived from an automatist (or unplanned, wholly spontaneous and 'thoughtless') drawing technique. He then fills his canvas with Pop images, fragments chosen, he says, by chance from the ubiquitous iconic bombardments of the mass media. Another currently acclaimed artist is Darío Villalba (b. 1939), who superimposes photography upon painting and vice versa, employing fragmented imagery and serial repetition. According to Calvo Serraller, Villalba 'best represents the stereotype of Spanish expressionism, that dark interior, made out of violence, hallucination and mysticism'. Guillermo Pérez Villalta (b. 1948) employs realistic figuration to express a dense, symbolic language such as that employed by the post-Tridentine painters, but without any reference to standard Catholic iconography. Villalta considers himself to be something of a learned painter in the Renaissance mode. He explains: 'Scepticism about modern artistic movements made the Prado and books about art my favourite places of recreation.' A rather different approach is taken by Ferrán García Sevilla (b. 1949), who combines the modernist 'traditions' initially established by Miró and Tàpies with poignant messages obliquely scrawled in graffiti. Working in a more Formalist idiom, the bleak metal sculpture of Susana Solano (b. 1946) harks back to the craftsperson-generated abstractions pioneered by Gargallo and González. Presently, the most internationally lionized Spanish painter is the relatively youthful Miquel Barceló (b. 1957). His stratagem, also having its roots in pictorial *tradicionalismo*, is to create tension between a rigorously composed perspectival composition and a superimposed and almost impenetrable object. Thus the 'double game' (*doble juego*), as he calls it, is a dialectical opposition between rigid geometry (a mental construction), and largely unformed matter: 'This mutation of matter is what excites me in painting; that's my theme.'

Likewise, as has been repeatedly argued here, the implicit basis of traditional Spanish imagery has been that same uneasy dialectic between the spirit and this world, between mind and matter, between utopian expectations and mundane, straightforward reportage. Lacking a crystal ball, no art historian can predict the future course of Spanish art. Nonetheless, we can be certain that it will, somehow, remain uniquely Spanish while eagerly responding to international fashion. Two examples of contemporary architecture hint at future directions. The handsome National Museum of Roman Art in Mérida, opened in 1985 and designed by Rafael Moneo (b. 1937), uses a concrete core revetted in brick in a brilliant postmodern synthesis of indigenous Roman and Romanesque forms and materials. The

170 Miquel Barceló, *Big Spanish Dinner*, 1985

controversial Museo Guggenheim, ostentatiously erected in post-industrial Bilbao, the Basque capital, by the lionized Californian architect Frank Gehry (b. 1929), is a titanium-clad *tour de force* to which reactions have been widely divergent. Whereas others speak of a snug 'global village', Antonio Saura recognizes the real postmodern impulse behind this grandiose international project: 'a massive cultural tourism.' The architectural historian Juan Antonio Ramírez has described Gehry's cleverly 'deconstructive' museum as a 'cultural franchise', a sign of the 'McDonaldization of the universe', also suggesting a 'California jokiness at the expense of the tribal tragedy' of the Basques. It is intriguing to wonder how the great masters of the Golden Age would react to this profit-driven and globalized 'culture of spectacle'. Times have changed.

Select Bibliography

General surveys and historico-cultural analyses
Ars Hispaniae (various authors), 18 vols, Madrid, 1947–.
Bertrand, Louis, and Sir Charles Petrie, *The History of Spain: From the Musulmans to Franco*, New York, 1971.
Bevan, Bernard, *History of Spanish Architecture*, London, 1938.
Brenan, Gerald, *The Literature of the Spanish People*, Cambridge, 1951.
Crow, John A., *Spain, the Root and the Flower: An Interpretation of Spain and the Spanish People*, Berkeley, Calif., 1985.
Gudiol Ricart, José, *The Arts of Spain*, London, 1964.
Hagen, Oskar, *Patterns and Principles of Spanish Art*, Madison, Wis., 1948.
Hooper, John, *The New Spaniards*, London, 1995.
Hughes, Robert, *Barcelona*, New York, 1993.
Introducción al Arte Español (various authors), 9 vols, Madrid, 1994–7.
Menéndez Pidal, Ramón, *The Spaniards in their History*, New York, 1966.
Michener, James A., *Iberia: Spanish Travels and Reflection*, New York, 1969.
Post, Chandler R., *A History of Spanish Painting*, 14 vols, New Haven, Conn., 1930–66.
Pritchett, V. S., *The Spanish Temper*, New York, 1965.

Chapter One
Arribas, Antonio, *The Iberians*, London, 1963.
Harrison, Richard J., *Spain at the Dawn of History*, London, 1988.
Keay, Simon J., *Roman Spain*, Berkeley, Calif., 1988.
Los Iberos, Barcelona, 1998.
MacKendrick, Paul, *The Iberian Stones Speak: Archaeology in Spain and Portugal*, New York, 1969.
Moffitt, John F., *Art Forgery: The Case of the Lady of Elche*, Gainesville, Fla., 1995.
Savory, Hubert N., *Spain and Portugal: The Prehistory of the Iberian Peninsula*, London, 1968.

Chapter Two
Dodds, Jerrilynn D., *Architecture and Ideology in Early Medieval Spain*, University Park, Pa., 1990.
———— (ed.), *Al-Andalus: The Art of Islamic Spain*, New York, 1992.
Montequín, François-Auguste de, *Compendium of Hispano-Islamic Art and Architecture*, Hamline University, Minn., 1976.
O'Neill, John P. (ed.), *The Art of Medieval Spain, AD 500–1200*, New York, 1993.
Palol, Pedro and Max Hirmer, *Early Medieval Art in Spain*, New York, 1966.
Williams, John, *Early Spanish Manuscript Illumination*, New York, 1977.

Chapter Three
Berg Sobré, Judith, *Behind the Altar Table: The Development of the Painted Retable in Spain, 1350–1500*, Columbia, Miss., 1989.
Grabar, Oleg, *The Alhambra*, Harmondsworth, 1978.
Mann, Vivian B., et al. (eds), *Convivencia: Jews, Muslims, and Christians in Medieval Spain*, New York, 1992.
Young, Eric, *Bartolomé Bermejo: The Great Hispano-Flemish Master*, London, 1975.

Chapter Four
Brown, Jonathan, et al., *El Greco of Toledo*, Boston, Mass., 1982.
Davies, David, *El Greco*, Oxford and New York, 1976.
Elliott, J. H., *Imperial Spain, 1469–1716*, New York, 1963.
Kubler, George, *Building the Escorial*, Princeton, N. J., 1982.
Mallory, Nina Ayala, *El Greco to Murillo: Spanish Painting in the Golden Age, 1556–1700*, New York, 1990.
Rosenthal, Earl, *The Palace of Charles V in Granada*, Princeton, N. J., 1985.
Soria, Martin and George Kubler, *Art and Architecture in Spain and Portugal and their American Dominions, 1500–1800*, Harmondsworth, 1959.

Chapter Five
Brown, Jonathan, *Images and Ideas in Seventeenth-Century Spanish Painting*, New Haven, Conn., and London, 1978.
————, *Velázquez: Painter and Courtier*, New Haven, Conn., and London, 1986.
————, *The Golden Age of Painting in Spain*, New Haven, Conn., and London, 1991.
———— and Robert Enggass (eds), *Sources and Documents in the History of Art: Italy and Spain, 1600–1750*, Englewood Cliffs, N. J., 1970.
Maravall, José Antonio, *Culture of the Baroque: Analysis of a Historical Structure*, Minneapolis, Minn., 1986.
Moffitt, John F., *Velázquez: Práctica e idea (Estudios dispersos)*, Málaga, 1991.
Stoichita, Victor I., *Visionary Experience in the Golden Age of Spanish Art*, London, 1995.

Chapter Six
Gassier, Pierre and Juliet Wilson, *The Life and Complete Work of Francisco Goya*, New York, 1971.
Glendinning, Nigel, *Goya and His Critics*, New Haven, Conn., and London, 1977.
Licht, Fred S., *Goya in Perspective*, New York, 1973.
Reyero, Carlos, *La pintura de historia en España: Esplendor de un género en el siglo XIX*, Madrid, 1988.

Chapter Seven
Ades, Dawn, *Dalí and Surrealism*, London, 1982.
Berger, John, *The Success and Failure of Picasso*, Harmondsworth, 1965.
Brown, Jonathan (ed.), *Picasso and the Spanish Tradition*, New Haven, Conn., and London, 1996.
Calvo Serraller, Francisco, *Del futuro al pasado: Vanguardia y tradición en el arte español contemporáneo*, Madrid, 1988.
Cervera, J. P., *Modernismo: The Catalan Renaissance of the Arts*, New York and London, 1976.
Cirlot, Juan Eduardo, *A Dictionary of Symbols*, New York, 1962.
Cirlot, Lourdes, *El grupo 'Dau al Set'*, Madrid, 1986.
Harris, Derek (ed.), *The Spanish Avant-Garde*, Manchester, 1995.
Kaplan, Temma, *Red City, Blue Period: Social Movements in Picasso's Barcelona*, Berkeley, Calif., 1993.
Morris, C. Brian, *Surrealism and Spain, 1920–1936*, Cambridge, 1979.
Oppler, Ellen C. (ed.), *Picasso's Guernica*, New York, 1988.
Penrose, Roland, *Miró*, London, 1985.
Rubin, William (ed.), *Pablo Picasso: A Retrospective*, New York, 1980.

List of Illustrations

Measurements are given in centimetres, followed by inches, height before width before depth, unless otherwise stated.

Frontispiece Francisco de Zurbarán, *St Serapion*, c. 1628. Oil on canvas, 120 × 103 (47¼ × 40½). Courtesy the Wadsworth Atheneum, Hartford, Connecticut.

Map drawn by Ben Cracknell Studios.

1 Painted rock protuberance in a cave at Altamira, c. 8500 BC. Photo Archivo Fotográfico Museo Arqueológico Nacional, Madrid.

2 Wall painting in the Cueva de Araña, Bicorp, 'The Fate of a Bee-Robbing Honey-Gatherer', c. 5000 BC. Photo Oronoz.

3 The Bulls of Guisando, c. 200 BC. Photo Oronoz.

4 Tomb at Pozo Moro, c. 500 BC as reconstructed in the Museo Arqueológico Nacional, Madrid. Photo Archivo Fotográfico Museo Arqueológico Nacional, Madrid.

5 Sculptural relief from tomb at Pozo Moro, c. 500 BC. Photo Archivo Fotográfico Museo Arqueológico Nacional, Madrid.

6 Sculptural relief from the *Heroön* at Porcuna, c. 425 BC. Photo Archivo Fotográfico Museo Arqueológico Nacional, Madrid.

7 Iberian ceramic vessel, 450–150 BC. Photo Archivo Fotográfico Museo Arqueológico Nacional, Madrid.

8 The *Lady of Baza*, 400–350 BC. Polychromed limestone figure. Photo Archivo Fotográfico Museo Arqueológico Nacional, Madrid.

9 Sculptural fragment from the temple precinct at Osuna, c. 50 BC. Limestone, 65 (25⅝). Photo Archivo Fotográfico Museo Arqueológico Nacional, Madrid.

10 The *scenae frons* at the Roman theatre, Mérida, begun 18 BC and completed c. AD 200. Photo Martin Hürlimann.

11 Roman mosaic from Bell-lloc del Pla, c. AD 150. Museo Arqueológico, Barcelona.

12 Roman floor mosaic from Cuevas de Soria, c. AD 150. Photo Archivo Fotográfico Museo Arqueológico Nacional, Madrid.

13 A page from the *Codex Vigilano*, 976. El Escorial. Photo Hirmer.

14 Bas-relief sculpture from Santa María de Quintanilla de las Viñas, c. 690. Photo Hirmer.

15 Bas-relief sculpture from San Pedro de la Nave, c. 691. Photo Institut Amatller d'Art Hispanic, Barcelona.

16 Magius, *Angels Presenting the Gospel of St John*, from the *Commentary on the Apocalypse* by Beatus de Liébana, c. 950. Photo The Pierpont Morgan Library/Art Resource, New York.

17 Interior of Santa Combe de Bande, c. 670. Photo Oronoz.

18, 19 Interior of the Great Mosque, Córdoba: portal of the *mihrab*, 965; nave, 987. Photos Walter B. Denny.

20 Reconstruction of mural-cycles in the nave and transept of San Julián de los Prados, Oviedo, c. 830. Photo Institut Amatller d'Art Hispanic, Barcelona.

21 Santa María de Naranco, Oviedo, 842–50. Photo Hirmer.

22 *Cross of the Angels*, 808. Gold filigree, jewels, stones and cameos. Cathedral Treasury, Oviedo. Photo Institut Amatller d'Art Hispanic, Barcelona.

23 Magius, *The Heavenly Jerusalem*, from the *Commentary on the Apocalypse* by Beatus de Liébana, c. 950. Photo The Pierpont Morgan Library/Art Resource, New York.

24 San Miguel de Escalada, 913. Photo Hirmer.

25 Ende, *The Woman on the Seven-Headed Beast*, from the *Commentary on the Apocalypse* by Beatus de Liébana, c. 975. Gerona Cathedral. Photo Hirmer.

26 *Last Supper*, mural from the Hermitage of San Baudelio, Casillas de Berlanga, c. 1125. Courtesy the Museum of Fine Arts, Boston.

27 *Elephant*, mural from the Hermitage of San Baudelio, Casillas de Berlanga, c. 1125. The Metropolitan Museum of Art, New York. The Cloisters Collection.

28 Tympanum from the Puerta de las Platerías, Cathedral of Santiago de Compostela, c. 1100. Photo Martin Hürlimann.

29 Master Mateo, Pórtico de la Gloria, Cathedral of Santiago de Compostela, 1168–88. Photo Hirmer.

30 The façade of Santa María de Ripoll, c. 1160. Photo Hirmer.

31 *Christ in Majesty with the Symbols of the Four Evangelists, Angels and Saints.* Apse mural from the Church of San Clemente de Tahull, 1123. Museu Nacional d'Art de Catalunya, Barcelona. Photo MNAC Photographic Services (Calveras, Mérida, Sagristà).

32 *The Creation of Adam, and the Original Sin.* Apse mural from the chapel of the Hermitage of the Holy Cross, Maderuelo, c. 1125. Museo del Prado, Madrid.

33 Ceiling paintings from the Pantheon of the Kings, beneath the Palatine Church of San Isidoro, León, c. 1105. Photo Hirmer.

34 *Crucifixion with Fernando I and Queen Sancha.* Ceiling painting from the Palatine Church of San Isidoro, León, c. 1105.

35 A page from the *Cantigas de Santa María de Alfonso X, el Sabio*, c. 1280. Biblioteca del Palacio Real, Madrid.

36, 37 *The Life and Martyrdom of St Julita and her son St Quiricus*, a painted wooden *antependium* from the hermitage church of Santa Julita de Durro, c. 1170. 100 × 120 (37⅜ × 47¼). *Funeral Procession*, a painted wooden panel from the sepulchre of Don Sancho Saínz Carillo, Mahamud, c. 1330. 54 × 87.2 (21¼ × 34½). Museu Nacional d'Art de Catalunya, Barcelona. Photos MNAC Photographic Services (Calveras, Mérida, Sagristà).

38 *Deposition* from Erill la Vall, c. 1180. Polychromed wooden sculptures. Museu Arqueologic-Artistic Episcopal, Vic.

39 Francisco Salzillo, *Agony in the Garden*, 1754 (detail). Museo Salzillo, Murcia. Photo Christobal Bolda.

40 Façade of the Alcázar, Seville, 1364–6. Photo Institut Amatller d'Art Hispanic, Barcelona.

41 Interior of Samuel Halevi's Synagogue (del Tránsito), Toledo, 1354–7. Photo Institut Amatller d'Art Hispanic, Barcelona.

42 Torre de San Martín, Teruel, c. 1315. Photo Oronoz.

43 Court of Lions, Alhambra Palace, Granada, c. 1360. Photo Martin Hürlimann.

44 Ceiling painting in the Hall of Justice, Alhambra Palace, Granada, c. 1375. Tempera on stretched skins. Photo Oronoz.

45 León Cathedral, 1225–1302. Photo A. F. Kersting.

46 Interior of Santa María del Mar, Barcelona, 1329–67. Photo Oronoz.

47 Ferrer Bassa, *The Adoration*, 1346. Mural in oils from the Chapel of San Miguel in the cloister of the Monastery of Pedralbes. Photo Institut Amatller d'Art Hispanic, Barcelona.

48 Luis Dalmau, *The Madonna of Councillors*, 1443–5. Tempera and oil on panel, 272 × 276 (107⅛ × 108¾). Museu d'Art de Catalunya, Barcelona. Photo MNAC Photographic Services (Calveras, Mérida, Sagristà).

49 Pedro Serra, *Altarpiece of the Holy Spirit*, 1394. Church of Santa María, Manresa. Photo Oronoz.

233

50 Fernando Gallego, *Pietà*, c. 1465. Panel painting, 118 × 102 (46½ × 40⅛). Museo del Prado, Madrid. Photo Oronoz.
51 Bartolomeo Bermejo, *St Domingo de Silos*, 1474. Oil on board, 242 × 130 (95¼ × 51⅛). Museo del Prado, Madrid.
52 Jaume Huguet, *The Episcopal Coronation of St Augustine*, c. 1480. Panel painting, 272 × 200.3 (107⅛ × 78¾). Museu Nacional d'Art de Catalunya. Photo MNAC Photographic Services (Calveras, Mérida, Sagristà).
53 The high altar of Toledo Cathedral, begun 1498. Photo Oronoz.
54 Gil de Siloé and Diego de la Cruz, High altar of the Carthusian Monastery of Miraflores, Burgos, c. 1496–9. Photo Oronoz.
55 Gil de Siloé, Double-tomb of Juan II and Isabella of Portugal, 1486–99. Carthusian Monastery of Miraflores, Burgos. Photo Oronoz.
56 Bartolomé Bermejo, *Pietà*, 1490. Panel painting. Cathedral Museum, Barcelona. Photo Institut Amatller d'Art Hispanic, Barcelona.
57 Juan de Alava, Façade of the Convent of San Esteban, Salamanca, c. 1524; shown as completed in 1610, by Juan Antonio Ceroni. Photo Martin Hürlimann.
58 Ayne Bru, *Martyrdom of St Cucufat*. Central panel of the *retablo major* of Sant Cugat del Vallés, 1502–6. 164 × 133 (64⅝ × 52⅜). Museu Nacional d'Art de Catalunya, Barcelona. Photo MNAC Photographic Services (Calveras, Mérida, Sagristà).
59 Pedro Machuca, Palace of Charles V, Alhambra, Granada, begun 1533. Photo Institut Amatller d'Art Hispanic, Barcelona.
60 Diego de Sagrado, Grotesque motif from *Medidas del Romano*, 1526.
61 Pedro Berruguete, *Auto de fe*, c. 1498. Panel from St Domingo Altarpiece, Santo Tomás, Ávila. Oil on board, 154 × 92 (60⅝ × 36¼). Museo del Prado, Madrid.
62 Pedro Berruguete, *Federico da Montefeltro, Duke of Urbino, and his son Guidobaldo*, c. 1480. Oil on board, 135 × 79 (53 × 31). Galleria Nazionale, Urbino.
63 Pedro Berruguete, *King Solomon*, c. 1485. Oil on panel, 94 × 65 (37 × 25⅝). Photo Institut Amatller d'Art Hispanic, Barcelona.
64 Juan de Borgoña, *Embrace Before the Golden Gate*, c. 1509–11. Mural in the Sala Capitular of Toledo Cathedral. Photo Oronoz.

65 Paolo da San Leocadio, *Madonna of the Knight of Montesa*, c. 1485. Oil on board, 102 × 96 (40⅛ × 37¼). Museo del Prado, Madrid.
66 Fernando Yáñez de la Almedina, *St Catherine*, c. 1515. Oil on board, 212 × 112 (83½ × 44). Museo del Prado, Madrid.
67 Bartolomé Ordóñez, *St Andrew*, detail from the Tomb of Philip the Fair and Joanna the Mad, Capilla Real, Granada, c. 1519.
68 Vicente Masip, *Martyrdom of St Agnes*, c. 1535. Oil on board, diameter 58 (22⅞). Museo del Prado, Madrid.
69 Juan de Juanes, *The Last Supper*, c. 1570. Oil on board, 116 × 191 (45⅝ × 73¼). Museo del Prado, Madrid.
70 Pedro Machuca, *Deposition*, before 1520. Oil on board, 141 × 128 (55½ × 50⅜). Museo del Prado, Madrid.
71 Alonso Berruguete, *Salome*, c. 1515. Oil on board, 87.5 × 71 (34 × 27½). Galleria degli Uffizi, Florence.
72 Alonso Berruguete, *Sacrifice of Isaac*. Polychromed wooden sculpture from the San Benito Altarpiece, 1527. Museo Nacional de Escultura, Valladolid.
73 Luis de Morales, *Pietà*, c. 1570–80. Oil on canvas, 120 × 85 (47 × 33½). Academia de Bellas Artes de San Fernando, Madrid.
74 Alonso Sánchez Coello, *Princess Isabel Clara Eugenia*, 1579. Oil on canvas, 116 × 102 (45⅛ × 40⅛). Museo del Prado, Madrid.
75 Antonius Mor van Dashorst (Antonio Moro), *Queen Mary Tudor*, 1554. Oil on board, 109 × 84 (42⅞ × 33⅛). Museo del Prado, Madrid.
76 Juan de Herrera, The Escorial, 1563–84, aerial view. Plate VII from Juan de Herrera, *Sumario*, 1587.
77 Juan de Herrera, The Patio de los Evangelistas at the Escorial, 1563–84. Photo Jean Dieuzade.
78, 79 Pompeo Leoni, Monument of Charles V and his Family, and the Tomb of Philip II, 1591–8. Basilica, El Escorial. Photos Insitut Amatller d'Art Hispanic, Barcelona.
80 El Greco, *Martyrdom of St Maurice and the Theban Legion*, c. 1580–2. Oil on canvas, 448 × 301 (176⅜ × 118½). El Escorial, Madrid.
81 El Greco, *View of Toledo*, c. 1610. Oil on canvas, 121.3 × 108.6 (47¾ × 42¼). The Metropolitan Museum of Art, New York, Bequest of Mrs H. O. Havemeyer, 1928. The H. O. Havemeyer Collection.
82 El Greco, *Burial of the Count of Orgaz*, c. 1586. Oil on canvas, 480 × 360 (189 × 141⅞). Santo Tomé, Toledo. Photo Oronoz.

83 El Greco, *Holy Trinity*, c. 1577–9. Oil on canvas, 300 × 179 (118⅛ × 70½). Museo del Prado, Madrid.
84 El Greco, *Agony in the Garden*, c. 1585. Oil on canvas, 102.2 × 113.7 (40⅛ × 44¼). The Toledo Museum of Art, Ohio. Gift of Edward Drummond Libbey.
85 El Greco, *Laocoön*, c. 1610. Oil on canvas, 137.5 × 172 (54⅛ × 67⅞). National Gallery of Art, Washington D.C. Samuel H. Kress Collection, 1946.
86 El Greco, *Adoration of the Shepherds*, c. 1613. Oil on canvas, 319 × 180 (125⅛ × 70⅞). Museo del Prado, Madrid.
87 Pedro de Campaña, *Deposition*, c. 1547. Oil on board. Seville Cathedral. Photo Oronoz.
88 Juan Fernández de Navarrete (El Mudo), *Martyrdom of St James*, c. 1571. Oil on canvas, 340 × 210 (133⅞ × 82⅝). El Escorial. Photo Oronoz.
89 Gaspar Becerra, *Danaë*, detail of a ceiling fresco-cycle in the Pardo Palace, Madrid, c. 1563. Photo Oronoz.
90 Juan Fernández de Navarrete (El Mudo), *St James and St Andrew*, 1577. Oil on canvas. El Escorial, Madrid. Photo Institut Amatller d'Art Hispanic, Barcelona.
91 El Greco, *St Andrew and St Francis*, c. 1590. Oil on canvas, 167 × 113 (65¾ × 44½). Museo del Prado, Madrid. Photo Oronoz.
92 Francisco Pacheco, *Immaculate Conception with Miguel Cid*, c. 1622. Oil on canvas, 160 × 109 (63 × 42⅞). Seville Cathedral. Photo Oronoz.
93 Francisco Ribalta, *Christ Embracing St Bernard*, c. 1622. Oil on canvas, 167 × 113 (65¾ × 44½). Museo del Prado, Madrid. Photo Oronoz.
94 Francisco Ribalta, *Vision of St Francis*, c. 1620. Oil on canvas, 208 × 167 (81⅞ × 65¾). Museo de Bellas Artes de Valencia.
95 Juan de las Roelas, *Martyrdom of St Andrew*, c. 1609–13. Oil on canvas. Museo de Bellas Artes, Seville.
96 Francisco Herrera the Elder, *St Bonaventura Received into the Franciscan Order*, 1628. Oil on canvas, 213 × 215 (83⅞ × 84⅝). Museo del Prado, Madrid. Photo Institut Amatller d'Art Hispanic, Barcelona.
97 Juan Martínez Montañés, *Cristo de la Clemencia*, c. 1603. Polychromed wood. Seville Cathedral. Photo Institut Amatller d'Art Hispanic, Barcelona.
98 Workshop of Pedro de Roldán, *Virgen de la Macarena*, c. 1695. Polychromed (and costumed) wood sculpture. Church of San Gil, Seville.

99 Gregorio Fernández, *Dead Christ*, 1605. Capuchin Convent of El Pardo, Madrid.

100 Francisco de Zurbarán, *Apparition of the Crucified St Peter to St Peter Nolasco, c.* 1630. Oil on canvas, 179 × 223 (70⅛ × 87⅞). Museo del Prado, Madrid.

101 Pedro de Mena, *St Francis, c.* 1663. Polychromed wood sculpture. Toledo Cathedral. Photo AKG, London.

102 Francisco de Zurbarán, *St Francis in his Tomb, c.* 1640. Oil on canvas, 209 × 110 (82¼ × 43¼). Musée des Beaux-Arts, Lyons.

103 Francisco de Zurbarán, *Still Life with Lemons, Oranges and a Rose*, 1633. Oil on canvas, 60 × 104.5 (24½ × 43⅛). The Norton Simon Foundation, Pasadena, CA.

104 Juan Sánchez Cotán, *Still Life, c.* 1602. Oil on canvas, 65.4 × 81.3 (25¼ × 32). Fine Arts Gallery, San Diego.

105 José de Ribera, *St Andrew, c.* 1632. Oil on canvas, 123 × 95 (48⅛ × 37⅜). Museo del Prado, Madrid.

106 José de Ribera, *Archimedes*, 1630. Oil on canvas, 125 × 81 (49¼ × 31⅞). Museo del Prado, Madrid.

107 José de Ribera, *Martyrdom of St Philip, c.* 1630. Oil on canvas, 234 × 234 (92⅛ × 92⅛). Museo del Prado, Madrid.

108 José de Ribera, *Boy with a Club Foot*, 1652. Oil on canvas, 134 × 92 (53¼ × 40¼). Musée du Louvre, Paris.

109 Diego Velázquez, *Waterseller of Seville, c.* 1619. Oil on canvas, 106 × 82 (41¼ × 32¼). Aspley House, London. Photo V&A Picture Library.

110 Diego Velázquez, *St John the Evangelist on the Island of Patmos, c.* 1618. Oil on canvas, 135.5 × 102.2 (53¼ × 40¼). © National Gallery, London.

111 Diego Velázquez, *Philip IV in Brown and Silver, c.* 1635. Oil on canvas, 195 × 110 (76⅞ × 43¼). © National Gallery, London.

112 Diego Velázquez, *The Surrender of Breda (Las Lanzas), c.* 1634. Oil on canvas, 307 × 367 (120⅞ × 144½). Museo del Prado, Madrid.

113 Diego Velázquez, *The Court Fool Calabacillas, c.* 1638. Oil on canvas, 106 × 83 (41¼ × 32⅛). Museo del Prado, Madrid.

114 Diego Velázquez, *Equestrian Portrait of the Count-Duke of Olivares, c.* 1633. Oil on canvas, 313 × 239 (123⅛ × 94⅛). Museo del Prado, Madrid.

115 Diego Velázquez, *Feast of Bacchus (Los Borrachos)*, 1629. Oil on canvas, 165 × 225 (65 × 88⅜). Museo del Prado, Madrid. Photo Oronoz.

116 Diego Velázquez, *Toilet of Venus*, the 'Rokeby Venus', *c.* 1647. Oil on canvas, 122.5 × 177 (48¼ × 69¼). © National Gallery, London.

117 Diego Velázquez, *Mars, c.* 1641. Oil on canvas, 179 × 95 (70½ × 37⅜). Museo del Prado, Madrid.

118 Diego Velázquez, *Las Meninas*, 1656. Oil on canvas, 318 × 276 (125¼ × 108⅜). Museo del Prado, Madrid. Photo Oronoz.

119 Bartolomé Esteban Murillo, *Holy Family with a Bird, c.* 1650. Oil on canvas, 144 × 188 (56¾ × 74). Museo del Prado, Madrid.

120 Bartolomé Esteban Murillo, *Aranjuez Immaculata, c.* 1650–60. Oil on canvas, 222 × 118 (87⅜ × 46½). Museo del Prado, Madrid. Photo AKG London.

121 Bartolomé Esteban Murillo, *Beggar Boys Throwing Dice*, 1668–72. Oil on canvas, 146 × 108 (57½ × 42½). Alte Pinakothek, Munich.

122 Bartolomé Esteban Murillo, *Girl and her Dueña, c.* 1660. Oil on canvas, 127.7 × 106.1 (50¼ × 41⅞). National Gallery of Art, Washington D.C.

123 Claudio Coello, *Holy Sacrament of Charles II (La Sagrada forma), c.* 1690. Oil on canvas. El Escorial, Madrid. Photo Insitut Amatller d'Art Hispanic, Barcelona.

124 José Benito Churriguera, The *retablo major* at San Esteban, Salamanca, begun 1692. Photo Oronoz.

125 Narciso Tomé, *Transparente*, 1721–32. Toledo Cathedral. Photo AKG, London.

126 Filippo Juvarra and Giovanni Battista Sacchetti, Garden façade of La Granja, 1735–64. Photo Martin Hürlimann.

127 Luis Paret y Alcázar, *Charles III Dining Before his Court, c.* 1775. Oil on board, 50 × 64 (19¾ × 35¼). Museo del Prado, Madrid.

128 Francisco Bayeu, Sketch for *Olympus: The Battle of the Gods with the Giants, c.* 1790. Ceiling painting at the new Palacio Real, Madrid. Oil on canvas, 68 × 123 (26¾ × 48⅜). Museo del Prado, Madrid.

129 Luis Meléndez, *Still Life with Melon and Pears*. Oil on canvas, 63.8 × 85 (25¼ × 33½). Courtesy Museum of Fine Arts, Boston, Margaret Curry Wyman Fund.

130 Francisco Goya y Lucientes, *The Parasol, c.* 1777. Tapestry cartoon: oil on canvas, 104 × 152 (41 × 59⅞). Museo del Prado, Madrid.

131 Francisco Goya y Lucientes, *The Sleep of Reason Produces Monsters*, no. 45 of *Los Caprichos, c.* 1797. Aquatint. Museo del Prado, Madrid.

132 Francisco Goya y Lucientes, *The Family of Charles IV, c.* 1800. Oil on canvas, 280 × 336 (110¼ × 132¼). Museo del Prado, Madrid.

133, 134 Francisco Goya y Lucientes, *Naked Maja, c.* 1798. Oil on canvas, 98 × 191 (38⅜ × 75¼). *Clothed Maja, c.* 1798. Oil on canvas, 95 × 188 (37⅛ × 74). Museo del Prado, Madrid. Photos Oronoz.

135, 136 Francisco Goya y Lucientes, *The Second of May, 1808 (Uprising), c.* 1814; *The Third of May, 1808 (Executions), c.* 1814. Oil on canvas, 266 × 345 (104¾ × 135⅞). Museo del Prado, Madrid. Photos Oronoz.

137 Francisco Goya y Lucientes, *What More Can be Done?* Etching from the *Disasters of War*, before 1820.

138 Francisco Goya y Lucientes, *Colossus, c.* 1808–12. Oil on canvas, 116 × 106 (45⅝ × 41⅞). Museo del Prado, Madrid.

139, 140 Francisco Goya y Lucientes, *A Duel to the Death with Clubs, c.* 1820–2; *Saturn Devouring his Children, c.* 1820–2. Fragments of a mural cycle in oils from the *Quinta del Sordo*. Museo del Prado, Madrid.

141 Leonardo Alenza, *¡Los Románticos!, c.* 1835. Oil on canvas, 37 × 28 (14½ × 11). Museo Romantico, Madrid. Photo Oronoz.

142 Eduardo Rosales, *Isabella the Catholic's Last Will and Testament*, 1864. Oil on canvas, 290 × 400 (113¾ × 157⅛). Museo del Prado, Madrid.

143 Antonio Esquivel, *A Reading by the Poet José Zorrilla, c.* 1846. Oil on canvas, 144 × 214 (56¾ × 84¼). Museo del Prado, Madrid.

144 Antonio Gisbert, *Execution by Firing Squad of General Torrijos and his Companions*, 1886–8. Oil on canvas. Museo del Prado, Madrid.

145 Mariano Fortuny, *The Vicarage*, 1870. Oil on canvas, 60 × 93.5 (23⅝ × 36½). Museu d'Art Modern, Barcelona. Photo MNAC Photographic Services (Calveras, Mérida, Sagristà).

146 Joaquín Sorolla y Bastida, *Children on the Beach*, 1910. Oil on canvas, 118 × 185 (46½ × 72⅞). Museo del Prado, Madrid. © DACS 1999.

147 Ignacio Zuloaga, *El Cristo de la Sangre*, 1911. Oil on canvas, 248 × 302 (97⅝ × 118⅞). Museo Nacional Centro de Arte Reina Sofia, Madrid. © DACS 1999.

148 José Gutiérrez Solana, *A Visit to the Bishop*, 1926. Oil on canvas, 161 × 211 (63⅜ × 83⅛). Museo Nacional Centro de Arte Reina Sofia, Madrid. © DACS 1999.
149 Antoni Gaudí, Church of the Sagrada Familia, Barcelona, begun 1883. Photo AKG London.
150 Isidro Nonell, *Repose*, 1904. Oil on canvas, 120 × 120 (47¼ × 47¼). Museu d'Art Modern, Barcelona. Photo MNAC Photographic Services (Calveras, Mérida, Sagristà).
151 Pablo Picasso, *The Tragedy*, 1903. Oil on wood, 105.4 × 69 (41⅛ × 37⅛). National Gallery of Art, Washington D.C. Chester Dale Collection. © Succession Picasso/DACS 1999.
152 Pablo Picasso, *Portrait of Gertrude Stein*, 1905–6. Oil on canvas, 100 × 81.3 (39⅜ × 32). The Metropolitan Museum of Art, New York. Bequest of Gertrude Stein, 1946. © Succession Picasso/DACS 1999.
153 Pablo Picasso, *Les Demoiselles d'Avignon*, 1907. Oil on canvas, 243.9 × 233.7 (96 × 92). The Museum of Modern Art, New York. Acquired through the Lille P. Bliss Bequest. Photograph © 1998 The Museum of Modern Art, New York. © Succession Picasso/DACS 1999.
154 Pablo Picasso, *Still Life with Chair-Caning*, 1912. Collage of oil, oil cloth and pastel on paper edged with rope, 29 × 37 (11⅜ × 14⅝). Musée Picasso, Paris. © Succession Picasso/DACS 1999.

155 Juan Gris, *Violin*, 1916. Oil on wood, 115.5 × 73.6 (45½ × 29). Öffentliche Kunstsammlung, Basel.
156 Julio González, *Woman Combing her Hair*, c. 1933–6. Iron. Moderna Museet, Stockholm. © AGDAP, Paris and DACS, London 1999.
157 Pablo Picasso, *Guernica*, 1937. Oil on canvas, 349 × 776 (137⅜ × 305½). Museo Nacional Centro de Arte Reina Sofia, Madrid. © Succession Picasso/DACS 1999.
158 Pablo Picasso, *Study after Velázquez 'Las Meninas'*, 1957. Oil on canvas, 161 × 129 (63⅜ × 50¾). Museu Picasso, Barcelona. © Succession Picasso/DACS 1999.
159 Salvador Dalí, *The Metamorphosis of Narcissus*, 1937. Oil on canvas, 51.1 × 78.1 (20⅛ × 30¾). Tate Gallery, London. © Salvador Dalí-Fundacion Gala-Salvador Dalí/DACS 1999.
160 Joan Miró, *Garden with Donkey*, 1918. Oil on canvas, 65 × 71.5 (25⅔ × 27½). Moderna Museet, Stockholm. © AGDAP, Paris and DACS, London 1999.
161 Joan Miró, *Canvas*, 1953. Oil on canvas, 195 × 378 (76¾ × 148¾). Solomon Guggenheim Museum, New York. © AGDAP, Paris and DACS, London 1999.
162 José Caballero, *Falangist Soldier with the Angel of Victory*. Illustration from *Laureados de España*, 1939. Biblioteca de Catalunya, Barcelona. © DACS 1999.
163 Antoni Tàpies, *Black Form on Grey Square*, 1960. Mixed media on canvas,

162 × 162 (63¾ × 63¾). Fundacio Antoni Tàpies, Barcelona. © AGDAP, Paris and DACS, London 1999.
164 Antonio Saura, *Imaginary Portrait of Goya No. II*, 1967. Oil on canvas, 159 × 195 (62½ × 76¾). Courtesy Galerie Stadler, Paris. Photo Augustin Dumage. © AGDAP, Paris and DACS, London 1999.
165 Manuel Millares, *Sarcophagus for Philip II*, 1963. Plastic paint on sackcloth, 130 × 194 (51⅛ × 76⅜). Coleccion de Arte Abstracto Español, Fundacio Juan March, Cuenca. © DACS 1999.
166 Antonio López, *Taza de Water y Ventana*, 1968–71. Oil and paper on board, 143 × 93.5 (56¼ × 36¾). Courtesy Galeria Marlborough, Madrid. © DACS 1999.
167 Juan Genovés, *El Foco*, 1966. Oil on canvas, 100 × 100 (39⅜ × 39⅜). Staatsgalerie, Stuttgart. © DACS 1999.
168 Equipo Crónica, *'El Perro' Posición, Autoretrato en Palacio*, 1970. Acrylic on canvas, 200 × 140 (78¾ × 55). Museo de la Asguerada, Alicante.
169 Luis Gordillo, *Adam Y Eva A*, 1973. Acrylic on canvas, 152 × 190 (59⅞ × 74¾). Courtesy of the artist. © DACS 1999.
170 Miquel Barceló, *Big Spanish Dinner*, 1985. Mixed media on canvas, 200 × 200 (78¾ × 118⅛). Museo Nacional Centro de Arte Reina Sofia, Madrid. © AGDAP, Paris and DACS, London 1999.

Index

237

239